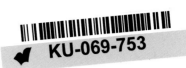
BRAQUE

The Late Works

BRAQUE

THE LATE WORKS

John Golding
Sophie Bowness
Isabelle Monod-Fontaine

The Menil Collection, Houston
in collaboration with
Royal Academy of Arts, London

Yale University Press, New Haven and London

First published on the occasion of the exhibition 'Braque: The Late Works'
Royal Academy of Arts, London, 23 January – 6 April 1997
The Menil Collection, Houston, 25 April – 31 August 1997

This exhibition is supported by an indemnity from the Federal Council on the Arts and the Humanities

LIBRARY OF CONGRESS CATALOGING-IN-PUBLICATION DATA
Golding, John
 Braque : the late works / John Golding.
 p. cm.
 "In association with the Royal Academy of Arts, London"
 Includes bibliographical references and index.
 ISBN 0-300-07159-0 (cloth). ISBN 0-300-07160-4 (alk. paper)
 1. Braque, Georges, 1882–1963—Exhibitions. I Title
ND553.B86A4 1997
759.4—dc21 96-51627
 CIP

Exhibition Curators: John Golding and Simonetta Fraquelli
Exhibition Organiser: Susan Thompson
Exhibition Assistant: Harriet James
Text Editor: Robert Williams
Editorial Coordinator: Sophie Lawrence
Photographic Coordinator: Miranda Bennion
Translator: Caroline Beamish

THE MENIL COLLECTION, HOUSTON
In Houston, Susan Davidson, Associate Curator, and Julia A. Bakke, Registrar,
have been instrumental in the overall organization of the exhibition

Designed by Sally Salvesen
Typeset in Bembo by SX Composing, Rayleigh
Printed in Italy
5 4 3 2

COVER ILLUSTRATION: *The Echo*, 1953–6,
Private Collection, courtesy Helly Nahmad

FRONTISPIECE: Braque working on *The Echo* (cat. 32) in his studio at Varengeville.
Photograph © Alexander Liberman

CONTENTS

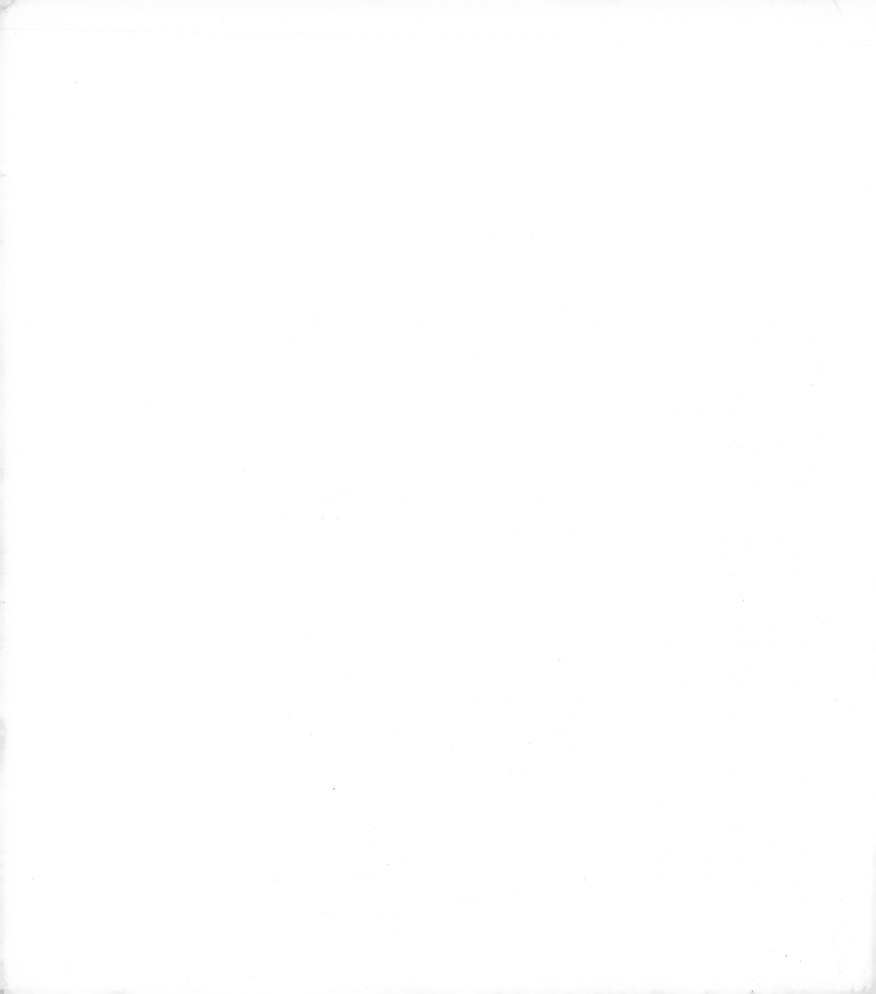

PRESIDENT'S FOREWORD

Braque is one of the great artists and innovators of this century and, although his reputation rests primarily on his invention of Cubism together with Picasso, his grand and often sumptuous late works in many ways represent the summit of his artistic achievement. The Royal Academy is delighted, therefore, to present this exhibition to celebrate this period of Braque's career. Concentrating on the three great cycles of paintings, the Billiard Tables, the Studios and the Birds, together with the interiors and landscapes that Braque worked on between 1941 and his death in 1963, the exhibition draws attention to Braque's lifelong interest in the depiction of space and the relationship of objects within it. We hope that for many of our visitors the exhibition will come as a revelation, highlighting a period of this master's work that hitherto has been neglected in this country.

The exhibition was first proposed several years ago by the late Sir Roger de Grey, former President of the Royal Academy and a great admirer of Braque, especially his late work. We were delighted that John Golding, painter and eminent art historian, who has been closely associated with Braque's work, agreed both to select the exhibition and to write for the catalogue. He has been assisted by Simonetta Fraquelli, Curator in our Exhibitions Office. Isabelle Monod-Fontaine and Sophie Bowness have also made invaluable contributions to the catalogue.

We have so many people to thank. First, we are indebted to the artist's heirs, Mr and Mrs Claude Laurens, and their son Quentin. Without their unfailing support and generosity it would not have been possible to realise the exhibition. As always, we are most grateful to all the owners and curators of collections from Europe and America who have so generously lent their treasures. In particular we extend our thanks to Germain Viatte of the Musée national d'art moderne, Centre Georges Pompidou, Paris; to Paule and Adrien Maeght, and their daughter Isabelle, and to Jean-Louis Prat of the Fondation Maeght in Saint-Paul. We would also like to thank John Richardson for his continued support and advice throughout the preparation of this exhibition.

Following its showing in London, the exhibition will travel to The Menil Collection in Houston and we owe a special debt of gratitude to Mrs Dominique de Menil, and to Paul Winkler, Walter Hopps and Susan Davidson, Director, Founding Director and Associate Curator of The Menil Collection for their warm collaboration and assistance with the organisation of the exhibition.

The Royal Academy's most sincere appreciation must also be expressed to the sponsors of this exhibition, The Royal Bank of Scotland. It has been through their committed support that this exhibition of Braque's late works has been made possible.

Sir Philip Dowson, CBE
President, Royal Academy of Arts

ACKNOWLEDGEMENTS

In addition to those already mentioned in the President's Foreword, the organisers would like to thank William S. Lieberman of the Metropolitan Museum of Art in New York and Stewart G. Rosenblum for facilitating the loan from the Florene M. Schoenborn Estate; Casilda Fernandez-Villaverde y Silva, Condesa de Carvajal and Michael Findlay of Christie's, Madrid and New York, and Alexander Apsis and Michel Strauss of Sotheby's, New York and London, for their tireless help in securing the loan of several key works; and the following people who have contributed to the organisation of the exhibition and the preparation of the catalogue in many different ways:

Robin Airey
Doris Ammann
Julie Bakke
Ida Balboul
Ernst Beyeler
Harrison Birtwistle
Alan and Sarah Bowness
Sigrid Buan
François Chapon
Marie-Claude Char
Jeremy Coote
Crosby Coughlin
Nathalie Daireaux
Jill De Vonyar-Zansky
Bernd Dütting
John Elderfield
Dr Volkmar Essers
Evelyne Ferlay
Marianne Frisch
Matthew Gale
Pedro Girao
Dr Mechthild Haas
Dr Wolfgang Henze
Patrick Heron
Sofia Imber

Antoinette Jackson
Ellen Josefowitz
Veronique Léger
Alexander Liberman
Robert Littman
Margaret Loudon
Florence de Lussy
Lieselott Man
Yozo Mori
Takako Nagasawa
Joe Nahmad
Michael O'Hanlon
Pamela S. Paterson
Annette Pioud
Armande Ponge
Ruth Rattenbury
Paco Rébes
Christiane Rojouan
Elaine Rosenberg
Reinhard Rudolph
Andreas Rumbler
Carmen Schjaer
Dr Angela Schneider
Nicholas Serota
Jeremy Strick

David Sylvester
Sam Sylvester
Joanna Weber
Wendi West
Sarah Whitfield
John and Anne Willett
Robert Williams
Oliver Wootton
Armin Zweite

LENDERS TO THE EXHIBITION

Nationalgalerie, Berlin

Museo de arte contemporáneo de Caracas Sofia Imber, Caracas

Charles and Palmer Ducommun

Kunstsammlung Nordrhein-Westfalen, Düsseldorf

Galerie Jan Krugier, Geneva

The Menil Collection, Houston

Mr and Mrs Claude Laurens

Paule and Adrien Maeght Collection

Masaveu Collection, Oviedo

Yale University Art Gallery, New Haven

Corporate Art Collection, The Reader's Digest Association, Inc., New York

Musée national d'art moderne, Centre Georges Pompidou, Paris

Philadelphia Museum of Art, Philadelphia
Promised gift of Mr & Mrs Klaus Perls

John Richardson

Saarland Museum, Saarbrücken

The Saint Louis Art Museum, Saint Louis

Fondation Marguerite et Aimé Maeght, Saint-Paul

The Estate of Florene M. Schoenborn

Samir Traboulsi

The Phillips Collection, Washington, DC

and those lenders who wish to remain anonymous

1. Braque with *Studio IV* (Paul Sacher
Collection, Basle). Photograph ©
Michel Sima/SELON

JOHN GOLDING

THE LATE PAINTINGS
AN INTRODUCTION

Each of the two World Wars was to have a profound effect on Braque's art. He served in the first, and early on, in May 1915, was seriously wounded. Braque's recovery was to last some two years, during which he pondered his situation as an artist: his 'Pensées et réflexions sur la peinture' were published in December 1917 in the review *Nord-Sud*, edited by his friend the poet Pierre Reverdy. In the years between 1907 and the outbreak of war in 1914 Braque and Picasso had between them created Cubism which had revolutionised the language of painting. The partnership between the two artists had been that of equals, but Braque's contribution had been recognised only by a handful of individuals, most notably by the two dealers, Daniel-Henry Kahnweiler and Wilhelm Uhde, who were championing the movement. Now, after a moment of hesitation, during which his work acknowledged the influence of Juan Gris and the sculptor Henri Laurens, Braque began work on a series of large, upright still-lifes on pedestal tables or *guéridons* (fig. 2). When these were shown at Léonce Rosenberg's Galerie de L'Effort Moderne in March 1919 they established Braque's reputation as a major and totally independent artist; and in 1922 he was honoured with an entire room of his own at the prestigious Salon d'Automne.

At the time of the outbreak of the Second World War Braque was at the zenith of his maturity and had attained international recognition as one of the greatest living French artists. The still-lifes executed in the second half of the 1930s are among the fullest and most sumptuous in the entire French canon (fig. 3). Simultaneously Braque was enlarging his iconographic range by producing a series of large, monumental canvases of interiors furnished with still-lifes, many of which refer to the attributes of the painter's studio – easels and palettes proliferate – and also frequently by human figures or presences. These latter are mostly female, and they too appear to allegorise the creative act: some of them hold or contemplate works of art, others play music (fig. 4).

But the skulls, which first made an appearance in Braque's work of 1938, and which haunted him during the early months of 1939, struck an ominous note; they persisted as a motif for the next four years. In his response to the questionnaire launched by Christian Zervos's influential periodical *Cahiers d'Art* early in 1939 on the extent to which artists are affected by current events, Braque shows an awareness of impending world tragedy. Braque was not a political figure – and he kept himself totally free from the internal politics

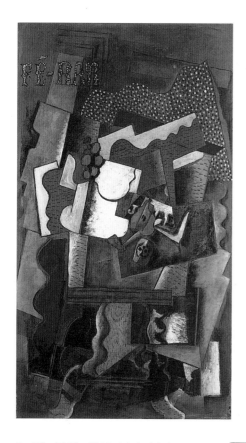

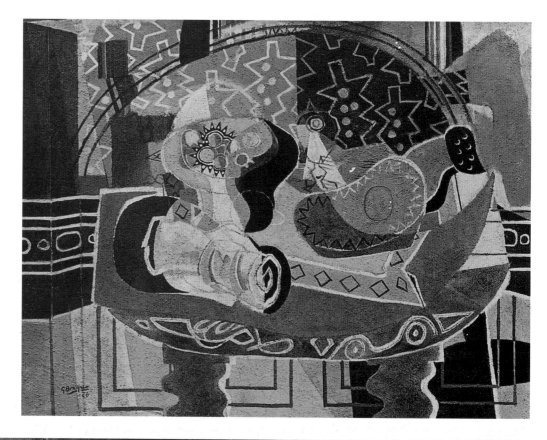

2. *The Table*, 1918 (Philadelphia Museum of Art, The Louise and Walter Arensberg Collection).

3. *Still Life on Red Tablecloth*, 1936 (Norton Museum of Art, West Palm Beach, Florida).

4. *Artist and Model*, 1939 (Norton Simon Museum of Art, Pasadena).

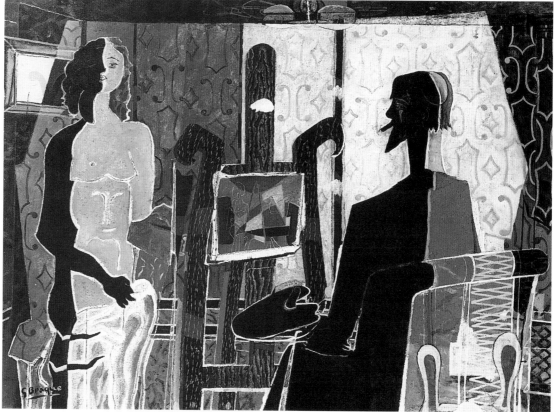

of the French art world – and he was not a pessimist. Yet he was simultaneously a visionary and a realist, and one of nature's Jansenists. 'The Artist is always under siege [*menacé*]', he wrote. And further on: 'People don't take sufficiently into account the dark forces that impel us. . .'[1] If the experience of the First World War had forced upon Braque a new, expectant self-awareness, that of the Second drove him back downwards into himself.

Braque was at his country house at Varengeville, in Normandy, when the German armies broke through the Maginot Line in 1940. He and his wife took refuge first of all in the house of their maid's family in the province of Limousin, and subsequently further south, in the Pyrenees. But in the autumn they made their way back to Paris, to the house that the distinguished architect Auguste Perret had designed and built for them in 1924 in the rue du Douanier (today the rue Georges Braque), just off the Parc Montsouris. There Braque remained throughout the war, making occasional trips to Varengeville, and becoming, like Picasso, a quiet symbol of resistance in occupied Paris. Not surprisingly Braque produced little in 1940, but in 1941 he resumed work. Many of the pictures produced during the war years share with the paintings of the 1920s a return to a greater naturalism, but it is a naturalism of a different order; whereas the earlier paintings were characterised by an air of serenity and a quiet, restrained splendour, the wartime pictures tend to be austere, at times even tragic in their implications.

After 1917 Braque's production tends to fall into two very general categories: large works, often executed in series, and smaller, more intimate, and more disparate works. These 'cabinet' pictures share some of the iconography and concerns of the larger pictures, and sometimes they help to resolve the new pictorial challenges that Braque constantly set for himself; but they are for the most part less experimental and ambitious. The two series of larger works that serve to characterise the war years are the still-lifes placed in bathrooms and those set in kitchens (cat. 6, 7, 8) – the only two rooms in the house that the Braques were able to keep even moderately warm. The bathroom pictures tend to be austere and smoothly painted, evoking surfaces of enamel and linoleum. The kitchen pictures are crustier and more highly textured. The objects in both series take on a ritualistic, sacramental air. *The Washstand* (*c.* 1942–4; cat. 7) is, by Braque's standards, not spatially inventive; but it comments movingly on the human condition in adversity, on man's ability to endure, to perform of necessity daily ablutions. The view through the window – and windows had made an appearance in Braque's work surprisingly late, not until 1938 – is grey and blank. *Kitchen Table with Grill* of 1943–4 (cat. 8) is equally sober but is spatially more complex and impacted, even somewhat claustrophobic in its density; kitchen utensils abound but food is at a minimum, the single fish sacrificial – food rationing had been introduced in Paris in May 1941.

But the austerities of life in occupied Paris are given their most forceful and poignant expression in *The Stove*, a major painting of 1942 (cat. 3). The studio stove is a subject that had been dignified by many 19th-century artists, including Corot, Delacroix and Cézanne. Here it is given a naked reality that is found nowhere else in Braque's entire output; it glistens coldly, and the coal-bucket in front of it appears to be empty. By contrast, the simple wooden table-top has been lifted up onto the picture plane by an abstract, sweeping and pall-like black plane that binds it to a framed picture or mirror on the wall behind. A potted plant has replaced the flowers shown in a preliminary sketch, and the brushes, that in the sketch protrude from the thumb-hole of the palette, have been removed; the palette now stands proxy for the human skull. The artist's palette had put in a single appearance in

a Cubist work of 1909–10,[2] but had then been banished from Braque's repertoire of objects until 1936. It haunts the late work.

One work more than any other ushers in Braque's late manner. The *Large Interior with Palette* or *Grand Intérieur* of 1942 (cat. 2) is the largest and also the greatest of all Braque's wartime canvases. A smaller version,[3] executed the previous year is, despite its beauty, somewhat grim and severe. The large canvas, on the other hand, is serene and contemplative and, although it is colouristically muted, it also demonstrates Braque's unique ability to extract every nuance out of an essentially tonal palette of blacks, greys and fawns. Superimposed onto the composition revived from the earlier work are two curving, lyre-like shapes derived from the upper section of an easel but rendered here as transparent. Braque's studios were filled with easels of all descriptions; the more decorative easels with volute tops of the type depicted here were used by artists and by many Parisian galleries to display finished works of art, so perhaps not only are we looking at a picture through an easel, but also, metaphorically, at a picture placed upon one. The inclusion of the easel shapes serves to insinuate the spectator into the artist's place and because of this, as we study the spatial relationships within the painting, we remain conscious also of the space between ourselves and what we are looking at. The spatial relationships of the objects depicted are totally convincing from a naturalistic point of view and yet simultaneously strangely shifting and evanescent, almost dreamlike. This work's sobriety and gravity, the implied reflection upon the nature of art and illusion, the combination of metaphysical speculation and poetic reflection, all these qualities usher in a new phase in Braque's art.

Braque's greatest single obsession was with the creation of pictorial space. In one of the most revealing and frequently quoted of his statements he said, 'There is in nature a tactile space, I might almost say a manual space. I have besides written "when a still-life is out of reach it ceases to be a still-life…" I have always felt the urge to touch things and not just to look at them. That is the kind of space that fascinated me so much, because that is what early Cubist painting was, a research into space.'[4] And if Picasso's approach to the multi-viewpoint perspectives that were central to Cubism was more incisive and daring than Braque's, it was Braque who invented the space in which Cubist objects could live and breathe. 'When fragmented objects appeared in my paintings around 1909', Braque explained, 'it was a way for me to get as close as possible to the objects as the painting allowed';[5] but it also meant that the objects in his paintings flow into the space that surrounds them while that space in turn flows back into them, informing them more fully, so that many of his Cubist paintings reflect or indeed even embody a single continuum of the material and the non-material.

Throughout the 1920s and 1930s Braque extended his spatial repertoire. In his pre-war Cubism Braque had deliberately limited depth in order to control the spatial sensations he experienced in front of objects; subsequently, while he continued to place the objects he depicted within the spectator's reach, he began to explore and expand the space around them. Some of the still-lifes of the mid-1920s, for example, are placed on mantelshelves with empty black grates below them. Other still-lifes of the late 1920s and early 1930s appear to be placed in the corners of rooms or else the space behind them has been folded in a screen-like fashion. In some of the largest paintings Braque includes the floorboards or tiles on which the tables stand, and at the top of some of the same pictures there are wedges of cornices or of ceilings. A new temporal element begins to assert itself to the extent that, while we can enjoy the immediate compositional impact of these paintings, it takes time

to come to terms with their spatial complexities; we cannot experience the space above and below the still-lifes simultaneously, just as we cannot experience visually at the same instant the floor and the ceiling of a room in which we stand.

The final twenty years of Braque's activity as a painter are dominated by three great series of predominantly large canvases: the 'Billiard Tables', executed between 1944 and 1952 (cat. 10–13A), the 'Ateliers' or 'Studios', of 1949–56 (cat. 19–24), and the final, valedictory 'Bird' paintings which emerge from them and succeed them (cat. 30–33, 35, 39, 40). To the end of his life Braque also continued to paint smaller, cabinet pictures. After the war the smaller still-lifes sometimes show more exotic foods again, for example lobsters and oysters (already a favourite subject in the 1930s) and are occasionally once more brightly coloured; some, by Braque's own restrained standards, even have a decorative quality to them. Braque retained his love of flowers, particularly of wild and simple garden flowers in informal arrangements; many of the flower pieces of his old age are small and intimate in feel. But others, like the famous *Sunflowers* of 1946 (cat. 15), are large and commanding, masterpieces of the genre. Most of Braque's sculpture belongs to the last two decades of his life, which also witnessed his greatest activity as a printmaker. But it is above all the late series paintings that expand and enrich Braque's repertoire, both spatially and iconographically.

The idea of painting billiard tables might at first seem strange (although van Gogh had done so), but Braque had been using tables as supports for his still-lifes throughout his career, and the idea of confronting and inscribing large, massive and intractable horizontal surfaces on two-dimensional, upright supports must have come as a challenge. (There were no billiard tables in either of Braque's houses and accounts as to how much he enjoyed or excelled in the game vary.) Four pictures within the series are of particular importance. The first of these, a monumental work of 1944 (cat. 10), is the most sober. The space of the room in which the table stands has been cracked or bent into two by a broken vertical axis that rises up through the billiard table to the cornice at the top of the picture, implying a corner view, although the window and the wall containing it are seen frontally. Two crossed billiard cues serve as markers, allowing us to measure mentally the length and width of the table; because of the three balls on the table surface we are metaphorically invited to pick up the cues and by doing so we insert ourselves into the space of the painting, moving in imagination around the table. Behind the table stands a small *guéridon* with a vase of flowers. To its left is the back of a chair; behind this in turn is a small oblong shape with a white, wing-like form on it, possibly a book resting on another small stand or table together with a small glass or pot. The gently arching lines that traverse the table vertically, and which have the effect of appearing to corrugate or fold the surface of the table top, sweep up into the still-life of flowers at the right; these lines are the vestigial presence of the decorative easel through which the great *Large Interior with Palette* (cat. 2) of 1942 is viewed.

The presence of the ghostly easel is seen, or sensed, more clearly in *The Billiard Table* of 1945 (cat. 12). Now a suspended light fitting with a lower horizontal axis supporting two shaded light-bulbs acts, together with the cue below, as a device for defining and measuring space. We look down on the table which is again cracked into two and thrust up towards us. But the space behind, organised in upright rectangular forms, we view frontally. At the top left there is a black-banded hat, presumably on a hat-stand. It is the object furthest from us, yet we feel we can reach out to it and pick it up. The hat reappears at the top of the

5

5. *Studio 1*, 1949 (J.-P. Guerlain Collection, Paris).

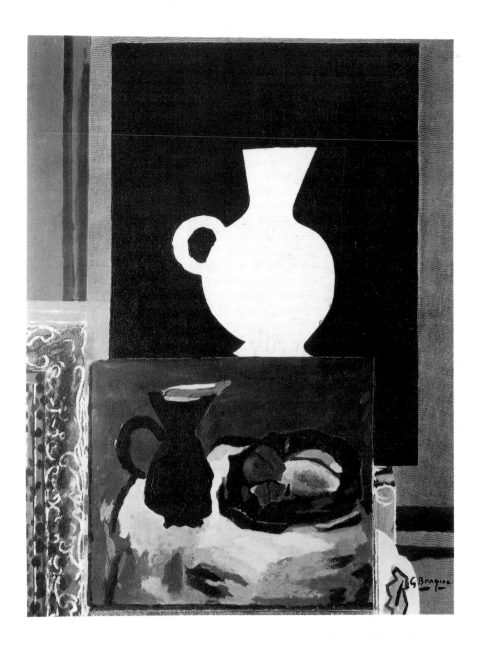

great vertical canvas, basically a work of 1944–5, but finished only in 1952, in the Jacques and Natasha Gelman Collection (cat. 13A). This picture is one of Braque's greatest *tours de force* for the billiard table is now seen from one of its narrower sides, rising up above us, with the sturdy supporting legs below anchoring the composition to the lower edge of the canvas. Yet again the table is folded into two along a horizontal axis but in such a way that we experience the furthest end of the table more forcefully than that which in reality would be closest to us. The forms suspended above it recede into depth yet cling simultaneously to the picture surface. The chair to the left of the composition again leads the eye back convincingly into the space of a comfortable domestic interior. The subject matter is reassuring, but the startling use of space challenges the eye.

The last of the 'Billiard Tables', of 1947–9, is the largest and also the most daring and revolutionary of the series (cat. 13). Here Braque returns to viewing the table along its longest axis and the supporting legs and the floor below are visible. But the table's contours

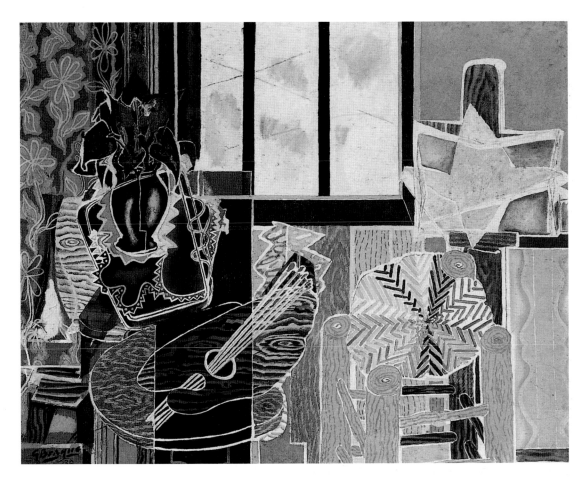

6. *Studio with a Stool*, 1939 (Lucille Ellis Simon collection, Los Angeles).

now shift and sway, and the whole subject has, as it were, been put out to sea. One cue is still discernible (as is the vestigial presence of the hat in the top left corner), but the table and indeed the whole picture are bisected by a long, narrow wavy loop or band (possibly derived from the dado on the wall behind) counteracted by an upright clutch of vertical, frond-like configurations. In retrospect it is hard not to read the multiple and prominent boomerang shapes above the table as birds. They may be part of a decorative wallpaper on the background plane but they wing their way forward and towards us and advance in the same measure that the floor below the table recedes. The deliberate, metamorphic ambiguity of the imagery and the creation of a complex spatial web that seems almost to liquefy before our eyes place this picture in the realm of the 'Studios' that follow on from it.

The pivotal role that he played in the invention of Cubism must always be accounted Braque's greatest achievement; through it he succeeded, indirectly, in influencing a very high proportion of subsequent 20th-century art. But within the evolution of his own art, which was on the whole remarkably free from outside influences, the late 'Ateliers' must be regarded as his supreme achievement. Braque's friend, the art historian Jean Leymarie, in a recent book devoted to these works refers to them as 'les Ateliers symphoniques'.[6] Leymarie also lists as antecedents six isolated studio pictures from the years 1938–42, ending with the *Large Interior with Palette* (cat. 2). Equally important in the unfolding of the background to the final 'Atelier' series is *Studio with a Stool* of 1939 (fig. 6). This picture also represents one of the climaxes of Braque's work of the second half of the 1930s. It is

one of the most sumptuously coloured and richly patterned of all Braque's works; the composition is organised in terms of pronounced verticals and horizontals and the vertical planes structured from them are viewed very frontally, with every one of them rendered in a slightly different manner.

Another work that is central to an understanding of the late studio pictures is *Le Salon* of 1944 (cat. 9). It celebrates Braque's return to Varengeville after the liberation of Paris, although the imaginary room it depicts is more Parisian than rustic in feel. In keeping with Braque's character the celebration is not jubilant, but takes the form of a meditation on the pleasures and virtues of a return to normal, daily domestic life. This is one of the gravest of all Braque's works; the silence that emanates from it is palpable. Braque's love of music was deep; but he also rejoiced in complete silence, and the air of calm serenity that permeated his studios was remarked on by all who were privileged to visit them. Possibly more than ever before in Braque's work we begin to experience the totality of the space of an entire interior. The left-hand side of the composition is simpler and more legible than that of the right, which becomes increasingly broken and mysterious as our eye moves towards its outer edge. The forms at the extreme right may hint at a human presence; many of the preparatory drawings of the 1930s and 1940s show figures that have subsequently been removed or replaced by objects in the finished pictures. The light filtered through the window is radiant but diffused; and it reminds us that Braque always preferred to work in shifting, filtered light. The studios built to his specifications faced south, as opposed to the northern exposures of traditional studios which yielded a harder, steadier light. Braque's studio windows were also equipped with fine muslin or cambric curtains which could further mute or soften light.

Like *Le Salon*, and in contrast to the interiors of the 1930s, the first six of the late 'Ateliers' are colouristically muted. Speaking of the virtually monochromatic phase of early, analytical Cubism, Braque said that he had discarded colour because it 'disturbed' the spatial sensations he was seeking. Now, in old age he was embarking on a new spatial odyssey. John Richardson, who witnessed the 'Ateliers' evolve, and who was one of the first to recognise their importance and the first to write about them, has emphasised that these pictures are not in any literal way depictions of Braque's studios (just as the billiard tables furnished imaginary interiors) and that the subject-matter of the series is in reality painting itself. 'In other words', he writes, 'the Ateliers are a microcosm of the painter's professional universe.'[7] They are also among the most profound and challenging of all 20th-century paintings.

Atelier I (fig. 5)of 1949 is relatively small in scale, and Braque regarded it as *hors série*,[8] almost certainly because its iconography is relatively limited and because of its upright format which limited his spatial invention; for us humans depth (as opposed to infinite space) tends to be apprehended horizontally rather than vertically. Yet the picture is of extraordinary presence and beauty. To the bottom left is an ornate, traditional frame, referring perhaps to painting of the past. Next to it stands an unframed painting, Braque's own *Pichet noir et citrons*, at the time nearing completion; this is painting present. Behind it, placed on a stool or chair (we identify it by its leg) is another picture depicting a single jug; it looks rough and unfinished and may be an unconscious reference to painting of the future. In reproductions the jug (achieved by experimenting with a piece of cut-out cardboard, subsequently kept in the studio) appears starkly white but is in fact painted in subtly modulated off-whites and creams which help to lend it a sense of volume; volume

is also conveyed by the justness of its silhouette. But because of its placing – it balances on the top of the canvas below – it also reads flatly.

Like all the other paintings in the series, *Atelier II*, also of 1949 (cat. 19), is large; generally speaking, after the mid-1930s Braque made all his most radical pictorial innovations on works of a large format. Some of the objects in it can be easily identified, but the identity of others is camouflaged or mysterious. Towards the end of his life Braque said: 'No object can be tied down to any one sort of reality; a stone may be part of a wall, a piece of sculpture, a lethal weapon, a pebble on a beach or anything else you like, just as this file in my hand can be metamorphosed into a shoe-horn or a spoon, according to the way I use it. . . . Everything . . . is subject to metamorphosis, everything changes according to circumstance. So when you ask me whether a particular form in one of my paintings depicts a woman's head, a fish, a vase, or a bird or all four at once, I can't give you a categorical answer, for this "metamorphic" confusion is fundamental to what I am out to express. It is all the same to me whether a form represents a different thing to different people or many things at the same time. And then I occasionally introduce forms which have no literal meaning whatsoever. Sometimes these are accidents which happen to suit my purpose, sometimes "rhymes" which echo other forms, and sometimes rhythmical motifs which help to integrate a composition and give it meaning.'[9]

Behind the prominent sculpted female head to the left of *Atelier II*, juxtaposed to a palette, stands an easel. To its right, presumably on another easel, is a painting of a gigantic bird thrusting its way forward. Its movement is counteracted by the totally abstract form of an arrow below, identified by Braque as one of his 'accidents'. A pronouncedly horizontal axis bisects the picture, but it is spatially activated by the upright vertical or slightly tilted lines that have the function of pleating space onto the picture surface, so that we experience in a 'manual' way the space of a large studio interior. Our eyes touch it, handle it and apprehend it in a fashion totally new to any other art heretofore.

The exact sequence in which some of the subsequent 'Ateliers' were produced is a matter of some dispute, and one that will probably never be resolved since it was Braque's practice to work on several pictures simultaneously, often returning later to individual canvases sometimes months or even years after having considered them finished. In *Atelier V* (also referred to as *Atelier III*), of 1949-50 (cat. 21), the canvas that comes closest in feeling to *Atelier II*, the pleating of space becomes more elaborate. On the right-hand side of the picture we become increasingly aware of its function because it is deliberately juxtaposed to the less impacted spaces on the left. The bird now appears to detach itself from its pictorial support and it ripples rather than flies its way through space; the space below it is in flux, its liquidity reinforced when we identify the form at the bottom right, flanked by two blue accents, as an aquarium containing two floating fish. In these two works Braque has for the first time achieved what he himself would have described as *le climat* and which he described as 'arriving at a temperature which renders things malleable.'[10] There is a sense in which these pictures have become foundries in which space is melted, folded, bent and shaped.

Atelier IV (or III according to some – it is impossible to avoid this confusion) (fig. 1), yet another work of 1949, is the most poetic of the series. The gigantic bird that dominates the composition, looking as if it had been cut out of cardboard and folded at intervals, is juxtaposed to the easel at the left, its wings echoing the easel's volutes; the palette and brushes below echo in turn the bird's own configurations so that it becomes, by

implication, another metaphor for the creative act. The bird's movement is held in check by the white slab which links one of the scrolls of the easel to the palette and the jar holding brushes; like many balancing compositional elements or counter-thrusts in this series it appears to be a purely abstract device or 'accident'.

Atelier III (IV or V; cat. 20) is, like *Atelier I,* a simpler, less enigmatic work. Like *Atelier I* it is an upright picture and once again Braque saw it as *hors série*.[11] But it is bold and majestic, and demonstrates Braque's frequent practice of playing off large, flat and stark compositional planes against more involved and elaborate passages of paint. The objects to the right are mostly easily identified, although the scroll-like shapes at the bottom right below the palette (and inscribed with letters) and the funnel-shaped forms above the palette are mysterious. *Atelier VI*, of 1950–51 (cat. 22), is the most sombre of all the pictures and in many ways the most baffling. The great brown bird shape is now headless while a small, almost naturalistic bird, whose presence is simultaneously startling yet also strangely inevitable, has perched on the easel; the easel and the palette below it have become soft and pulpy, almost deliquescent. We experience the space of this painting and that of the two large horizontal pictures that had preceded it (*Ateliers II* and *V*) with an extraordinary physicality, as we might experience the inside of large tanks of water by diving into and through them. Again these spatial sensations are totally new to the visual arts.

Atelier VII was subsequently to be reworked as *Atelier IX*. *Atelier VIII*, of 1954–5 (cat. 23), the largest painting in the series, is distinguished by its use of a relatively full, if restrained, palette. The great white bird is no longer enmeshed in the compositional substructure but detaches itself from its red canvas support and floats, suspended serenely in air; any potential movement it might imply is checked by two abstract white wedges on the central yellow table top. The bold arrangement of the red and yellow planes is played off against the complexity of the areas at the extreme right and left edges of the canvas; into these, space is now pleated or folded horizontally rather than vertically. Some of the still-life objects are immediately recognisable although they are rendered unnaturalistically; others, like the forms in the two bottom corners are intricate and in a sense particularised and may be derived from objects in the natural world although within their pictorial context they remain baffling and mysterious. In *Atelier IX* (cat. 24), the final painting in the series – begun as *Atelier VII*, Braque worked on this canvas intermittently between 1952 and 1956 – three major iconographical elements are immediately identifiable: a large cauldron which contains a *compotier* or chalice-like form within itself, the bird, rendered now in a complex, splintered form, and the fleshy, biomorphic palette to the left. Around these, space, furnished with mysterious objects or forms, pulses and throbs.

Towards the end of his career Braque said to John Richardson, 'You see, I have made a great discovery. I no longer believe in anything. Objects don't exist for me except in so far as a rapport exists between them or between them and myself. When one attains this harmony one reaches a sort of intellectual non-existence – what I can only describe as a sense of peace, which makes everything possible and right. Life then becomes a perpetual revelation. That is true poetry.'[12] The almost mystical feeling conveyed by Braque's words emanates directly only from the works of his late period – and the 'Ateliers' in particular. However, the seeds for all Braque's later work, and for his increasingly philosophical ruminations on the nature of painting and its relationship to the external world, were sown during the years of his Synthetic Cubism. In 1912 Braque had invented *papier collé*, which he always insisted was a way of reintroducing colour into Cubist painting. But he soon

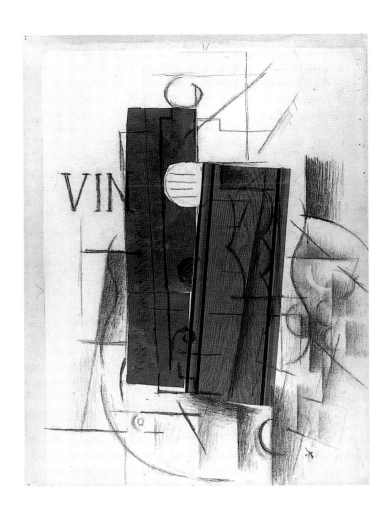

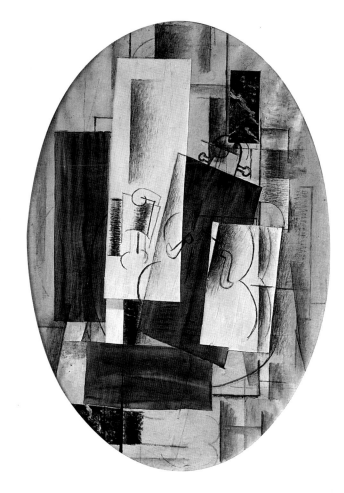

came to realise that coloured strips of paper slipped, as it were, into his faceted and often transparent spatial complexes could be made to relate to objects in his pictures while simultaneously retaining their own identities; colour and form could thus interact and reinforce each other and yet continue to act independently of each other (fig. 7).

Papier collé allowed Braque to find new ways of manipulating pictorial space, building up his canvases in terms of interacting, overlapping elements; some of these were qualified in such a way that they become objects, in other instances a subject was superimposed on them. Braque's paintings were to be profoundly influenced by both the appearance and the principles of his *papiers collés*. The compositions of many of the pictures of 1913–14 were achieved first of all in terms of arrangements of cut-out strips of paper which were pinned onto canvas supports; after their positions had been noted with pencil marks the paper elements would be removed and the actual painting begun. It must have been of these works that Braque was speaking when he said that before introducing objects into his paintings he had to create a spatial complex in which they could exist (fig. 8).

The use of *papier collé* and the new working methods Braque deduced from it, which now often involved proceeding from abstraction to representation, turning shapes into objects, or seeing a subject suggest itself in an abstract pictorial substructure of pictorial space, inevitably affected his subject-matter; the identities of particular objects in his painting and their relationship to each other were now much more conditioned by the way each painting evolved. Because of this individual elements within his paintings can take on

multiple meanings; at times objects seem to be themselves and yet simultaneously not themselves. In effect, Braque's method of work was now conditioning his way of apprehending the external world. Working from abstraction to representation, transforming transparent or coloured shapes into objects, Braque came to realise that for him no pictorial form could have any one ultimate meaning: a flat slab of green could be turned equally into a bottle, a pile of figs, or a bunch of grapes; its function within the painting would remain equally valid, its evocative power equally pungent. The foundation for the 'metamorphic confusion' that was so fundamental to his late manner had been laid. A very large proportion of artists come to look at the outside world in terms of their own work; but Braque's own art changed radically his whole view of reality.

When Braque embarked on the 'Atelier' series in 1949, there was to be seen in his studio a large canvas of a bird in flight.[13] In 1958 Braque wrote to Jean Leymarie of his long fascination with birds and the spatial implications of their flight[14] and he stated that the theme of the bird had come to him in 1929 when he was at work on his illustrations to Hesiod. In the late 1930s he used bird and fish motifs to decorate the engraved plasters that were becoming one of the hallmarks of his production. Some still-lifes of the period include bird-of-paradise flowers (*strelitzias*) and Braque might have been struck by the way the vivid, spiky blooms swayed in every current of air on their abnormally long and slender stalks. The highly abstracted forms on the picture standing on the easel in the great *Studio with a Stool* of 1939 (see fig. 6) suggest a bird in flight; significantly enough its configurations extend beyond the confines of its support.

In 1952 Braque chose birds as the subject for the ceiling decorations of the Etruscan Gallery (the Salle Henri II) in the Louvre, a state commission. In 1955 he visited a bird sanctuary in the Camargue and was deeply moved by it.[15] Braque was particularly struck by the flocks of white egrets and by the serene flight patterns of the majestic flamingos with their long necks and flame-coloured plumage. But it was while he was at work on the 'Ateliers' that the bird became an obsessive image for Braque, and it remained a dominant theme for him until his death in 1963. Braque always denied that his birds had a symbolic meaning, and this we must accept. But birds in flight clearly came to signify for Braque a new and final phase of his lifelong dedication to the depiction of pictorial space: the birds' trajectories describe and inform it – the beating of their wings stirs space and renders it tangible.

One of the first important, independent bird pictures is *The Bird and its Nest* (cat. 31), begun on the morning of Easter Sunday 1955 while Braque was still at work on *Atelier VIII* (cat. 23).[16] The bird, remarkably like the one in *Atelier VIII*, has detached itself from its studio setting and wings its way homewards to its nest, placed in the cleft of a stunted or truncated tree. Quite obviously this and Braque's other birds are not derived from particular prototypes in the natural world; they are imagined creatures, pictorial conceits that can exist only within the context of individual works by Braque himself. During the three months that he worked on *The Bird and its Nest* Braque continually embellished and enriched the dark, warm, brown tonalities of the nocturnal sky that envelopes the images, so that 'free' or empty space becomes more palpable than the bird itself which is thinly painted and which reads almost as a cut-out or negative shape. This is one of the most poetic and moving of all Braque's paintings.

It finds its counterpart in *In Full Flight* (cat. 39), begun in 1956 but not finished until 1961. Here the milky blue background again suggests infinite space but it is also almost

aggressively textured, so that it appeals to our sense of touch – throughout his life Braque had also been fascinated by the way in which texture could inform and influence colouristic sensations. Braque was characteristically lucid about his reasons for introducing the small painting within a painting at the bottom left, derived directly from a picture of *The Duck* that was in his studio (see cat. 39a); and Braque delighted in moving his works about in the studio, leaning them up against each other, seeing how they interacted. Having considered *In Full Flight* finished, at the end of a further four months of having looked at it daily he decided it had become too reassuring, or in Braque's own words, 'Too great a comfort for the eye ... I then decided to create a tension by painting in the bottom left of the picture another bird contained in a sort of rectangular white frame, the whole like a stencil [*estampille*], even a stamp. By creating a contradiction rather than a disharmony the whole picture came to life in an unexpected way. These unexpected effects are necessary, sometimes, to stop one taking things for granted'[17] The dominant black bird is arrow-like and emblematic as opposed to its drifting white antecedent, and close inspection reveals that it carries within itself a calligraphic diagram of its own movement. The black shape over which it hovers is enigmatic; it is at once generalised and amorphous and yet pictorially oddly specific.

The very large *Black Birds* of 1956–7 (cat. 33) is similar in composition to the vast Louvre ceiling decoration and is probably a meditation upon it. The Louvre decoration, although it is bold and compelling and projects itself dramatically in a vast space, is only partially successful because its reductiveness is at odds with the ornate mouldings and ceiling decorations which encompass it. Braque, who had enjoyed playing off broken areas against bolder, simpler and broader effects within a single picture, had probably gambled on a similar juxtaposition taking place between the ceiling decoration and its architectural surrounds; but it fails to work. In the mural-sized *Black Birds* the black shapes over which the birds circle remain an enigma and it is possible that they are simply part of a bold compositional device. It is worth remarking that the trajectory through space followed by Braque's birds is almost invariably horizontal; his birds rarely soar upwards or ascend; in keeping with the principles of his last years their effect is to make infinite depth more graspable to the eye. Here the broad, heavy grey–blue frame, devised by Braque himself, an answer to the ornate 17th-century splendour of the Louvre mouldings, works perfectly and helps to produce one of the most sober but also one of the most majestic of 20th-century decorations.

Braque's birds have attracted a considerable body of literature, although the writer who comes closest to capturing their poetic presence and atmosphere is significantly enough a poet: Saint-John Perse, in *L'Ordre des Oiseaux* of 1962. The 'Ateliers' can be described, although no words could give a feeling of the sensations they evoke, both psychologically and in terms of pictorial space, and the works can certainly not be explained. The bird pictures, despite their boldness and simplicity, defy both description and analysis. As Braque himself said, 'To define something is to substitute the definition for the thing', and again, 'Only one thing in art is valid, that which cannot be explained.'[18]

Braque had begun his career as a landscape painter. The Fauve landscapes executed in Antwerp in 1906 and shown at the Salon des Indépendants the following year were the first of his pictures to attract attention. The severe, reductive landscapes of 1908 that followed them were among his first Cubist works; but oddly enough – since landscape was of supreme importance to Cézanne – it was the spatial properties that he sensed in

Cézanne's art that encouraged Braque now to give up landscape and concentrate on still-life. Braque reinforced his earlier statement about pictorial space when he said, 'In a still-life space is tactile, even manual, while the space of a landscape is a visual space.'[19] In 1928 Braque began a series of small Dieppe landscapes; and in 1929 he built for himself a second home, complete with a large studio, at Varengeville. He was a Northerner by birth and temperament, and henceforth his sorties to the south were to be infrequent; apart from anything else he came to dislike its harsh, unyielding light. In 1930 he produced a set of small landscapes inspired by his return to his native soil, mostly sea- and beachscapes, thinly painted, some of which look slightly theatrical and somewhat toy-like in scale – a reminder, possibly, that a few years earlier Braque had been executing sets for the Ballets Russes and for Etienne de Beaumont's troupe, Les Soirées de Paris. Other, more solid landscapes followed at intervals throughout the 1930s.

While he was working on the late 'Ateliers' Braque resumed landscape painting in earnest (cat. 41–6). These late landscapes are almost invariably small in scale and emphatically horizontal in format. They are among the most naturalistic Braque ever painted, and have little in common with the 'Ateliers' except for a pronounced interest in 'facture', in highly pigmented and textured paint effects, in the case of the landscapes often applied with a palette knife, a technique pioneered by, among others, Courbet. The late landscapes, often stormy, windswept and brooding, also evoke comparison with van Gogh although they are tinged with resignation rather than with the Dutchman's extremes of ecstasy and tragedy. Most of Braque's late landscapes are memory pictures, drawn from visual experiences stored up while being driven back and forth between Paris and Normandy, through the Valley of the Seine and the Pays de Caux, through flat or very gently undulating fields of flax and wheat; a few were executed from photographs. They epitomise his love of the northern countryside where he felt most at home – and in a sense they are the companion pieces to his great bird compositions: on the one hand an acceptance of the earth, its rhythms and its seasons, on the other of sky, flight and the mystery of creation.

1 'Réponse à une enquête', Braque, 1939.
2 *Violin and Palette*, The Solomon R. Guggenheim Museum, New York.
3 Galerie Thomas, Munich.
4 Vallier, 1954, p. 16.
5 Ibid.
6 Leymarie, 1995.
7 John Richardson, 'The Ateliers of Braque', *The Burlington Magazine*, June 1955, pp. 164–70.
8 Leymarie, *op. cit.*, p. 184.
9 Richardson, 1959, p. 26.
10 Braque, 1947.
11 Leymarie, *op. cit.* p. 124.
12 Richardson, *op. cit.*, p. 27.
13 It was subsequently destroyed. See Richardson, 'The Ateliers of Braque', *op. cit.*
14 Letter from Braque to Leymarie. Leymarie, 1958, p.72.
15 Verdet, 1956. The bird sanctuary belonged to Braque's friend Lukas Hoffmann.
16 Pouillon and Monod-Fontaine, 1982, pp. 142–5.
17 Ibid, p. 155.
18 Braque, 1947.
19 Quoted in New York, 1988, p. 12.

ISABELLE MONOD-FONTAINE

THE MASTER OF CONCRETE RELATIONSHIPS

Braque undoubtedly preferred objects to figures, but he was possibly even more attached to the representation of the spaces between objects. Is this to suggest that he preferred painting empty space, the negative, to painting positive shapes silhouetted against a background? Some of the statements he made (or were attributed to him) late in his life certainly imply that this was the case. 'Objects do not exist for me', he told John Richardson, 'except in so far as a rapport exists between them or between them and myself. When one attains this harmony one reaches a sort of intellectual non-existence . . . which makes everything possible and right. Life then becomes a perpetual revelation. That is true poetry.'[1] Or, in an interview published in 1964: 'The point of departure is the void, a harmony in which words go farthest, have most meaning. When you arrive at an intellectual void, described by Mallarmé as a "musical hollow void", then you have arrived at painting.'[2]

Braque's somewhat awkward claim to this 'intellectual void' has led people to the conclusion that his painting, described in France (with mild disdain) as 'painting for painters', is unintelligible, or at least resistant to speculations – an inadmissible defect in France, as we all know. Though we may not, or we may no longer, have the courage to attack Braque's Cubist painting,[3] it is smart in France to gloss over the work that is the focus of this exhibition, the paintings of his last twenty years.

It is for this reason that, by looking closely at some of these paintings, I hope to establish what makes them survive the vagaries of fashion and the predilection to 'keep famine at bay', as André Breton and Pierre Reverdy both expressed it (and this was undoubtedly true of some of the still-lifes of the difficult war years).[4] Breton, who as early as 1928 expressed reservations about Braque, nevertheless continued to admire him as 'the master of concrete relationships', and paid tribute (albeit with a certain reticence) to the 'powerful attraction' exerted by some of his juxtapositions of objects.

Painting three oysters

A plate with three oysters lying on it: the arrangement of dark and light is so subtly handled that the impression is given of a painting in wash (fig. 9); this small work bears echoes of the past, from Japan to Matisse via Chardin, and evokes a whole world of visual sensations, whilst each oyster may contain innumerable nuances of flavour too. Braque painted a series

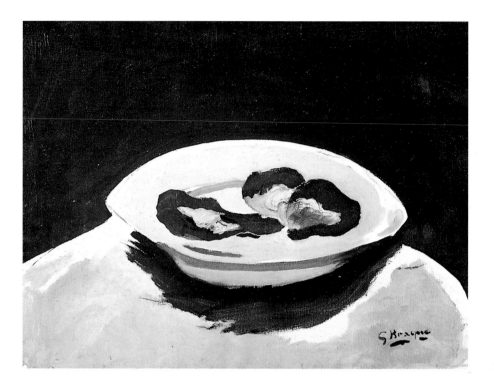

9. *The Oysters*, 1953 (Private Collection).

of still-lifes of oysters in 1937, and another in brighter colours in 1954–7, but the ones here float in solemn isolation, in a vast space, reduced to a few brushstrokes, a few deft touches, like a virtuoso exercise in Japonisme. These are the antithesis of Matisse's oysters; Matisse used the same subject in the years 1940–43 in an attempt to 'get closer to the substance of things', and in December 1940 explained in a letter on the subject to his friend Pallady 'With that in mind I painted some oysters. For these, my friend, you need taste buds. A painted oyster should be what it is, a bit as the Dutch painted them. This is the third painting I have done on the theme...I gave myself free rein; it cost me great effort and I managed to find some natural qualities, ones that I should perhaps have restrained years ago, flavours of very flavoursome painting which I think will interest you.'[5]

Braque's three oysters are not edible, they do no more for the taste buds than do his black fish of 1942 or his strange skinny loaves of 1941 – no more, indeed, than the three aubergines in a magically coloured interior painted by Matisse in 1911, nor the three apples (also painted by Matisse) silhouetted against the damp black of the monotype of 1914. In all these works the distinctive values of painting, or the distinctive values of the particular painting, are what matters; values of exchange and metamorphosis (these oysters could be stones, or fruit, the curve of the plate represents any closed space in an expanding world), relationships that are very *concrete* between emptiness and fullness, outlines and brushmarks, shade (generally associated with depth) and light – here the white that gives objects their form and body – between the paintings' restrictive frame and the space it creates, inside and outside the frame. The objection might be made that these modest items, reduced even further by Braque's habit of not presenting them dramatically, are always the same - 'a few too many violins, pipes, packets of tobacco, guitars', and too many apples, pedestal tables, jugs? Too many birds? Reverdy pre-empted this absurd criticism when he wrote: 'Do you think it really more logical and less surprising to have walls decorated with scenes of lion hunting or herds of cows?'[6] Braque's subjects may be predictable, to an extent, but the

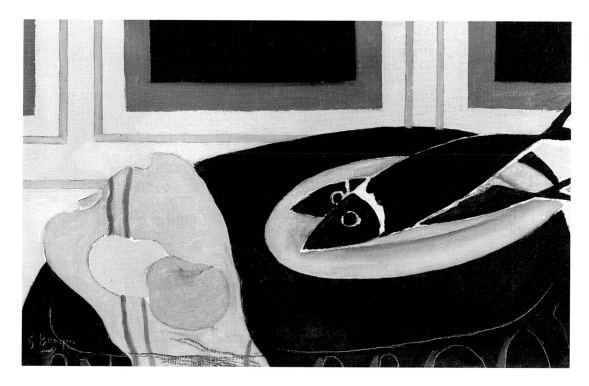

relationships he built up never are. In the eight *Studios* painted between 1949 and 1956 (see cat. 19–24) Braque mingled and reduced objects connected with the whole spectrum of his working life, regrouping them into secret landscapes, difficult to decipher and full of surprises; in these paintings his inventiveness and his enormous skill are amply demonstrated. The three black oysters of 1953 and the appearing/disappearing space of *Studio IX* are worlds apart. The *Studios* represent layers of accumulated experience, physical and emotional, set to work in all possible modes, from the simplest to the most complex.

Black is a colour

In 1911 Braque discovered white. That summer he wrote from Céret to Daniel-Henri Kahnweiler: 'I have discovered an indestructible white, velvet on the brush, I'm abusing it.'[7] Soon he was contrasting it with black, with the velvety shadows of the analytical paintings of 1911–12, or in more clearly defined matt areas in the collages and large canvases of 1913–14. In an unusually minimalist series, a single piece of cut-out paper in matt black with brown highlights represents a guitar, with strings drawn in white chalk: *Still-life* (1913; Philadelphia Museum of Art), or *Black and White Collage* (1913; Yale University Art Gallery). After the disruption of the War, black continued to appear in Braque's painting as a kind of 'ballast', balancing the other colours or, more frequently, as a shadowy background mixed with dust or sand from which the objects emerge surrounded by a faint white outline that gives them a ghostly presence. Black used as a reflector became more of a dominant force in the 1940s. This was not an opaque black, admitting no colour; nor was it Manet's luminous black, adopted later by Matisse. The grainy texture of Braque's tactile blacks lends a nocturnal depth and density, like a nourishing medium, to the various objects it supports (fruit, dishes, baskets, skulls, palettes, birds; fig. 10); the items are tenderly held and surrounded, losing none of their mystery in the process.

Two paintings now in the Musée National d'Art Moderne, that Braque kept until his

death in 1963, provide a clear illustration of this. They are of similar size and are on a related, if not complementary, subject (the bird that was a recurrent motif in his final years) and were both worked over in the studio at great length: *The Bird and its Nest* (1955, cat. 31) and *In Full Flight* (1956–61, cat. 39). Braque considered them to be the culmination of his work, and possibly as his testament as well. *The Bird and its Nest*, he admitted to Jean Leymarie, 'is a painting that I am very fond of and one which, I think, is a landmark in my work. Birds and space have been a preoccupation of mine for a long time. The motif first came to me in 1929 for an illustration to Hesiod. I had already painted birds in 1910, but they were incorporated into still-lifes, whereas recently I have been mainly preoccupied by space and movement.'[8] He included *The Bird and its Nest* in the Exposition Universelle in Brussels in 1958, and kept it by him until his death, even transporting it between his studios in Paris and Varengeville. A first version of *In Full Flight* was completed in 1956 and was also kept by Braque in his studio; it was reworked in 1961 for the exhibition in the Louvre, *L'Atelier de Braque*. The two canvases undeniably make a pair, reflecting the two sides of Braque's world; they are antithetical only on a superficial level. The theme of *The Bird and its Nest* is return, that of *In Full Flight* departure, for worlds unknown. The paintings can be read like the facing pages of an open book: the 1955 bird's flight crosses the canvas towards the left as it returns to its nest, as if making for the beginning of the written line. The 1956 bird flies towards the right, towards the future, towards a mysterious black smudge that looks set to absorb it totally. Black is used in a similar fashion in both paintings, to complement the colours. The painting that deals with return is entirely constructed from layers of dark material; blacks and muddy browns that are redolent of the stuffiness of humus or the warm darkness of the primordial magma. Into this thick brown paste the lighter forms of the bird and its star-filled nest are incised, hollowed out. The bird in *In Full Flight* on the other hand is – like *The Black Birds* (1956–7, cat. 33) – cut out in black, its silhouette also being treated like an incision in the paradoxical medium it flies across: a light-blue medium, varied in colour like the sky, but filled with lumps and bumps that are heavier than air. The bird flies in a straight line but is about to dive into this shapeless mass, this cloud as black as itself. This cloud, surely, must remind us of death. The painter, by this time nearly eighty years old, must certainly have been haunted by thoughts of death. At the end of the 1950s, with extraordinary skill and energy, Braque explored the different meanings of the whole spectrum of blacks, which he had used so often in the past, and found new 'colours' still to be invented: living humus, heavy, nourishing soil, a storm-cloud filled with menace (see also the narrow landscapes he painted at this time, with their louring dark skies, or the seascapes in which the water looks darker than the land, cat. 41–6) or a flight cutting through space with sombre energy. All these images are contained in Braque's paintings, expressed in pigment that is sometimes light and fluid, laid down in thin layers, and sometimes lumpy, sometimes matt and sometimes shiny. Braque's habit of overlaying (the light is overlaid by the dark in *The Bird and its Nest*; the black shapes in *In Full Flight* are overlaid by layers of light blue) adds further nuances and depths of meaning.

'Au creux néant musicien'

The line from Mallarmé quoted by Braque comes from 'Une dentelle s'abolit . . .' in *Autres poèmes et sonnets*.[9] It has a sonority similar to that found in the more famous 'Aboli bibelot d'inanité sonore', which mingles vowels and consonants just as thoroughly, using them to confront the ultimate 'creux', hollow – non-being. It seems to me that these various ideas can be of help when we look at Braque's last paintings, particularly at the series of *Studios*.

The eight paintings in this series have given rise to some remarkable writing (by Jean Paulhan and Francis Ponge, and not forgetting the invaluable contributions made by John Richardson and Jean Leymarie, both of whom knew Braque's studios when the artist was alive). These authors demonstrate the extraordinary richness of the series, its iconographic and formal richness, and above all its inexhaustible poetic richness. The still-life as a genre is raised to a level of complexity not reached hitherto (and certainly a level that has not been achieved since).

Some of Braque's paintings of the years immediately preceding the *Studios* have been labelled 'whole rooms', for example *The Duo* of 1937, *Le Salon* (cat. 9) and the *Billiard Table* series (cat. 10–13A). The *Studios*, however, explore the interpenetration of space much more thoroughly; here we find a collection not only of recognisable objects, the things Braque used and which were daily to hand – his tools (easel, palette, brushes) and his subjects (jars, bunches of flowers, pieces of sculpture) – but also the objects furnishing his secret, mental universe (the recurring presence of the bird, a painted presence as well as one dreamed-of). During the slow process of evolution of each of the *Studios,* and of the series as a whole (from 1949 to 1956), Braque rehearsed a lifetime's experience of the different degrees of the material presence of objects: the tactile qualities of fullness and emptiness, the opaque and the transparent, the harmonic inter-relationships that constitute a painting. Each of these symphonic paintings is a variation on an identical theme, to be situated in a musical time-scale. Obviously they do not reveal themselves at first glance, they need time and attention (this is the case with most of Braque's paintings and in fact this is the characteristic that discourages some spectators from the outset); they appear dark, hermetic and just as difficult to decipher as the analytical Cubist paintings of 1911–12. To anyone willing to look long enough the carefully distributed spatial markers appear and disappear, but nevertheless have a disconcerting capacity to elude the gaze. It is also impossible to describe these paintings using the conventional terminology of space and depth. In addition to the tangible and easily located markers that measure out the space are images with only faint material existence, whose forms and disposition provoke a second wave of feelings and ideas that fundamentally contradict the first. Of overriding importance is the activation of the *gaps* in space, their availability or receptiveness, the affirmation of the malleability of painted space. The painted space can receive everything at once – past, present and future; it can dilate and unroll into infinitesimal mental convolutions. Or, alternatively, it can withdraw into the barest description (which brings us back to the three oysters, or the plate with two black fish on it). In the *Studios,* by cutting and dislocating, by superimposing and suggesting projections, Braque hollowed out space into innumerable layers *beneath* (and above) the surface of the canvas.

Space in the *Studios* has a musical resonance. There are visual echoes within each painting and between all the paintings in the series. *Leitmotifs* (particularly the bird and the palette) transport the spectator into a time-scale (a period of waiting) that is as much that of music as it is of looking at paintings. These works, so accurately described by John Golding as giving an experience of space comparable to that caused by diving into or through a tank of water or a swimming pool,[10] also suggest sound: they suggest the experience in a concert hall in which members of the orchestra are practising scraps of music, or the unfolding of great instrumental themes, the murmur of a thousand simultaneous conversations with, now and again, one or two words audible above the hubbub. Like the recesses of memory, these 'interior' paintings refer back to time regained.

1 Richardson, 1961, p.4.

2 Louis Goldaine/Pierre Astier, *Ces peintres vous parlent*, Paris 1964.

3 See Marcelin Pleynet's article 'Georges Braque et les écrans truqués' (*Art Press*, no. 8, Dec.–Jan. 1974), which is preceded by the following preamble: 'However, it is at the pedestal tables, studios and birds that we are encouraged to marvel – these are the ones mainly reproduced in colour magazines. What can this painting contain that blinds people to such a degree?' A little further on he continues: in 1909–10 'Braque is far from possessing the fluency of style and the freedom in regard to the model that Picasso enjoys, as he is far from possessing Cézanne's intelligently obsessional nature; how else to explain. . . the lack of naturalism, the vulgarity of the nipples on the lighthouses in *Harbour in Normandy* and in *Le Sacré Coeur*, of the banana and the pears in *The Fruit Dish*,

not to mention the rising pinnacles in the *Château de la Roche Guyon*.'

4 André Breton, in *Le Surréalisme et la peinture,* 1928: 'As far as I'm concerned, the only paintings I like, including paintings by Braque, are the ones able to survive famine.' In 1950 (in *Une aventure méthodique*), Reverdy replied to the implicit question, to the scarcely voiced suspicion, in his corroborative statement: 'Yes, it survived, and survived a number of other things as well, because these paintings are not intimidated by anything.'

5 Letter of 7 December 1940 quoted in Henri Matisse, *Ecrits et propos sur l'art*, edited by Dominique Fourcade, Paris 1972, p. 186.

6 Reverdy, *op. cit.*

7 Archives Leiris, Paris.

8 Jean Leymarie, 'Les chefs-d'oeuvre de l'exposition: 50 ans d'art moderne – Georges Braque: L'oiseau et son nid', in *Quadrum V*, 1958, pp. 72-3.

9 The complete tercet of this poem published in 1887 and connected (like many of Mallarmé's poems) with Braque runs: 'Mais chez qui du rêve se dore / Tristement dort une mandore / Au creux néant musicien' (But within him who gilds himself with dreams there sadly sleeps a mandore, musican of hollow nothingness); Mallarmé, *Oeuvres complètes*, 1965, p.74. Literal translation from the Penguin *Mallarmé*, 1965, translated by Anthony Hartley. Sophie Bowness also quotes this poem in connection with some of Braque's Cubist paintings – *Mandore* 1909–10 (Tate Gallery, London) and *Piano and Mandore*, 1909–10 (The Guggenheim Museum, New York) – in 'Braque and Music' in Liverpool and Bristol, 1990.

10 Golding, in Liverpool and Bristol, 1990.

SOPHIE BOWNESS

Braque le Patron
BRAQUE AND THE POETS

A special kinship existed between Braque and a number of the major writers of post-war France, whom he counted as friends. The title of the important book on the artist by the writer and editor Jean Paulhan, *Braque le Patron*, first published in 1945, suggests the tributes of respect and affection paid to Braque as 'master' by four poets or writers in particular – Pierre Reverdy, Paulhan himself, Francis Ponge and René Char.[1] Paulhan concluded *Braque le Patron* with a statement of the very high regard in which he held Braque: 'if the greatest painter is the one who gives of painting at once the most acute and most nourishing idea, then it is Braque, without hesitation, whom I take as *patron*.' The word *patron* carries connotations of master or boss, protector and patron saint or revered mentor. The writings on Braque by these four men – Reverdy's *Une aventure méthodique*, Ponge's *Braque le Réconciliateur* or Char's 'Sous la Verrière', for example – and the collaborations they undertook with him on illustrated books, such as *Cinq Sapates* or *Lettera Amorosa*, are explored here.

Of the four figures, two were Braque's contemporaries – Reverdy, the closest and oldest friend, and Paulhan – and two were younger men, Ponge by seventeen years and Char by twenty-five. Their writings on art, often close to their poetry and far from art criticism in its conventional form, tell us as much about the poets as they do about Braque. The nature of their affinities with Braque and the distinctive characters of their exchanges with him are seldom dicussed in the literature on the artist.

The dialogue between painting and poetry is most obviously seen in the illustrated books on which Braque collaborated with his poet friends, in which text and illustrations have an equal part. It was significant that Aimé Maeght, Braque's dealer from 1947, had a particular interest in the publication of illustrated books and *livres d'artistes* and a love of poetry. Maeght brought together contemporary artists with their literary counterparts on these projects, as well as in the review of the Galerie Maeght, *Derrière le Miroir*, which reflected the activities of the gallery and its publishing arm.[2] In his later years of indifferent health, Braque devoted much attention to illustrated books and graphic work in general, published by Maeght and others.

11. Jean Paulhan with his *papier collé Violin*, Paris, 1954. Photograph © Lipnitzki-Viollet, Paris.

12. Francis Ponge, 9 June 1948. Photograph by Izis, courtesy Armande Ponge.

13. Braque with René Char at Varengeville, February 1948. Photograph © Mariette Lachaud, courtesy Archives Laurens.

14. Marcelle Braque, Braque, Henriette Reverdy and Reverdy (below), at Sorgues, *c.* summer 1912. Photograph courtesy Archives Laurens.

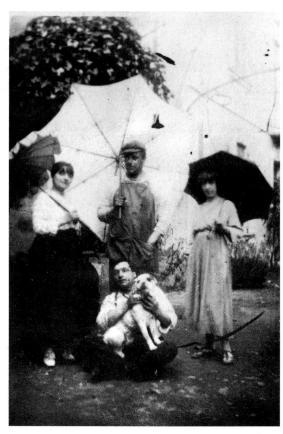

Braque valued the quality of 'poetry' in painting very highly, and many contemporaries found his late work 'poetic' in nature. He described what he meant by poetry in a number of interviews, one of the most revealing being, significantly, the conversation he had with Reverdy at the Galerie Maeght on the eve of the opening of Braque's exhibition there in 1950. Braque stated that in painting – and in poetry too – what matters above all are the relations between things. Reverdy agreed (this had long been his conviction), and described the poetic relations he had observed in Braque's latest paintings, for example between the palette and the bird (the exhibition included the first five *Studio* paintings). As a poet himself, he felt that the power of the poetry in the recent paintings touched him especially strongly.[3] Braque responded by defining his understanding of poetry: 'Poetry is something which applies to life as a whole: it is relationships, new relationships, which give life to all they touch.'[4] He cited the very Reverdian image 'a swallow stabs the sky' to illustrate this.[5]

'Is it not the poet's role in life constantly to transform everything about him?' Braque asked in an interview published in 1945, here presenting himself as a poet.[6] A favourite example given by Braque was the occasion during the First World War when his batman transformed an old petrol can into a makeshift stove by poking holes in it with his bayonet.[7] Poetry gives objects a new life, it metamorphoses them. Braque likened what he sought in a painting to the temperature at which iron becomes malleable: it is at this moment that poetry comes into play.

The French poets, he told John Richardson in 1957, have been particularly helpful at adding to the general obscurity, which Braque regarded as all to the good: 'Few of them have understood the first thing about modern painting, yet they're always trying to write about it.' (He made an exception of Reverdy.) This remark was directed particularly against Apollinaire, 'a great poet and a man to whom I was deeply attached', but one who understood nothing about painting.[8] The harsh judgement is, however, qualified by another statement, made to André Verdet, that during the Cubist years the poets Apollinaire, Max Jacob, Reverdy and others 'were best at spreading knowledge of our work'.[9] He also confessed to Richardson that 'instead of having matters made clearer, I should like to have them made even more obscure: thus I always prefer criticism which increases rather than decreases the general obscurity.'[10] Braque's love for Apollinaire's poetry, as opposed to his writings on art, is evident in a book he produced towards the end of his life, *Si je mourais là-bas* (1962), for which he himself selected and edited poems from Apollinaire's *Poèmes à Lou* and accompanied them with wood engravings.

The obscurity, suggestion, mystery and metamorphosis prized by Braque were all associated by him with poetry. To John Richardson he summarised his thinking thus: 'If there is no mystery then there is no "poetry", the quality I value above all else in art. What do I mean by "poetry"? It is to a painting what life is to man. But don't ask me to define it; it is something that each artist has to struggle to discover for himself through his own intuition. For me it is a matter of harmony, of *rapports*, of rhythm and – most important for my own work – of "metamorphosis".' When life becomes a perpetual revelation, 'That is true poetry!'[11] 'Reality is only revealed in the illumination of a ray of poetry.'[12]

In a letter to Jean Paulhan, Braque wrote of a 'very clear concordance between the arts (painting, literature, music).'[13] But despite this conviction of the affinity between painting and poetry, Braque had an absolute belief in the autonomy of painting. His distaste for 'literary painting' was an aspect of this uncompromising rejection of any blurring of the boundaries between each medium.

Pierre Reverdy: Une aventure méthodique

'What Braque has is poetry!' Reverdy declared,[14] and Braque returned the compliment: 'He talked about painting just as we did ... And he led us to discover our secrets.'[15] Indeed, in the conversation with Braque held at the Galerie Maeght in 1950, Reverdy admitted: 'I believe I should have been a painter.'[16] Following Reverdy's death in 1960, Braque said that Reverdy, unlike Apollinaire, had a sure knowledge of the visual arts, and a love of the craft of the artist and of the company of artists.[17] Their own close friendship and fraternal sympathy dated from the Cubist years, when painting and poetry – not least Reverdy's own poetry – were so much in accord. Reverdy himself named Cubist painting 'poésie plastique' in an essay of 1919 because of the powerful influence of poetry on it: Cubist painters, he said, had been the first to follow the example of poetry in seeking the relations between things.[18] The exchange between Reverdy and Braque described above has shown their fundamental agreement on the importance of relations between things.

'It was Reverdy', Braque recalled, 'who, discovering by chance my reflections in the margins of drawings, wanted to publish them in his review *Nord-Sud* just as they were. I would never have had the idea, and I owe to him whatever impact these reflections, which I hold close to my heart, may since have had.'[19] With their echoes of Reverdy's thought, Braque's 'Pensées et réflexions sur la peinture', published in December 1917, take their place naturally in the theoretic and poetic context provided by Reverdy's *Nord-Sud*, in which an aesthetic common to painting and poetry was set out.[20]

In the post-war period their long alliance was celebrated in two major publications that were also collaborations – Reverdy's *La Liberté des Mers*, published by Maeght Editeur in 1959 with illustrations by Braque, and Reverdy's study of Braque, *Une aventure méthodique*, published in 1950, also illustrated by Braque. In it Reverdy returns to the question of the bond between Braque's painting and poetry. 'Poetry', he writes, 'in its widest sense, is the highest culmination of all art. It is the supreme end of art. Where it is not present, art is nothing, or virtually nothing.'[21]

Poetry, Reverdy claimed in a radio conversation with André Breton and Francis Ponge, had never been held in such honour by painters as today: 'The painters who count today all claim kinship with poetry and maintain that they are sensitive to poetry alone. Their appetite for collaboration with poets is enormous'.[22]

Jean Paulhan: Braque le Patron

'If I had been a painter, I would have liked to have been Braque', Paulhan wrote to Marcel Arland in 1943.[23] An influential figure in French intellectual life and former director of *La Nouvelle Revue Française*, Paulhan (1884–1968) had a strong interest in the visual arts. Preoccupied in his own work with the nature of language, he explained this interest by saying that painting is also a language, 'a particular instance of language.'[24] Braque's devoted champion, Paulhan also wrote on Jean Dubuffet, Jean Fautrier and others. He worked on the text of *Braque le Patron* over a period of about twelve years, modifying and extending it (the first edition was published in 1945, the definitive one in 1952).[25] The book profited from Paulhan's close contact with Braque, whom he had first met in 1935, which involved frequent visits to his studio and conversations with him. In a letter to the artist, Paulhan explained his aims: 'I try to take things from the simplest and most fundamental level...I would also like to prepare the reader to *understand* your reflections precisely.'[26] He described Braque at work in the studio, on one occasion watching a

painting of a woman at a window advance, and a shape metamorphose from an eye form to a cloud to a sky before dawn.[27] Paulhan was impressed by Braque's willingness to show his work in process: 'he works with absolute openness . . . , he allows you to come and go in his studio, where, for every finished painting, you see all the unsuccessful or unfinished works of the last thirty years'; Picasso, by contrast, shows you selected works only.[28] Paulhan's preference for Braque over Picasso was marked. In 1932, three years before he met Braque, he wrote to a friend: 'Picasso makes so much noise that one loves Braque first for his discretion, then for his silence and, finally, because one imagines that he knows so much more than the other.'[29] And in 1946 he wrote: 'Braque never stops growing, while Picasso drifts and spreads himself thin'.[30] (Braque and Picasso rarely saw one another in later years, but mutual friends kept each informed about the other.) In a letter to Braque, Paulhan explained that he intended the word 'patron' in the title of his book 'in the Christian sense of the word. What Orientals call the *guru*.'[31] He shared with Braque an interest in Eastern mysticism, and may well have introduced Braque to the eleventh-century Tibetan hermit, magician and poet Milarepa, the subject of a book illustrated by Braque in 1950.[32]

Paulhan read Braque's works as metaphysical, and he believed others had neglected this.[33] He wrote of their secret, mysterious and sacred character: 'he knew how to paint as if he were God', he declared at Braque's funeral in Varengeville.[34] Shortly after Braque's death, Paulhan told a friend: 'he <u>knew</u> what we had such difficulty in finding out.'[35] He resolved problems to which Paulhan sought answers in his own work.[36]

Paulhan's collection of works of art included a group of Braques. He attached great importance to Braque's revolutionary invention, the *papier collé*, writing extensively on it, particularly in *La peinture cubiste*, and he owned a *papier collé*, *Violin*, 1914 (now in the Cleveland Museum of Art).[37] Francis Ponge dated his veneration for Braque from the moment in 1923 when he first saw the *papier collé* in Paulhan's apartment (see fig. 11), and it would always haunt him. Years later, in 1945, when Ponge was writing his first text on Braque, Paulhan lent it to him.[38] Paulhan also owned two paintings of 1942, *The Kitchen Table*, a pair to cat. 8 in this exhibition, and *The Black Fish*, which Braque had given him.[39] Paulhan loved the paintings of this period, writing to his friend the writer Marcel Jouhandeau on his return from a visit to Braque's studio on 19 February 1942: 'These latest paintings are marvellous. What serenity, what presence. I am <u>captivated</u> by them.'[40]

Francis Ponge: 'L'objet, c'est la poétique'

In March 1945 Paulhan took Ponge (1899–1988; fig. 12) to Braque's studio for the first time. On the painter's death Ponge described the meeting as one of the most important of his life: 'I immediately proclaimed my devotion to him'.[41] On that day in Braque's house Ponge was seized by a 'irrepressible sob' on seeing a still-life painting of fish on a plate beside a stove: 'I dare say that my nervous condition had something to do with it, we were all rather ill-nourished at that time. But it is very unusual for painting to have such a powerful effect on me.'[42] In each place he had lived during the Occupation, Ponge had put on his wall a small colour reproduction of the *Mandolin and Score* (*The Banjo*; cat. 1) and a black-and-white one of a head of a woman by Picasso, 'a bit like my colours, or my reasons for living (and struggling)'.[43]

Paulhan's role as intermediary between his two friends was decisive. A mentor and father figure to Ponge, he had sent Braque a copy of Ponge's *Le Parti pris des choses* on its

LA CRUCHE

Pas d'autre mot qui sonne
comme cruche. Grâce à cet U qui
s'ouvre en son milieu, cruche est

15. Ponge, 'La Cruche', with an
etching by Braque, from *Cinq Sapates*,
1950. Photograph Bibliothèque
Nationale, Paris.

publication in 1942. This collection of prose poems about objects written between 1924
and 1939 had established Ponge's reputation. Braque admired his poems ('Braque is <u>thrilled</u>
by *Le Parti-Pris*', wrote Paulhan to Ponge).[44] Paulhan encouraged Ponge in his desire to
write about the artist,[45] and Ponge, who admired *Braque le Patron*, shared Paulhan's very
high esteem for Braque, although he was never the close friend that Paulhan was.
Altogether he wrote nine essays on Braque between 1946 and 1982.[46] The first two were
collected in his first book of art criticism, *Le peintre à l'étude*, with a cover by Braque
(designed at Paulhan's instigation).[47]

Ponge met several other artists at around the time of his introduction to Braque –
Picasso, Hélion, Fautrier and Dubuffet – because of their appreciation of *Le Parti pris des
choses*. The first of his extensive writings on contemporary art dates from the same period.[48]
He found it useful to have friends who worked in a medium that was not his own, but
whom he saw as being in the same situation in relation to the world. He was especially
interested in learning of the technical difficulties specific to painting.[49] The painters he
wrote about had concerns that paralleled his own;[50] the strong kinship with Braque was
founded on their shared attention to the simple objects closest to us.

Ponge recalled that it was Braque's regard for the humblest objects, 'this appreciation of
small objects', that encouraged Braque's interest in, and affection for himself, the author of
Le Parti pris des choses, and Ponge's veneration for Braque in return.[51] One thinks, for
example, of the poems in *Le Parti pris des choses* devoted to 'La Bougie', 'L'Huître' or 'Le
Pain', all objects in Braque still-lifes. The affinity between poet and painter was exemplified
by their collaboration on *Cinq Sapates* (1950), illustrated with five etchings by Braque at
René Char's request.[52] The five objects of Ponge's prose poems are the earth, olives, a jug,
fish, a shutter; and Braque's five illustrations, in the black and white he said they required,
relate directly to each. 'La Cruche' ('The Jug', fig. 15) opens: 'No other word that rings
like "jug". Thanks to the U that opens in the middle, jug sounds hollower than hollow,
and so it is.' This object in daily use, 'a bit rough, perfunctory', made of the most common
of materials, singular in Ponge's eyes because it is at once mediocre and fragile, was one so
often painted by Braque. Text and image are perfectly matched.

In 1956 Braque declared his 'intense affinity' with Ponge, 'the poet who, avoiding all
random speculations, has the wisdom to start from the lowest point (nothing is lower than
the earth), so giving himself the chance to raise himself. Leaving roads and paths, we will
follow his tracks.'[53] Ponge found the same characteristic in Braque, listing their likenesses
thus: 'taking the world as it comes, in fragments, in our studios; starting from scratch each
time in an atmosphere of uncertainty and risk'.[54]

Ponge's work is often fragmentary and provisional in form, and Braque's emphasis on
the act of painting rather than the finished product ('one is more interested by the journey',
he told Dora Vallier in 1954) accorded exactly with Ponge's own interests.[55] He wrote on
Braque's drawings with particular sympathy as a result, finding in them 'the authentic
imprint' of Braque and discoveries at every turn.[56] An extension of his interest in the
creative process, in the work in progress, was his fascination for artists' studios (as reflected
in the titles of his collections of art criticism, *Le peintre à l'étude* and *L'Atelier contemporain*),
visits to which he described in his writings.

Ponge's keen attention to language can be compared with Braque's love of and attention
to his materials.[57] Ponge himself drew the comparison between, on the one hand, lines
from one of the *Cinq Sapates*, 'La Terre' – 'the deep respect for matter: what more worthy

of the mind?' – and, on the other, Braque's paintings and some of the writings in his *Cahiers*.[58]

Ponge adopted several of Braque's reflections and maxims as his own. Most significantly, he took to heart Braque's phrase 'the object is the painter's poetics'.[59] He also appropriated Braque's expression 'art and life are one'.[60] Ponge declared in 1967: 'I take him completely for my own.'[61] Critics have commented on how Pongean such phrases sound, and Ponge does not always acknowledge Braque as the author, so completely have they become his own.[62]

For Ponge, 'Braque the reconciler' rights our state of disequilibrium, shores us up, does us good, repairs and cures all;[63] he guides us and gives us lessons;[64] he takes risks constantly, starting again from zero each time; 'he has no rival in the hearts of poets. He is grafted to them for ever.'[65] Braque was one of the deepest thinkers ever to have painted ... his meditation was essentially concerned with painting itself'.[66] Rather as Paulhan took Braque as his *patron*, Ponge found in him 'a master of life': 'each of his greatest works, from each of his periods, was like a stage in my "ethics" [sic]; ... for me he was a great master of life'.[67]

René Char and Braque: 'substantial allies'

Of all the 'substantial allies' found among painters and sculptors by René Char (1907–1988), Braque was the closest.[68] Picasso, Miró, Giacometti, Matisse and de Staël were among over forty artists with whom Char collaborated, but his affinities with Braque were particularly profound. In the texts and poems devoted to Braque by Char and in Braque's illustrations for Char's works, their mutual sympathy is evident.[69]

'Heartfelt compliments on *Feuillets d'Hypnos* which I have just read with the attention they deserve', Braque wrote to Char in 1946 on receiving from him a copy of Char's recently published book: 'You look at things directly and stand firm – all heroism lies there.'[70] The following year Char responded to Braque's appreciation of his poetry with his first text on Braque's paintings, written for the issue of *Derrière le Miroir* devoted to Braque on the occasion of his first exhibition at the Galerie Maeght: 'Work which is rooted in the earth like no other, and yet what a *frisson* of alchemy!'[71]

Later in 1947 Braque and Char met in the Vaucluse, Char's native region, at the time of the exhibition of contemporary painting and sculpture at the Palais des Papes in Avignon, in which Braque was included.[72] The exhibition was organised by Yvonne Zervos, who had introduced the pair. A number of poems by Char bear witness to Braque's stay. 'Georges Braque Intra-Muros' recalls Braque in the Palais des Papes (and also records Char's visit to Braque's Varengeville house the following winter; see fig. 13).[73] The first 'collaboration' between them was the illustrated manuscript of 'Le Thor', a beautiful short prose poem of September 1947 named for a village that Braque and Char visited together near Char's birthplace, L'Isle-sur-Sorgue, east of Avignon. Char collaged onto his manuscript text of the poem a drawing illustrating it by Braque.[74] Char's poetry was rooted in the Vaucluse (in his dedication on the cover of Char's copy of *Lettera Amorosa*, the book they produced together at the end of Braque's life, Braque wrote: 'My old friend who brings us a breath of the freshness of L'Isle-sur-Sorgue'[75]). They shared a love of the region; Char had been a boy of five when Braque made his first *papiers collés* at Sorgues, north of Avignon, in 1912, and Braque was a regular summer visitor there until the late 1920s (fig. 14).

Char's play *Le Soleil des Eaux*, published in 1949 with four etchings by Braque, was also Vauclusian. The fish that had been the subject of a long series of still-lifes (such as cat. 6 and 8) are here aptly adapted by Braque as a motif to illustrate a play about the fishermen

SOUS LA VERRIERE

LE PEINTRE

Prenez la chaise de jardin, vous serez agréablement
assis. Je fais entrer quelque lumière dans l'atelier.
Le temps de jeter de l'eau sur les couleurs. Tâtez de
cette orange au bord de son assiette. Elle n'est pas
seulement là pour se lisser les flancs. Portez-lui joie.
Quoi de neuf?

LE POETE

Vos moindres actions ont une saveur familière. Et
les choses que vous acclimatez conservent l'attitude de
leur vérité, même si celle-ci n'importe plus! Comment
faites-vous, Braque? Visiblement elles n'aspirent
qu'à votre compagnie, à votre intervention. D'autres
caresseurs, d'autres brutaux pourtant...

16. René Char, 'Sous la Verrière',
Derrière le Miroir, January–February
1950. Photograph Bibliothèque
Forney, Paris.

of the Sorgue whose livelihood is menaced by pollution of the river by a local factory.[76]

On the occasion of Braque's second exhibition at the Galerie Maeght in 1950, Char again contributed a text, 'Sous la Verrière', to *Derrière le Miroir* (fig. 16).[77] It takes the form of an imaginary dialogue (though one that conveys something of their real conversations) between the Poet and Painter in the Painter's studio. This remarkable conversation opens with the Painter inviting the Poet to sit in a garden chair – such as those Braque had on the terrace of his Varengeville house. At the time he was working on a series of paintings which includes the chairs, and Braque's illustration of Char's text is related to the series (see cat. 38). The Poet observes that the Painter's objects 'aspire only to your company, to your intervention.'[78] The intense 'jubilation' of looking at Braque's works is again referred to by Char in 'Peintures de Georges Braque', published in *Cahiers d'Art* in 1951.[79] Char's response to twelve paintings (including cat. 17 and 26) is prefaced by an apology for 'plagiarising' Braque, for translating paintings into words, for creating 'the poet's canvas!'

Braque also provided the frontispiece for Char's *La bibliothèque est en feu* (1956), dedicated to Braque.[80] Two years later Char published five poems dedicated to him, *Cinq poésies en hommage à Georges Braque* (1958), with a colour lithograph by Braque.[81] Lines from one of them, 'L'Oiseau spirituel', have a particular resonance in relation to Braque's birds:

> Beseech me not, great eyes. Take cover, Oh desires.
> I flee to the skies, limitless pools.
> I glide in freedom through the ripened wheat.

The last collaboration between Char and Braque, *Lettera Amorosa*, published in 1963 shortly before Braque's death, was also the most important.[82] The project took five years to complete. Freely inspired by words and themes in Char's text, Braque's twenty-seven colour lithographs complement and enhance it, taking up Char's recurring motifs (which were also his own) of birds and flowers. The correspondence between poet and painter is complete.

Char's aphoristic style and taste for concision were shared by the painter. Char admired Braque's reflections on art, copying extracts from a *Cahier* at Braque's home in 1948.[83] Both loved the fragmentary, aphoristic writings of Heraclitus, and they collaborated on an edition of them in 1948, Braque contributing an etching and Char a preface.[84] Both were also interested in the poetry of Pindar, and to *Le ruisseau de blé* (1960) Char contributed a translation and Braque an engraving.

Among Char's *objets-poèmes*, works of art made on wood, bark, stones, paper and other materials, was 'A thought for Braque' dated February 1957, a pebble found at Varengeville (such as Braque loved and himself made sculptures from), inscribed 'Une pierre de l'océan'. After Braque's death, Char put together *L'Amitié de Georges Braque*, a homage composed of eight poems or fragments of poems by himself with drawings and gouaches by Braque – a sort of retrospective of their collaboration. (It has recently been acquired by the Bibliothèque Nationale in Paris together with the majority – twenty-three – of Char's other 'illuminated manuscripts' consisting of handwritten poems by Char, illuminated by artist friends.)[85] *L'Amitié de Georges Braque* included the decorated manuscript of 'Le Thor', extracts from *Lettera Amorosa* and the gouache of *La Charrue* which Braque had dedicated to Char in July 1960 'in memory of "L'Avenir non prédit"', onto which Char now copied the poem admired by Braque.[86] A punning photograph of 1960 shows Char in Braque's studio standing in front of the painting of *The Plough*, (cat. 36; fig. 17).[87]

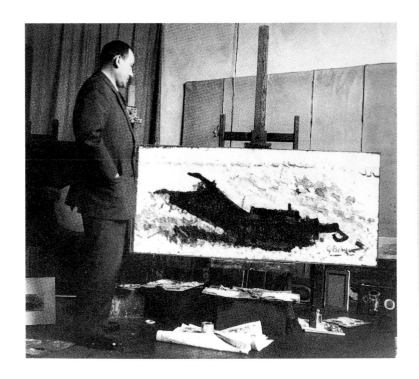

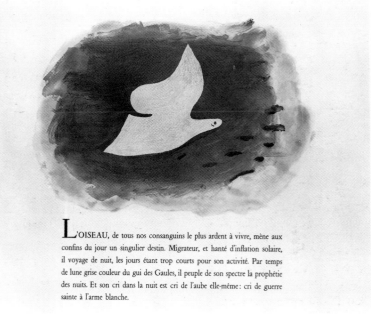

L'OISEAU, de tous nos consanguins le plus ardent à vivre, mène aux confins du jour un singulier destin. Migrateur, et hanté d'inflation solaire, il voyage de nuit, les jours étant trop courts pour son activité. Par temps de lune grise couleur du gui des Gaules, il peuple de son spectre la prophétie des nuits. Et son cri dans la nuit est cri de l'aube elle-même : cri de guerre sainte à l'arme blanche.

17. René Char in Braque's studio, 1960, with *The Plough* (cat. 36).

18. Saint-John Perse and Braque, *L'Ordre des Oiseaux*, 1962, first page. Photograph Bibliothèque Nationale, Paris.

Saint-John Perse and L'Ordre des Oiseaux

The unusual collaboration between Braque and Saint-John Perse (1887–1975) serves as a coda to this essay. Introduced by their mutual friend Jean Paulhan, Braque and Perse had met only twice, in 1958 and in 1961, when their collaboration on *L'Ordre des Oiseaux* (published in 1962 with colour etchings by Braque) was initiated (fig. 18).[88] Braque called it an encounter rather than a collaboration, for they had in fact begun work separately. The poet had conceived the text independently, adding the references to Braque when the project was proposed; and Braque had already prepared most of the etchings, making two additional ones for the poem. The resultant poem 'Oiseaux' is a poetic meditation on birds in general and on Braque's in particular, and it moved Braque strongly.[89] The poet admired Braque's work and found the man 'profoundly sympathetic.'[90] An amateur ornithologist, his predilection for birds is evident in his work. This was a special case of the discovery of common ground between painter and poet, ground which had proved so fertile in the case of Braque.

1 Other poets or writers whose books Braque illustrated or who wrote on Braque (either poems or texts) include Guillaume Apollinaire, Carl Einstein, Paul Eluard, Saint-Pol Roux, Antonin Artaud, Jules Supervielle, Tristan Tzara, Georges Ribemont-Dessaignes, André Verdet, Georges Limbour, Marcel Jouhandeau, Saint-John Perse, Jacques Prévert, Jacques Dupin. The impact of Carl Einstein (1885–1940) on Braque's thinking is evident in the key words Braque took over from him, such as 'hallucination'.

2 See especially *A proximité des poètes et des peintres. Quarante ans d'édition Maeght*, Centre de Création Contemporaine, Tours, and Adrien Maeght éditeur, Paris 1986.

 At around the time of the launch of Maeght's activities, Christian Zervos, editor of *Cahiers d'Art*, argued that writing by poets on art, which goes much further than conventional criticism, can be more successful at helping people to see ('Quelques préfaces poétiques', *Cahiers d'Art*, Paris, 1947, p.334; Char's preface to Braque's 1947 Galerie Maeght exhibition, discussed below, was reprinted on the same page).

3 'I noticed the poetic relationships in your recent paintings, between the palette and the bird, I noticed all the poetry, and that perhaps explains it … it is the powerful poetry that emanates from your recent paintings that affected me most of all, as a poet.' Conversation published in *Derrière le Miroir*, 'Hommage à Georges Braque', May 1964, p.75.

4 Compare the statement made by Braque in 1928: 'What I have always looked for in painting is poetry, the poetry that comes from painting, which in fact is simply achieved by juxtaposing two plastic facts' (Tériade, 1928, p.6.)

5 A favourite metaphor, quoted in e.g. the *Cahier de Georges Braque 1917–1947*, p.70. In his 1918 essay 'L'Image', Reverdy defined the poetic image as born of the 'the bringing together of two more or less distant realities', 'between which only the spirit grasps the relationship.' (*Nord-Sud*, 13 March 1918, an issue containing two drawings by Braque; reprinted in Reverdy, *Oeuvres Complètes: Nord-Sud, Self Défence et autres écrits sur l'art et la poésie (1917–1926)*, edited by Etienne-Alain Hubert, Paris 1975, pp.73–5.)

6 Diehl, 1945, p.309.

7 As recalled in conversation with e.g. Paul Guth, 1950, and John Richardson, where he described it as the first time he had been struck by the importance of this phenomenon (Braque, 1957, p.16). The original object is here a bucket.

8 Braque, 1957, p.16. Cf. Braque's comments of 1952 recorded by Père Couturier, 1962, p.147 (and quoted in *L'Art Sacré*, 7–8, March–April 1955, p.8), and his comments to Dora Vallier, 1954, p.18.

9 Verdet, 1978, p.21.

10 Braque, 1958, p.72.

11 Braque, 1957, p.16.

12 Braque, *Cahiers 1947–1955*

13 Letter of 23 May 1953 (Braque and Paulhan, 1984, p.19). Paulhan's letter to him (which is not published) had confirmed it. In conversation with Georges Charbonnier, Braque likened form and colour in painting to the words and rhythm of poetry: they exist before the content of a painting or poem is known (Charbonnier, 1959, p.16).

14 Reported by Stanislas Fumet, 'Battements', Reverdy and Braque issue of *Derrière le Miroir*, December 1962–January 1963, p.1.

15 See Pierre Cabanne, *L'Epopée du Cubisme*, Paris 1963, p.342.

16 p.74

17 Conversation with Braque, August 1961, quoted by Leymarie, 1962, p.301. When asked in 1928 for his views on the relations between painters and writers, Braque surely had Reverdy in mind when he said: '"I think it is rare to find a person who is sensitive to painting but is not himself a painter, as rare as painters are themselves.' (Tériade, 1928, p.6)

18 'Le Cubisme, poésie plastique', *L'Art*, 6, February 1919 (reprinted in Reverdy, *Oeuvres Complètes: Nord-Sud*, pp.142–8). The poetry of Mallarmé in particular was important for the Cubism of Braque and Picasso, especially their 'hermetic' Cubism of around 1911.

19 Leymarie, 1962, p.301. Braque continued to record his reflections, publishing two important selections in 1947 and 1956.

20 A manuscript of the 'Pensées' in Reverdy's hand, made in preparation for publication, is in the Bibliothèque Littéraire Jacques Doucet in Paris. It shows the significant role played by Reverdy in the editing of the text. I am grateful to M. François Chapon for permission to see it. An extract is reproduced in *Georges Braque, les papiers collés* (Paris (Pompidou) 1982, p.182).

 On Reverdy's influence and thinking see Christopher Green, 'Purity, poetry and the painting of Juan Gris', *Art History*, v 2, June 1982, especially p.189.

21 p.48.

22 'Entretien avec Breton et Reverdy', a radio interview, published in Francis Ponge, *Le Grand Recueil. II. Méthodes*, Paris 1961, pp.287–8.

23 Letter of 'Vendredi', *Jean Paulhan à travers ses peintres* (Paris, 1974, p.78). Published with the date 1943 in Paulhan, *Choix de Lettres II. 1937–1945. Traité des jours sombres*, Paris 1992, p.344.

24 Paulhan, *Les incertitudes du langage. Entretiens à la radio avec Robert Mallet*, Paris 1970, p.119 (conversations broadcast in 1952).

25 The first published extract appeared in *Comoedia*, Paris, 31 October 1942, pp.1 and 3. Other editions of the book were published in 1946 and 1947. My references are to the 1952 edition, reprinted in volume v of Paulhan's *Oeuvres Complètes*, Paris 1970. Braque made a lithograph and cover drawing for the 1945 edition and two lithographs for the 1947 one. He also illustrated Paulhan's *Les Paroles Transparentes*, 1955 (a re-edition of *Le pont traversé*, published in 1921) and the text by Paulhan in *Paroles Peintes*, 1962.

26 Letter of 'Jeudi 25' [*c.* 1943], quoted in *La Nouvelle Revue Française*, Paris, Paulhan special issue, 197, 1 May 1969, p.1028 (and in part in Paris, 1974, p.73).

27 p.18. The painting may well be *La Toilette devant la Fenêtre*.

28 Letter to Marcel Arland of *c.* December 1946, quoted in Paulhan, *Choix de Lettres III. 1946–1968. Le Don des langues*, Paris 1996, p.44.

29 Letter to Marcel Jouhandeau, March 1932, quoted in Paulhan, *Choix de Lettres I. 1917–1936. La littérature est une fête*, Paris 1986, p.237. In 1943 Picasso told Paulhan with reference to *Braque le Patron*: 'I am happy that justice is done to the woman who has loved me best.' (As recorded by Paulhan in a letter to Jean Grenier, quoted in *Jean Paulhan/Jean Grenier. Correspondance 1925–1968*, Quimper 1984, p.145.)

30 Letter to Ungaretti, 25 May 1946, Cahiers Jean Paulhan 5, Correspondance Jean Paulhan, Giuseppe Ungaretti 1921–1968, Paris 1989, p.364.

31 He continues: 'I would like to make one think of the old names of guild members ['*compagnons*']: Anatole-la-Justice … etc.' Letter of 'Jeudi 25' [*c.* 1943], quoted in *La Nouvelle Revue Française*, Paulhan special issue, 1 May 1969, p.1028.

32 Paulhan certainly introduced Milarepa to Aimé Maeght, who was to publish Braque's edition.

33 See e.g. his letters to Braque of 'Lundi' (Paris, 1974, p.73) and of 'Mardi' (p.74), and to Jouhandeau of 16 October 1943 (p.71).

34 'Peindre en Dieu', *La Nouvelle Revue Française*, 130, 1 October 1963, reprinted in *Oeuvres Complètes*, v, p.40. The titles of two of his articles on Braque are revealing: 'Braque ou le sens du caché' (*Cahiers d'Art*, Paris, 1940–44 issue, published 1944, pp.87–8) and 'Braque ou la Peinture Sacrée' (*Le Figaro Littéraire*, 183, 22 October 1949).

35 As recorded by Robert Wogensky, 'Celui qui aimait les Peintres', *La Nouvelle Revue Française*, Paulhan special issue, 1 May 1969, p.881.

36 Letter to Marcel Arland of *c.* December 1946 (Paulhan, *Choix de Lettres III*, pp.44–5.

37 *La peinture cubiste* was written between 1945–57 and published posthumously in Paulhan, *Oeuvres Complètes*, Paris 1970, v; extracts had appeared in e.g. *La Nouvelle Nouvelle Revue Française*, nos 4 and 5, April and May 1953.

 See *Jean Paulhan et ses environs*, Galerie Krugier, Geneva 1967 on Paulhan's collection. Paulhan recorded that Braque liked a painting he owned by Fautrier, *L'homme ouvert* [1928]. (Letter to Fautrier, 25 June 1943, *Choix de Lettres II*, p.314.)

38 'Braque ou un méditatif à l'oeuvre', in Ponge, 1977, p.296. First published as 'Braque ou la méditation-à-l'oeuvre' in Ponge, Descargues and Malraux, 1971.

39 *Catalogue de l'Oeuvre de Georges Braque, Peintures 1942–1947*, Paris 1960, p.28, as *Le Poisson*, 1942. Paulhan's letter to Braque describing it is quoted in the catalogue entry to cat. 6. Paulhan also owned one of the sculptures of fish, *Poisson*, gilded bronze, 1955, 35 x 12 cm.

40 Paris, 1974, p.71 (Paulhan, *Choix de Lettres II*, p.264).

41 'Feuillet votif', Ponge's contribution to the 'Hommage à Georges Braque', *Derrière le Miroir*, May 1964, p.10; collected in Ponge, *Nouveau Recueil*, Paris 1967, and then in Ponge, 1977.

42 'Feuillet votif', p.10; see also 'Braque ou un méditatif à l'oeuvre' (Ponge, 1977, p.300).

43 'Braque ou un méditatif à l'oeuvre' (Ponge, 1977, p.296). Cf. his essay 'Bref condensé de notre dette à jamais et re-co-naissance à Braque particulièrement en cet été 80', in Saint-Paul, 1980, p.15. I am grateful to Armande Ponge for confirming that her father had a reproduction of cat. 1.

44 *Jean Paulhan/Francis Ponge. Correspondance 1923–1968*, Paris 1986, I, p.280, letter of 7 September [1942]. Paulhan had encouraged Ponge in the composition of *Le Parti pris des choses*, and played a role in the editing. The title is perhaps best understood as 'to side with things', although it is possible to read it as 'the side things take'.

45 After the first essay, *Braque le Réconciliateur*, was published, Ponge sought Paulhan's approval and advice in a highly self-critical letter of December 1946; Paulhan responded with praise and encouragement. See *Jean Paulhan/Francis Ponge. Correspondance 1923–1968*, Paris 1986, II, pp.35–6. The text was published by Skira, Geneva, 1946. It was written as the preface to an album of reproductions of works by Braque in the series 'Les Trésors de la Peinture Française'.

46 Seven of these are in Ponge, *L'Atelier Contemporain*, Paris 1977 (most of his writings on art are collected here, with the exception of a few later and a few minor texts). Ponge wrote two further texts on Braque

after 1977, one for the catalogue of the 1980 Braque exhibition at the Fondation Maeght (Saint-Paul, 1980, pp.13–20), and 'Braque-Argenteuil', the preface to a centenary exhibition of Braque's graphics at the Galerie du Centre Culturel, Argenteuil, May–June 1982; collected in Ponge, *Nouveau Nouveau Recueil, III, 1967–84*, ed. Jean Thibaudeau, Paris 1992, pp.151–5.

47 Paris 1948; collected in *Tome premier*, Paris 1965, and then in Ponge, 1977. The same cover in a different colour was used for Ponge's *Proêmes*, also published in 1948.

48 Among those who have written on Ponge's art criticism are Richard Stamelman, Ian Higgins, Serge Gavronsky and especially Shirley Ann Jordan (*The Art Criticism of Francis Ponge*, London 1994).

49 *Entretiens de Francis Ponge avec Philippe Sollers*, broadcast 1967, published Paris 1970, pp.90, 92, 93.

50 'Au lecteur' (1976), Ponge, 1977, p.viii.

51 Saint–Paul, 1980, p.18.

52 The book was dedicated to Char. Collected in Ponge, *Le Grand Recueil. III. Pièces*, Paris 1961, pp.102–21. A 'sapate' is a valuable gift hidden within a commonplace object – for example a diamond inside a lemon. It is a practice found in Spain and Italy.

53 *La Nouvelle Nouvelle Revue Française*, Paris, XLV, 1 September 1956, p.385, part of a 'Hommage à Francis Ponge'. Braque was here adapting one of the maxims in his *Cahiers 1947–1955*.

54 Saint-Paul, 1980, p.15. Interestingly, in his 1944 essay on Ponge, 'L'Homme et les choses', Sartre had drawn a comparison between the fragmentary phrases which make up Ponge's texts and paintings by Braque and Gris, which the eye must piece together out of many elements. (Collected in Sartre, *Situations, I. Essais critiques*, Paris 1947, p.253.)

55 See also Braque, 1957, p.16, and a maxim in his *Cahiers 1947–1955*: 'For me, creation of more important than the expected results.' Ponge ended 'Feuillet votif' with Braque's maxim 'Ne concluons pas' from the *Cahier de Georges Braque 1917–1947*.

56 Introduction to *Braque Dessins*, Paris 1950; collected in *Le Grand Recueil. I. Lyres*, Paris 1961, and then in Ponge, 1977.

57 Ponge believed it essential for the poet or painter to be sensitive to materials and to technique (*Entretiens de Francis Ponge avec Philippe Sollers*, p.48).

58 'Braque ou un méditatif à l'oeuvre' (Ponge, 1977, p.297).

59 Taken from the *Cahier de Georges Braque 1917–1947*: 'The painter thinks i forms and colours, the object is the painter's poetics.' 'L'objet, c'est la poétique' is the title of a text of 1962 (collected in Ponge, *Nouveau Recueil*, Paris, 1967, and in Ponge, 1977).

60 The last of the reflections in the *Cahier de Georges Braque 1917–1947*: 'Avec l'âge l'art et la vie ne font qu'un.' Braque often quoted it in interviews too.

61 *Entretiens de Francis Ponge avec Philippe Sollers*, p.106.

62 He quotes uncredited, for example, Braque's maxim 'I like the rule that corrects the emotion' in *Pour un Malherbe*, Paris 1965, p.310.

63 See *Braque le Réconciliateur* and *Braque Dessins*.

64 Preface, *Braque Lithographe*, Monte Carlo 1963 (in *Nouveau Recueil*, Paris 1967, pp.187 and 9).

65 'Braque-Japon', preface to the catalogue of a Braque exhibition held in Tokyo in 1952 (in *Le Grand Recueil. I. Lyres*, Paris 1961, p.107).

66 'Braque ou un méditatif à l'oeuvre' (Ponge, 1977, p.286).

67 'Feuillet votif', p.10. Cf. 'Braque-Japon', 1952 (in *Le Grand Recueil. I. Lyres*, p.100).

68 The subtitle 'Alliés Substantiels' was used for the group of writings on art (more on Braque than on any other artist) collected in Char's *Recherche de la base et du sommet*, first published 1955, expanded 1965, collective edition 1971.

69 On their relationship see especially the catalogue of the exhibition *Georges Braque, René Char* at the Bibliothèque Littéraire Jacques Doucet, Paris, 1963; and of the *Exposition René Char*, Fondation Maeght, Saint-Paul de Vence, and Musée d'Art Moderne de la Ville de Paris, 1971. Also Mechthild Cranston, *Orion Resurgent. René Char: Poet of Presence*, Madrid 1979, especially pp.301–18; and Rosemary Lancaster, *La Poésie Eclatée de René Char*, Amsterdam 1994, especially pp.157–63.

70 Letter of 5 July 1946, reproduced in facsimile in Marie-Claude Char, 1992, p.147.

71 No. 4, June 1947, n.p. Reprinted in Char, 1971, p.54.

72 In 1963 Char recorded that Braque had longed since 1912 to hang his paintings in the Palais des Papes (in 'Braque, lorsqu'il peignait', collected in Char, 1971, p.58). 'The only of Avignon's chosen ones who is loved by the walls of its palace', wrote Char in 'Octantaine de Braque', 1962.

73 Published in *Les Matinaux*, Paris 1950; collected in Char, 1971, pp.58–9. Manuscript illustrated in Marie-Claude Char, 1992, p.157.

74 Illustrated in *Cahiers d'Art*, Paris, 1947, p.7.

75 Reproduced in facsimile in Marie-Claude Char, 1992, p.206.

76 Compare the plate of fish drawn by Braque on a copy of the catalogue of the Palais des Papes exhibition dedicated to Char, under the words 'Souvenir du Thor' (reproduced in Marie-Claude Char, 1992, p.156).

77 Nos 25–6, January–February 1950, Braque issue, n.p. Reprinted in Char, 1971, pp.54–6.

78 'Visiblement elles n'aspirent qu'à votre compagnie, à votre intervention.'

79 pp.141–9. A shortened variant was reprinted as 'Lèvres incorrigibles' in Char, 1971, pp.56–8.

80 The seventh fragment of *La bibliothèque est en feu* was used in *A Braque*, a 'minuscule' published by the editor Pierre André Benoit in 1955. Benoit published other collaborations between Braque and Char including *Jeanne qu'on brûla verte* (1956) and *Nous ne jalousons pas les dieux* (1962), as well as the tributes they paid to one another: Braque and Benoit, *Salut à René Char* (1955) and *Né le* (1957) for Char's fiftieth birthday; and Char and Benoit, *A Braque* (1955), already mentioned.

81 See Char, *Oeuvres Complètes*, Paris 1983, pp. 397-8, from *La Parole en archipel*, 1962 (four of the five poems only).

82 Char recalled that Braque particularly wanted to illustrate this poem, the first version of which had been published in 1953 (interview with Thomas Jensen Hines, quoted in Hines, *Collaborative Form. Studies in the Relations of the Arts*, Kent, Ohio, and London 1991, p.16).

83 Including some which have never been published. Char's notes are in the Fonds René Char, Bibliothèque Littéraire Jacques Doucet, Paris. I am grateful to Mme Marie-Claude Char for permission to consult this archive. Five of Braque's maxims are quoted in *Cinq poésies en hommage à Georges Braque*.

84 *Héraclite d'Ephèse*, in a new translation by Yves Battistini, Paris, Aux Editions *Cahiers d'Art*, 1948.

85 The Braque manuscript was exceptional among them in that it was assembled after Braque's death. See *René Char. Manuscrits enluminés par des peintres du XXe siècle*, Bibliothèque Nationale, Paris 1980, and Edmond Nogacki, *René Char, Orion pigment d'infini ou De l'écriture à la peinture (Enluminures, Illustrations, Poèmes-Objets)*, Valenciennes 1992. This contains listings of the illustrated and illuminated works, and of Char's plastic works.

86 Braque's gouache was a version of the lithograph *La Charrue* (1960), which had been published alongside Char's poem 'L'Avenir non prédit' in *Derrière le Miroir*, 119, March–April 1960.

87 It may perhaps be significant that there was a plough in the garden of Char's house, Busclats (mentioned by Jean Voellmy, *René Char ou le mystère partagé*, Seyssel 1989, p.143).

Braque also depicted 'Le Char' (chariot) in a group of mythological works, mainly graphic works (begun before he met Char).

88 The first meeting is recorded in the photograph of Braque, Paulhan and Perse in Braque's studio in front, appropriately, of *The Bird and its Nest* (cat. 31), reproduced in *La Nouvelle Revue Française*, Paulhan special issue, 1 May 1969.

89 'I have read "Oiseaux" and was very moved. You push literature into the background.' Card to Perse, 21 March 1962, quoted in Aix-en-Provence and Paris 1976-7, p.125.

90 Letter to the book's publisher, Janine Crémieux, 26 January 1962. In 1960 he had said: 'I like Braque. I admire his integrity and his constant quest.' (Conversation with Christian Gali, published in *Parler*, Grenoble, Spring and Summer 1976, p.56.) On the collaboration see especially the catalogue of the exhibition organised by the Fondation Saint-John Perse, *Les Oiseaux et l'Oeuvre de Saint-John Perse*, Aix-en-Provence and Paris 1976-7 (including a text by Malraux on Braque and Perse).

Perse contributed 'Pierre levée' to the 'Hommage à Georges Braque', *Derrière le Miroir*, May 1964.

NOTES

The reference 'Maeght' is to the relevant
Catalogue de l'Oeuvre de Georges Braque
published by Maeght Editeur (Paris) in seven
volumes, under the direction of Nicole S.
Mangin (Worms de Romilly):
Peintures 1936–1941 (published 1961),
Peintures 1942–1947 (published 1960),
Peintures 1948–1957 (the first of the series,
published 1959).

This abbreviated reference is followed by
the number of the page on which the painting
appears in the relevant volume: no numbers
are given to the works in these volumes. No
catalogue has been published for the last years,
1958–63.

Our catalogue numbers 11, 12, 18, 25, 28,
29, 30, 41, 43, as well as all works completed
after 1957, are uncatalogued.

In this catalogue the works are arranged in
chronological order except for the series of
Billiard Tables, Studios and Landscapes, where
they are arranged chronologically within the
series.

Variant titles are given in brackets. Braque
often did not give titles himself. Dimensions
are given in centimetres, height first. It is
important to note that Braque frequently
mixed materials such as sand, ashes and
sawdust with his paint; where possible this has
been indicated.

The dating of Braque's paintings frequently
presents problems: he often did not date his
paintings and worked on them over a number
of years. Where there is some uncertainty,
dates are given in square brackets.

Full citations for publications referred to in
the entries are provided in the bibliography at
the back of the catalogue

Illustrations to the essays are cited as fig.★★.
Comparative illustrations to the catalogue
entries are referred to by the catalogue number
followed by a letter, e.g. cat. 17a.

1 MANDOLIN AND SCORE (THE BANJO)
Mandoline à la Partition (Le Banjo)

1941
oil on canvas
signed and dated
108 × 89 cm
Maeght 81
Collection of Charles and Palmer Ducommun

PROVENANCE
André Lefèvre; October 1942, bought by the
Galerie Louise Leiris, Paris; 1942, sold to an
unidentified buyer; Madame Figerio, Paris;
private collection, Paris/Robert Kahn-Sriber,
Paris; sold Sotheby's, London, 1 July 1975 (lot
50)

Mandolin and Score presents a rich formal
contrast between curvilinear and angular
elements, with the instrument, its rope, the
rolling staves of the sheet-music and the fruit
bowl played off against the dramatic hanging
spikes of the tablecloth and the rectilinear
divisions of the background space. The bold
colour scheme serves to heighten the
exuberance of the whole. The painting looks
back to the series of ornamental still-lifes of the
second half of the 1930s.

 The instrument in this painting and two
related works of 1939–40, *La Mandoline I* and
La Mandoline II (Maeght 75 and 76), has also
been named a banjo. In Jean Paulhan's *Braque
le Patron* (1946 ed., p.127), for example,
Mandolin and Score is illustrated with the title
Le Banjo. During the Occupation the poet
Francis Ponge kept a colour reproduction of
this painting, which he knew as *Le Banjo*: he
recalled that it was 'a bit like my colours, or
my reasons for living (and struggling)'. He
described the colours as 'very bold but very
well-organised in their variety, with a
particularly aggressive purple' (Ponge, 1977,
p.296).

 Braque had a great love of music and was
an accomplished amateur musician. He had
introduced the motif of the musical instrument
into Cubism, and it continued to be a
favourite with him, though he treated it less

frequently in later years. In this exhibition,
instruments also feature in *The Two Windows*
(cat. 27), *Woman with a Book* (cat. 14) and *The
Man with the Guitar* (cat. 37). From the late
1930s, music's place was increasingly taken by
painting itself: the palettes of the painter stand
in for the analogous forms of guitars and
mandolins, with thumb-holes likened to
sound-holes and paintbrushes placed like
strings. The instrument in *Mandolin and Score*
itself bears a likeness to a palette.

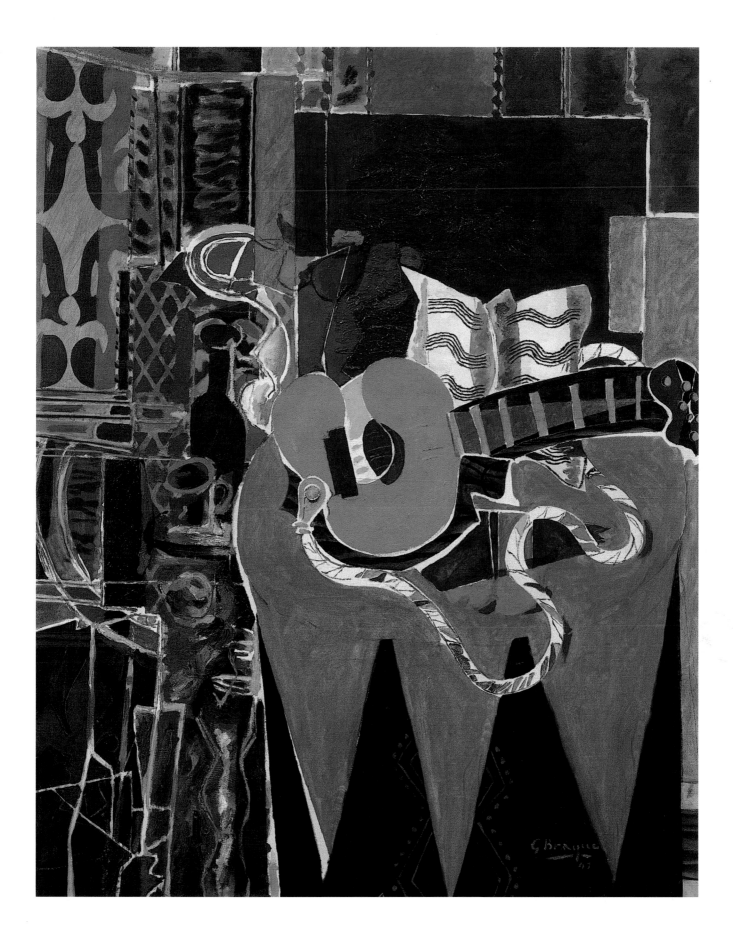

1942
oil and sand on canvas
signed and dated
141 × 195.6 cm
Maeght 4
The Menil Collection, Houston

PROVENANCE
Hugo Gallery (Alexander Iolas), New York;
1953, acquired by John and Dominique de
Menil

With its rigorously balanced composition and
the sobriety of its colour harmonies, *Large
Interior with Palette* possesses a magisterial
grandeur and serenity. The lyre-like outline of
the top of an easel is audaciously superimposed
on the still-life objects placed on the table:
palette and brushes, orange on a plate, glass
and plant in a pot. The painting mediates
between the first studio paintings, dating from
the later 1930s, and the great post-war series.
The easel form will also be found in two
works in the Billiard Table series, those of
1944 and 1945 (cat. 10, 12).

The origins of the easel form can be traced
back ten years, to the sinuous, branching form
which rises out of the foreground in
sketchbook drawings related to paintings such
as *Grande Nature Morte Brune* of 1932 (see e.g.
Pouillon and Monod-Fontaine, 1982, p.92).

A painting closely related to cat. 2, *Interior
with Palette* (Maeght 83), which dates from the
year before, lacks the easel form.

Large Interior with Palette was one of the
group of recent works by Braque shown at the
1943 Salon d'Automne in Paris, as were *The
Stove* and *Still-life with Palette* (cat. 3, 5). The
exhibition was a notable success for the sixty-
one year old painter. Previewing it in
Comoedia, the artist Jean Bazaine wrote that
Braque had reached a state of grace, a quiet
certainty which comes at the end of many
struggles: 'Braque comes once again to give us
the true measure of French art.' (Bazaine,
1943, p.1) One dissenting voice that reacted

against the widely-held view of Braque as the
most French of painters was that of Kandinsky.
Friends had told him that the Braque room
had nothing new to offer. Braque is considered
the greatest French painter, he wrote to Pierre
Bruguière: 'all they talk about is true French
painting - a very patriotic spirit!'[1]

Large Interior with Palette was also shown in
the 'Braque-Rouault' exhibition held at the
Tate Gallery in 1946, together with *The Stove,
The Washstand* and *The Billiard Table* of 1944
(cat. 3, 7, 10). It can be seen, together with
The Washstand, in a photograph of Braque in
the gallery on the occasion of his visit to
London, reproduced in *Picture Post*.[2] In his
review of the exhibition, which made a great
impact on him, the painter Patrick Heron
included a detailed reading of *Large Interior with
Palette*.[3]

[1] Letter of 1 December 1943, quoted in Christian
Derouet, 'Vassily Kandinsky: Notes et documents sur les
dernières années du peintre', *Cahiers du Musée National
d'Art Moderne*, Paris, 1982, no.9, p.98.
[2] London, 6 July 1946, p.27.
[3] *New English Weekly*, 4 July 1946, p.119; reprinted in the
composite chapter on 'Braque' in Heron, 1955, pp.86–8,
and in extract in Heron, 1958, p.18.

2a. Pencil sketchbook drawing for *Large Interior with
Palette*. Courtesy Archives Laurens.

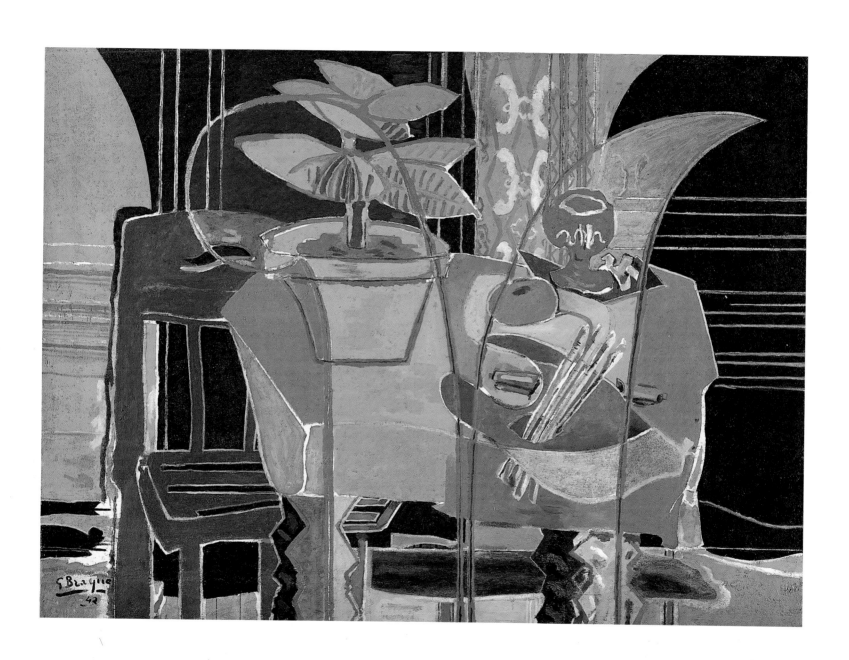

3 THE STOVE
Le Poêle

1942
oil and sand on canvas
signed
145.7 × 88.3 cm
Maeght 6
Yale University Art Gallery, New Haven. Gift
of Paul Rosenberg & Co. in memory of Paul
Rosenberg

PROVENANCE
1952, bought directly from the artist by Paul
Rosenberg; Paul Rosenberg & Co., New
York; 1960, given to Yale University Art
Gallery in memory of Paul Rosenberg

Braque's studio stove is represented here with
striking naturalism, down to the number
legible on its front. It is accompanied by a coal
scuttle, wastepaper basket, skull-like palette
and plant in a pot placed on a table, and a
painting (or mirror) on the wall behind. The
vertical format, favoured by Braque at around
this time (compare the Washstand and Kitchen
Table paintings), is accentuated by the
pronounced verticals of the stove, the edge of
the door beyond, the table and the black plane
superimposed on it. Light is forcefully
contrasted with shade, yellow with its
complementary blue.

Photographs taken by Brassaï in Braque's
studio in 1946 show the stove (cat. 3a). The
ashes produced by his stove fascinated him,
and he mixed them with his paint to give it
more substance (Fumet in *Le Point*, 1953, p.4).

Several sketchbook drawings relate to the
painting, one of which is squared-up, although
in the finished work Braque excluded a
number of elements found in them, for
example the hairbrush (which has strayed in
from the contemporaneous series of Washstand
paintings, such as cat. 7), the vase of flowers
(which becomes the plant in its pot), the
poster (map?) hanging on a nail on the back of
the door, the paintbrushes and a different
representation of the palette (cat. 3b; see e.g.
Cooper, 1972, p.82 and Zurcher, 1988, p.

166). A couple of other sketches show a
female figure seated on a chair in front of the
stove (Braque, *Carnets Intimes*, 1955, pp.25 and
105).

Commenting on his sketches, Braque told
an interviewer that 'everything changes when
you come up against the matter itself.' (Howe,
1949, p.104) He maintained that he never
knew how a painting would develop. He
likened his sketchbooks to recipe books, to
which he returned repeatedly for inspiration.
They were made of cheap gridded paper and
were always to hand; he guarded them
jealously, allowing only a selection of drawings
to be published, notably in the *Carnets Intimes*
(1955).

Paul Rosenberg, who owned *The Stove*,
was Braque's dealer from 1924 until the war,
when he transferred his gallery to New York.
He did much to spread Braque's reputation in
the United States.

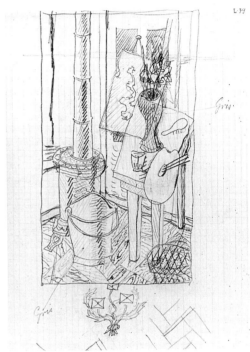

3b Study for The Stove, pencil on squared paper.
Courtesy Archives Laurens.

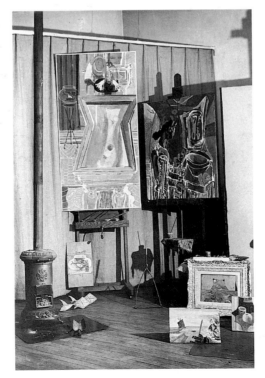

3a Braque's studio in Paris with the first state of *The
Billiard Table* (cat. 13A) and showing the stove.
Photograph © Brassaï, courtesy Archives Laurens.

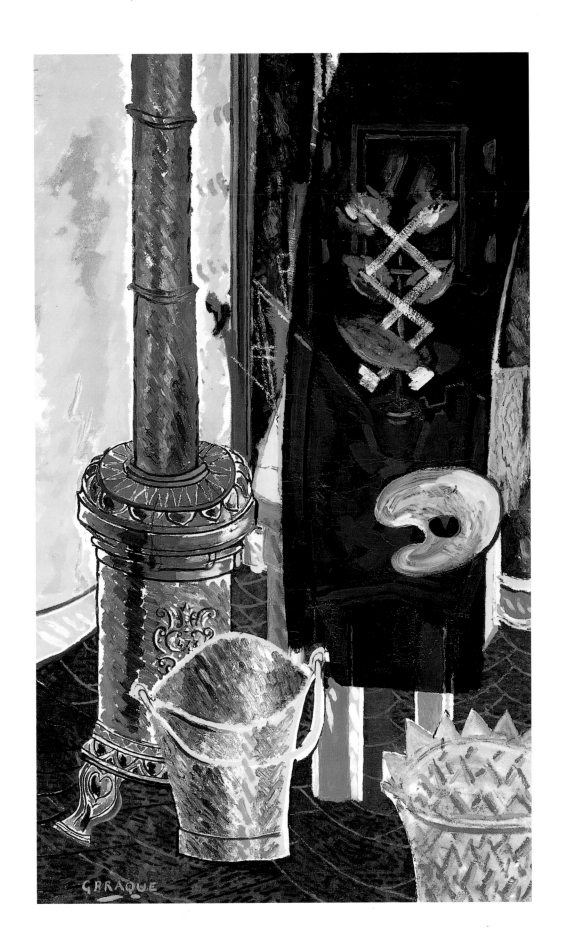

1943
oil on canvas
signed and dated
43 × 73 cm
Maeght 36 (as *Hamlet*)
Saarland Museum, Saarbrücken,
Stiftung Saarländischer Kulturbesitz

PROVENANCE
Private Collection, U.S.A; sold Stuttgarter
Kunstkabinett, (Roman Norbert Ketterer),
Stuttgart, 25 November 1954 (lot 911);
bought from the sale by the Saarland Museum,
Saarbrücken

Braque painted a series of Vanitas still-lifes
between 1938 and 1943 (cat. 29, which he had
begun in 1941, was not completed until
c.1954). *Pitcher and Skull* recasts the skull and
cross on a round table found in *Vanitas*, 1939
(Musée National d'Art Moderne, Paris),
omitting the rosary found in the earlier
painting and adding the pitcher and a small
bible or prayer book in the immediate
foreground.[1] Braque kept a skull in his studio
– it is visible on a table at Varengeville in
photographs taken in the winter of 1939 – and
it appears in the first studio paintings, for
example *L'Atelier au vase noir*, 1938 (Maeght
40).[2] Braque often played on the formal
analogy between the palette and the skull.

Cézanne's still-lifes with skulls, such as
Crâne et Chandelier (1866; Private Collection,
Switzerland) offered probably the most
important precedent for Braque, who revered
Cézanne above all other artists.

Braque denied that his Vanitas paintings
carried any symbolism, telling John
Richardson that they were painted 'not as
allusions to the fact that mankind is mortal, but
because I was fascinated by the tactile quality
of the rosary and the formal problems of mass
and of composition posed by the skull.'
(Braque, 1958, p.26) Yet the fact remains that
the introduction of the skull coincided with
the imminence of conflict, and it remained a
motif in Braque's work for the duration of the
war only.

Braque told Georges Limbour that a
mummy of Antinous, which had impressed
him in the Le Havre museum in his youth,
came to mind when he painted the skulls
(Limbour, 1957, p.29). To another friend he
recounted his joy on overhearing the reaction
of an American woman to one of the still-lifes
with skulls: 'Quelle horreur!' He took it as an
expression of praise, greatly preferring the
rawness of this response to an intellectual one
(Fumet, 1965, p.68).

[1] A related drawing shows a monk in a cowl seated at a
table on which are a skull, rosary and cross (Braque,
Carnets Intimes, 1955, p.92).
[2] The photographs are reproduced in Zervos, 1940, pp.4
and 7.

Nature Morte à la Palette

1943
oil and sand on canvas
signed
58.8 × 80 cm
Maeght 40
The Saint Louis Art Museum, Saint Louis, Gift
of Mr and Mrs Joseph Pulitzer, Jr.

PROVENANCE
(Galerie Maeght, Paris); Private Collection,
France; 19th and 20th Century French Art,
Inc. (Sam Salz), New York; 1954, bought by
Mr and Mrs Joseph Pulitzer Jr., Saint Louis,
Missouri; 1956, gift of Mr and Mrs Joseph
Pulitzer Jr. to the Saint Louis Art Museum

Still-life with Palette belongs to a series of works
of 1943 characterised by their polygonal
backgrounds and impasto style (Maeght 35,
39–44). On the table-top Braque sets a vase of
flowers, apples, tubes of paint, a palette and
paintbrushes. In order to simulate the wood-
graining of the palette Braque has combed the
wet paint, one of the techniques he had
brought to Cubism from his early training as a
painter-decorator.

 The highly tactile areas of impasto found in
this group of paintings (and in *Pitcher and Skull*,
cat. 4) may relate to Braque's experiments in
sculpture at the time, such as the bronze *Tête
de cheval* with its clotted surface.

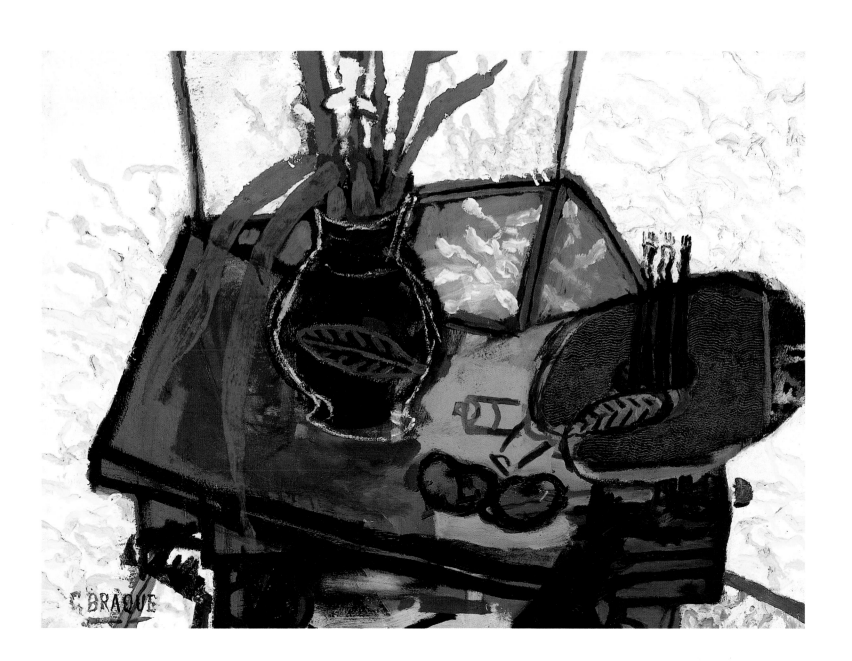

PITCHER, CANDLESTICK AND BLACK FISH
Vase et Poisson Noir

1943
oil on canvas
signed
64.7 × 49.5 cm
Maeght 48
The Menil Collection, Houston

PROVENANCE
Hugo Gallery (Alexander Iolas), New York;
1947, acquired by John and Dominique de
Menil

Braque had begun his series of still-lifes with
fish in 1936. In *Pitcher, Candlestick and Black
Fish*, their horizontal formats have been
replaced by a vertical format which opens up
the space. The two Kitchen Table paintings of
1942 and 1943–4 (Maeght 7 and 71; the latter
is cat. 8), also featuring fish, expand the space
further to include the area between table and
floor. The goldfish bowl paintings and the
small sculptures of fish subsequently took over
the theme (see cat. 25).
 Pitcher, Candlestick and Black Fish shares the
background panelling of several of the fish
still-lifes, such as *Les Poissons Noirs* ([1942],
Musée National d'Art Moderne, Paris). A
related painting with a horizontal format
represents a detail of cat. 6, without the
candlestick or loaf of bread (Maeght 49).
Braque gave a painting in the series, *Le Poisson
Noir* (1942, Maeght 28), to the writer Jean
Paulhan, who described it in a letter to
Braque: 'The fish makes me reflect on your
personal mixture of extreme violence and
serenity.' (Paris, 1974, p.73)

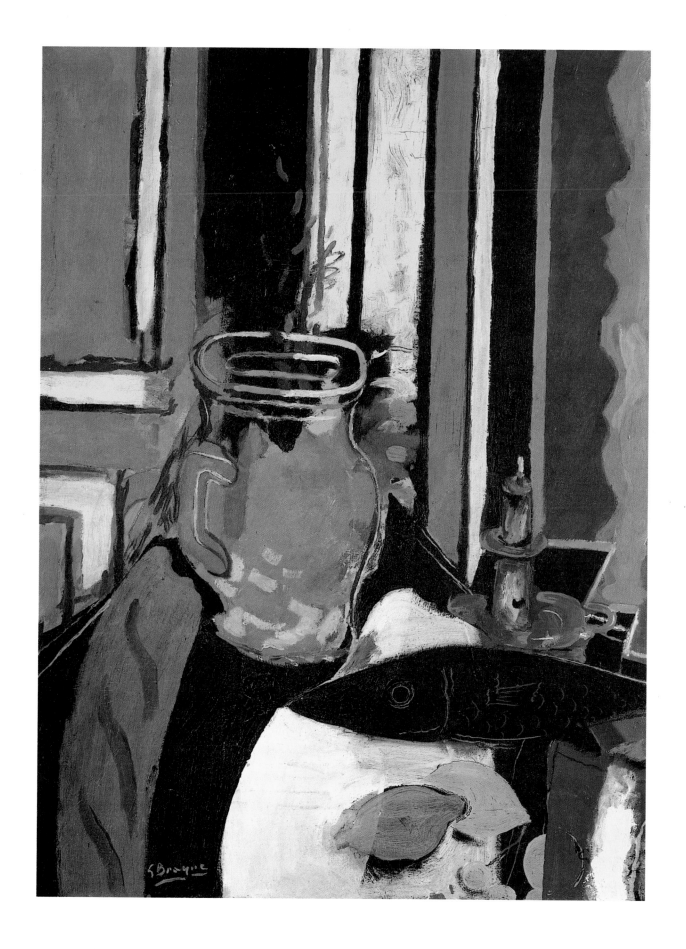

7 THE WASHSTAND
La Toilette aux Carreaux Verts

[1942–4]
oil and sand on canvas
signed
162 × 63.8 cm
Maeght 70
The Phillips Collection, Washington DC

PROVENANCE
Paul Rosenberg & Co., New York; 1948,
purchased by the Phillips Collection

This painting is the last of the Washstand series
and it provides the connecting link between
that series and *Le Salon* (cat. 9). Set beside
windows, some open to the sky, some closed,
only one of the group contains the female
figure whose presence is implied in the others.
Female figures at their toilet occur more
frequently in the related drawings (Braque,
Carnet Intimes, 1955, pp.71, 106, 107). The
drawings in general contain many more figures
than the paintings.

 The Washstand is the most austere of the
group, in this looking forward to *Le Salon* (cat.
9), to which it is closely related. The table
with its checked pattern and the window of
The Washstand are found again in the left-hand
portion of *Le Salon*. The composition of *The
Washstand* is highly controlled; the rhyming,
curved forms of the lip of the water jug, the
hairbrush and the top of the stool, which help
to unify the elongated canvas, are set off
against the strong rectilinear elements.

 The Washstand can be seen nearing
completion in a photograph of Braque's studio
dated 1943, alongside several other Washstand
paintings and *The Man with the Guitar* (cat. 37)
(see cat. 7a). The illustration of the painting in
the Maeght catalogue and elsewhere shows
some additional chalk lines in the area beneath
the table which were removed from the
finished work.

 Duncan Phillips, creator of the Phillips
Collection, played an influential role in
introducing Braque's work to America. He
had an important Braque collection,
particularly strong in the paintings of the 1920s
which he admired above all.

7a Braque's studio, 1943, with *The Man with the
Guitar* and *The Washstand*, from *Labyrinthe*, 15 January
1945. Photograph courtesy Bibliothèque Forney,
Paris.

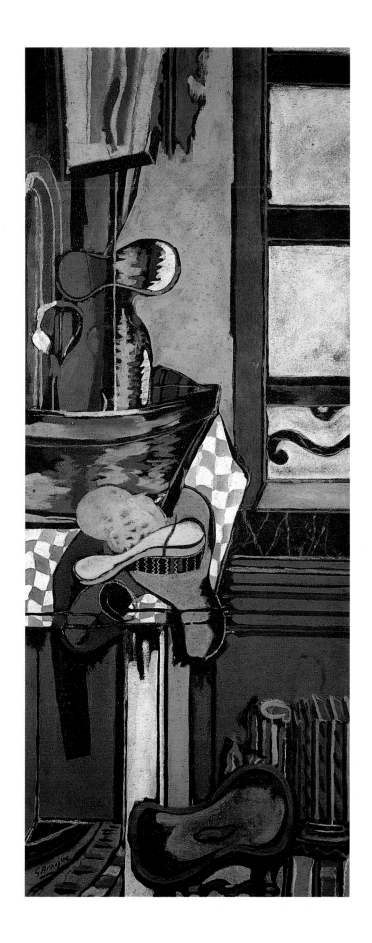

KITCHEN TABLE WITH GRILL
La Table de Cuisine au Gril

1943–4
oil and sand on canvas
signed
130 × 73.5 cm
Maeght 71
Private Collection, Switzerland

PROVENANCE
Aimé Maeght, Paris; 1954, bought by Gustav Zumsteg, Zurich; sold Christie's, London, 26 June 1995 (lot 45)

This painting is the companion piece to the earlier, sparser *Table de Cuisine* that was owned by the writer Jean Paulhan (1942, Maeght 7). Both Kitchen Table paintings feature fish that derive from the series of horizontal still-lifes of fish (compare cat. 6). The table-top still-life had been a privileged subject in Braque's work from the Cubist years. Here he places on the table a jug, grill, salt or pepper mill, glass, fish on a plate, fish slice, fork, fruit; a broom can be seen on the left.[1] One of the finest of the wartime works, it is painted in a restrained, earthy palette.

In *Kitchen Table with Grill* Braque has mixed sand with the paint to create a dry, coarse effect that is often found in his work. A consummate craftsman with a great love of materials, he was fascinated by the ways in which materials affect colour: 'I must have the sense of the material', he told an interviewer. (Frankfurter, 1949, p.56) To another he said: 'I place great emphasis on the tactile sense; it absorbs me greatly.' (Jakovski, 1946, p.34) He painted still-lifes with the aim of stirring the sense of touch, of making the spectator want to touch the objects represented.

Braque had always painted simple objects that were closest to hand: painting, he said in 1949, was about 'the common things; the things that you and I share' (Howe, 1949, p.104). Yet the wartime works have a particularly domestic focus, reflecting the confinements and hardships of daily life in occupied Paris. Many are painted in a relatively naturalistic style and have a sombre colour range.

[1]Related drawings are illustrated in Cooper, 1972, p.83, and Braque, *Carnets Intimes*, 1955, p.107 (top left).

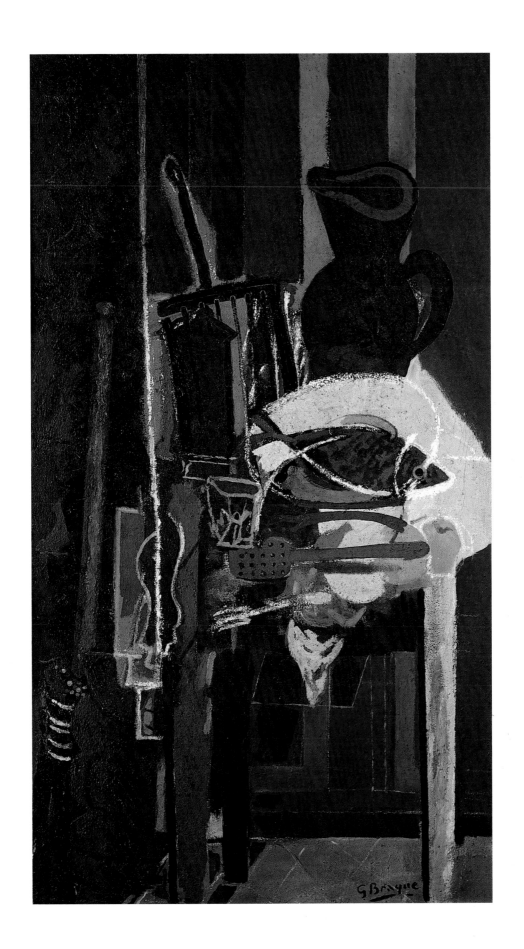

THE LIVING-ROOM (INTERIOR)
Le Salon (Intérieur)

1944
oil and sand on canvas
signed
120.5 × 150.5 cm
Maeght 68
Musée National d'Art Moderne, Centre
Georges Pompidou, Paris (1946)

PROVENANCE
1946, purchased from the artist by the Musées
Nationaux

Braque here represents the interior space of a
room, as well as bringing exterior space into
play by way of the half-open window
(compare the Billiard Tables of 1944 and 1945,
cat. 10, 12). While the left-hand portion of the
painting looks back to *The Washstand* (cat. 7)
and its relative legibility, the right-hand side
anticipates the ambiguities and metamorphic
forms of the Studio paintings. There appears to
be a female presence – with long tresses and a
hat – at the far right, who is related to figures
such as that at the left of *The Man with the
Guitar* (1942–61, cat. 37). Before her on the
table (or piano?) are a scroll of paper, a glass, a
packet of tobacco and a vase with plants.

The painting was completed at Varengeville
on Braque's return there shortly after the
Liberation. It has generally been thought that
he did not go to Varengeville between the
German invasion in 1940 and 1944, but he
had in fact continued to visit, at least until
1942: he spent a month there in 1941, and was
again there at the time of the Dieppe landings
in August 1942.[1]

A cardinal work, *Le Salon* was purchased
from Braque by the Musée National d'Art
Moderne in 1946, one of six paintings – also
including *The Billiard Table*, 1944, cat. 10 –
acquired at this time in preparation for the
official opening of the museum the following
year.

[1] As he told Marguette Bouvier (*Comoedia*, 29 August
1942, p.8). He had just returned to Paris at the time of this
interview: 'Very calmly he described the breakfast that had
been so abruptly halted by the air-raid. The farmhouse
that collapsed around him while he was sitting in front of a
steaming bowl of coffee. "How fortunate that the
farmhouse was built of cob!" he observed.'

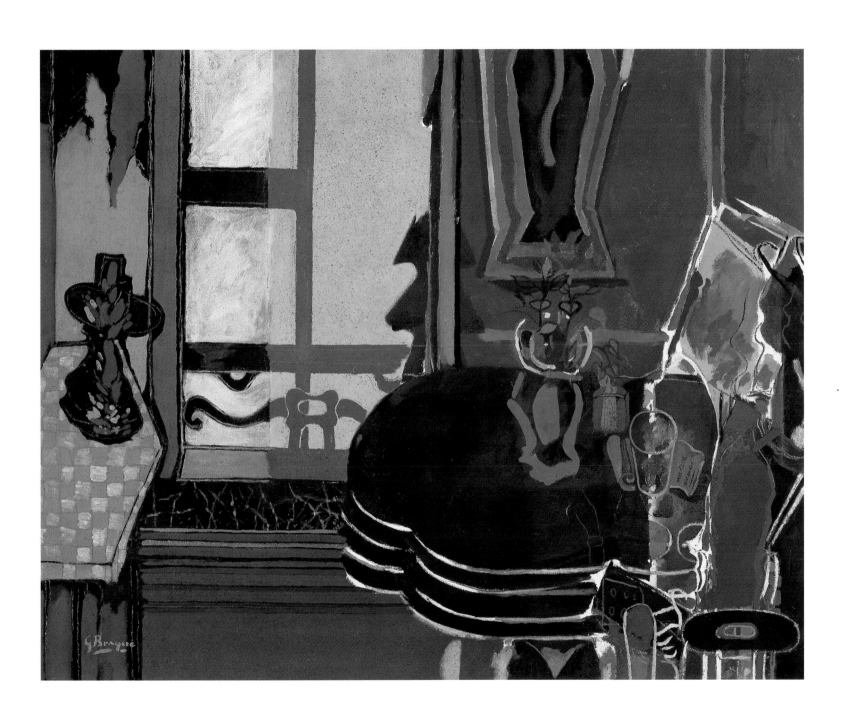

[1944]
oil and sand on canvas
signed
130.5 × 195.5 cm
Maeght 69
Musée National d'Art Moderne, Centre
Georges Pompidou, Paris (1946)

PROVENANCE
1946, purchased from the artist by the Musées
Nationaux

This is the first in the series of Billiard Tables
and one of the three major versions of the
theme (the others are cat. 13 of 1947–9 and
cat. 13A). The table in this work is articulated
in a very bold manner and tipped up onto the
picture plane so that the objects on it invite
the spectator to pick them up. The joint of the
table coincides with the corner of the room.
The outline of the easel form, as seen in *Large
Interior with Palette* (cat. 2), arches over the
foreground and incorporates the round table
on the right, bringing it forward. Two
diagonally-placed cues intersect one another.
The trajectories of the billiard balls are
suggested, and their bright red accents enhance
the dominant green and brown colour scheme.

In the background can be seen the back of
a chair, behind which is a book and a glass on
a small square table. On the round table beside
it is a vase of flowers. The vase may be the
same as that in *Still-life with Palette* (cat. 5),
with its distinctive leaf marking. In the left-
hand corner is a hat-stand, as found in cat. 13:
a hat and/or its stand are found in all the major
Billiard Table paintings. Cat. 10a shows a
drawing closely related to cat. 10.

The painting was included in the Braque
exhibition held in the French Pavilion at the
1948 Venice Biennale (as was *Kitchen Table
with Grill*, cat. 8). At this important Biennale –
the first since the war – Braque was awarded
the prize for a foreign painter. He was not the
unanimous choice, but was chosen over
Rouault at the third vote by the International
Jury (the other contenders were Picasso,
Kokoschka and Szonyi). The prize was for his
exhibition as a whole, not specifically for the
1944 *Billiard Table* as is often stated (see
Venice, 1948).

Extensions of his table-top still-lifes, the
Billiard Table paintings presented Braque with
a great spatial challenge. His radical
representations of the table perhaps convey the
variety of viewpoints of a player bending over
the table in the course of a game. Braque did
not own a billiard table but he knew the game,
even if he had last played it in his youth. Van
Gogh, whose importance for Braque's late
flower paintings, chair paintings and landscapes
will be seen, had painted the billiard table in
the Café de la Gare at Arles (*Le Café de Nuit*,
1888, Yale University Art Gallery, New
Haven), to which Gauguin had responded
with *Au Café* (1888, Pushkin State Museum of
Fine Arts, Moscow). In contrast to the public
spaces of these paintings, Braque's imaginary
billiard tables appear to be in domestic settings
that are unpeopled. Degas also painted the
subject (two versions, including *Salle de billard
au Ménil-Hubert*, 1892, Staatsgalerie Stuttgart).

10a Sketchbook study for *The Billiard Table*, pencil
on paper. Courtesy Archives Laurens.

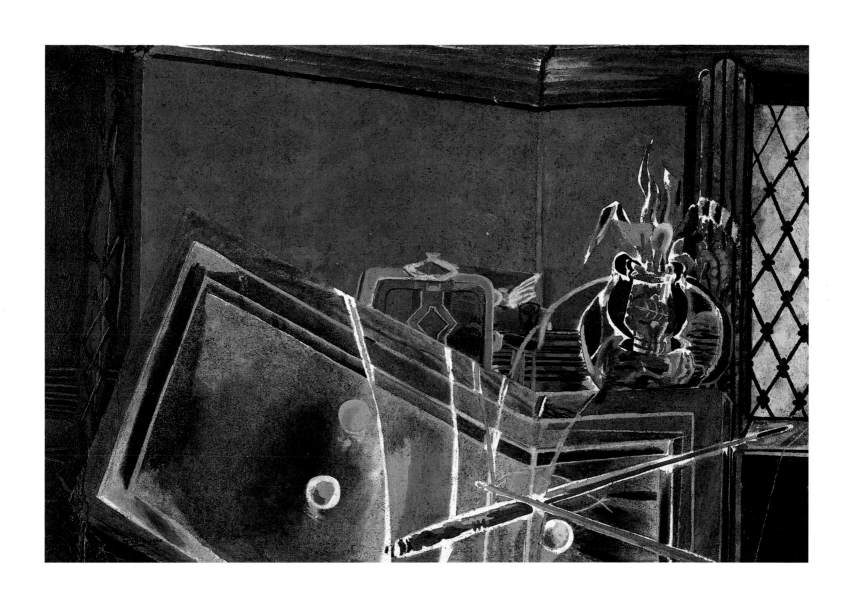

THE BILLIARD TABLE UNDER THE LIGHT
Le Billard sous le lustre

1944–5
oil on canvas
unsigned
50 × 62 cm
not in Maeght
Mr and Mrs Claude Laurens Collection

PROVENANCE
Collection of the artist

In addition to the major works of the Billiard
Table series, there are a number of smaller
related paintings, of which this is an example.
Braque kept it and several other small Billiard
Tables (as well as cat. 12). Like another small
example of the series that is almost identical in
size, *Le Petit Billard* of 1945 (Maeght 96), this
work shows a corner of a billiard table tipped
up towards the viewer, a detail from the larger
works of 1944–5 (cat. 10, 12). The ornamental
lampshades of the chandelier are found also in
The Billiard Table of 1944–52 (cat. 13A).

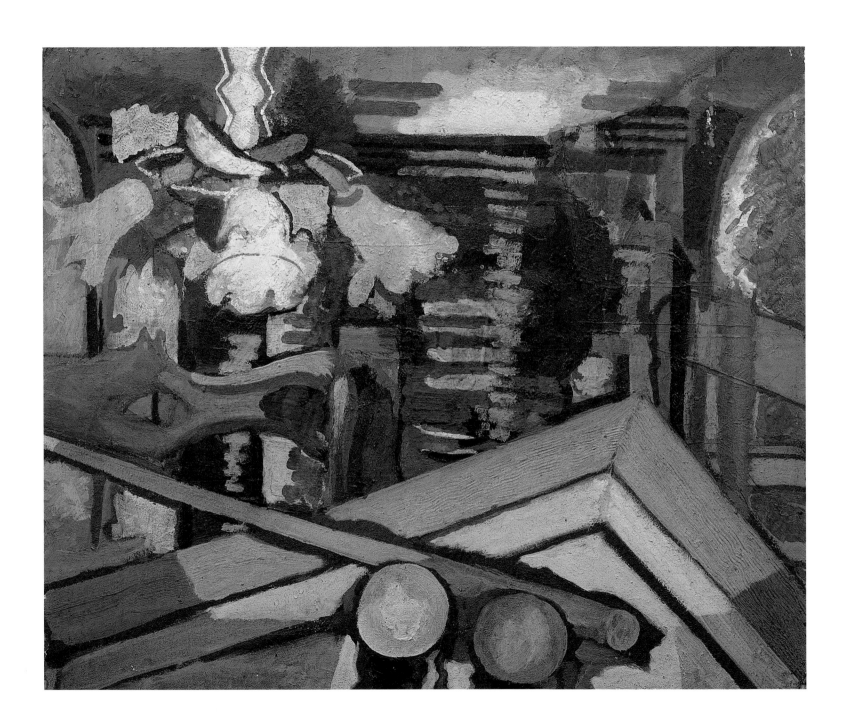

12 THE BILLIARD TABLE
Le Billard

1945
oil and sand on canvas
unsigned
89.5 × 116 cm
not in Maeght
Mr and Mrs Claude Laurens Collection

PROVENANCE
Collection of the artist

The configuration of the billiard table in this medium-sized version of the theme is close to that of *The Billiard Table* painted in the previous year (cat. 10). The outline of the easel form in the foreground is also found here. The background is quite distinct, however: an abacus stands in front of an open window, which replaces the lattice window of the earlier painting; a vase with plants on a small square table takes the place of the different vase and round table of 1944; a double lamp is suspended over the billiard table; a hat and checked scarf can be seen on the left, and below them what may be a music stand with either sheet music or a poster on it. It has been suggested that it could be the 'Loi sur l'Ivresse' (law on drunkenness) found on the walls of bars (Claude Laurens in conversation, 1990). The wall is insistently rectilinear, and the composition more crowded than the earlier work.

A heavily-worked related drawing (illustrated in e.g. Zurcher, 1988, p.185, plate 141, bottom drawing) includes a pot plant in the place of the vase and abacus.

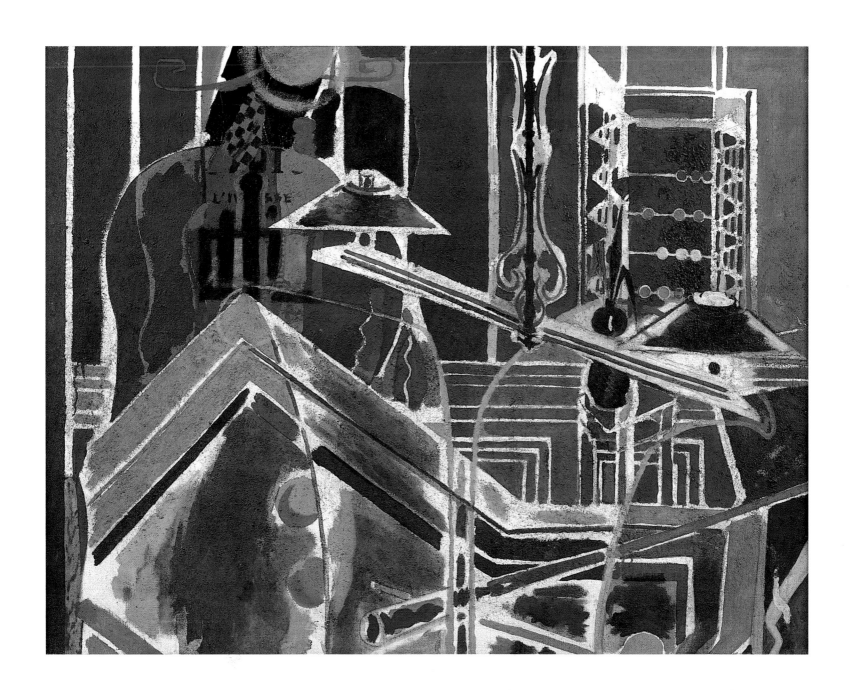

13 THE BILLIARD TABLE
Le Billard

1947–9
oil on canvas
signed
145 × 195 cm
Maeght 12
Museo de Arte Contemporáneo de Caracas
Sofia Imber

PROVENANCE
Aimé Maeght, Paris; Leigh B. Block, Chicago;
Galerie Louise Leiris, Paris

In September 1948 Braque explained to an interviewer, Alfred M. Frankfurter, that this painting, which he was then bringing to completion, was an attempt to suggest movement, the life of the objects, continuing beyond the canvas (Frankfurter, 1949, pp.35 and 56). This *Billiard Table* is the largest, most audacious and most glorious of the series, which had been interrupted by illness, and it was the last to be conceived. It belongs to the same world of metamorphic freedom as the late Studio paintings, and was completed in the year Braque began work on them. It also contains the bird motif that was to be so important in Braque's late works. Remarkably, a large bird is inscribed over the billiard table, as related sketches reveal.

The whole table is shown in the painting, as in the Gelman *Billiard Table* (cat. 13A, 1944–52), but it is viewed horizontally – as are the tables in cat. 10–12 – not vertically as in the Gelman painting.

Taking flight from the wallpaper on which they seem to originate as decorative motifs, a flock of birds advances towards the viewer in the Caracas *Billiard Table*, their wing-spans echoing the hinge of the table and their bodies rhyming with the balls. In fact the balls, placed like pieces of fruit, seem to take to the air with the birds. The composition pivots around the fiery red ball almost dead centre, and is intersected by the sweeping form of the dado-rail.

Of the three related drawings the first does not yet have the bird forms, although the wallpaper pattern is already suggestive of them; a small painting which hangs on the wall subsequently disappears (reproduced in Zurcher, 1988, p.194). The birds have been introduced to dynamic effect in a second related sketchbook drawing (cat. 13a) (Braque, *Carnets Intimes*, 1955, p.108, bottom). A chandelier (compare *The Billiard Table under the Light*, cat. 11) which is omitted in the painting can be seen here and in the last related drawing. The latter is drawn on tracing paper and is squared up in preparation for painting (cat. 13b). The outline of a large bird with outstretched wings can clearly be seen in the foreground of this drawing overlaying the billiard table and reaching right across the composition from edge to edge, and it is also there in the previous drawing where the wings seem to be represented in movement. Its curved contours complement the angular lines of the table. Traces of this bird, which is seen frontally, remain in the painting: the head and beak, for example, can be seen over the red billiard ball in the centre, and a wing-tip spills over the lower right edge of the table. This bird outline, which has never previously been pointed out, is analogous to the outline of the easel form found in the Billiard Tables of 1944 and 1945 (cat. 10, 12), with the two lyre-like points of the easel becoming the wings of the bird.

The painting is visible in a photograph of the studio taken by Maywald in 1948 (cat. 26a). Although Braque has already signed the painting, it is not quite complete: a colour notation ('Blanc') is written in the left-hand edge of the billiard table, and the floor area at the bottom left would be retouched. Two photographs by Fritz Henle dating from June of the same year show a very similar scene (New York, 1949, p.154). Writing in 1948–9, the American art historian Henry Hope described how Braque had been working on the painting through the summer and late autumn of 1948, 'slowly adding to the rich yellow green surface.' (New York, 1949, p.145)

The Billiard Table was shown together with five of the Studio paintings at Braque's Galerie Maeght exhibition early in 1950, as was *The Cauldron* (cat. 17).

13a Study for *The Billiard Table*, pencil on paper. Courtesy Archives Laurens.

13b Study for *The Billiard Table*, ink on tracing paper. Courtesy Archives Laurens.

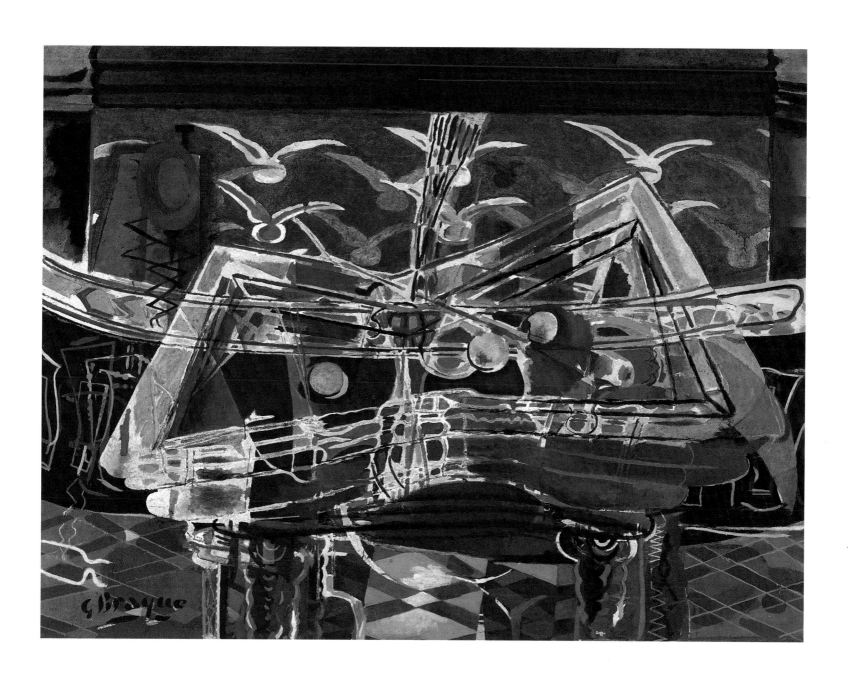

13A THE BILLIARD TABLE
Le Billard

1944-52
oil, sand and charcoal on canvas
signed
181 x 97.8 cm
Maeght 37
The Jacques and Natasha Gelman Collection

Not exhibited

PROVENANCE
Aimé Maeght/Galerie Maeght, Paris

Braque began this work in 1944 – the year in which he painted the first of the Billiard Table series (cat. 10) – but it was the last to be completed. As in the Caracas *Billiard Table* (cat. 13), the whole table is shown in this version, but here it is presented head-on in a vertical format. The imposing, upright table rears up on its sturdy legs; it is hinged across the middle and the top section – the far end – is folded forward towards the viewer with vertiginous effect. It is the most theatrical of Braque's treatments of the theme.

The first state of the painting can be seen in Brassaï's photographs of the studio in 1946 (cat. 3a). Braque returned to it in 1952, reworking the left-hand side in particular. He introduced the chair and table(?) and repainted the goldfish bowl on a tripod, very close to the painting of *L'Aquarium au verre* (Maeght 82) which is seen in Brassaï's photograph leaning against the easel below *The Billiard Table*. He also reworked the floor, treating it as if it were a flight of steep steps.

Three related drawings lie behind the painting. They appear on adjacent pages of a sketchbook (reproduced in e.g. Zurcher, 1988, pp. 189, 193). Two depict a window in the background, which in the painting became a framed picture or mirror; in the third drawing there is a view past a balcony to the open air. The goldfish bowl appears in one of the sketches and a slatted chair appears in all three. One shows a cue lying diagonally across the table. There is also a gouache sketch related to the painting, dominated by vivid blues (reproduced in Zurcher, 1988, p. 187).

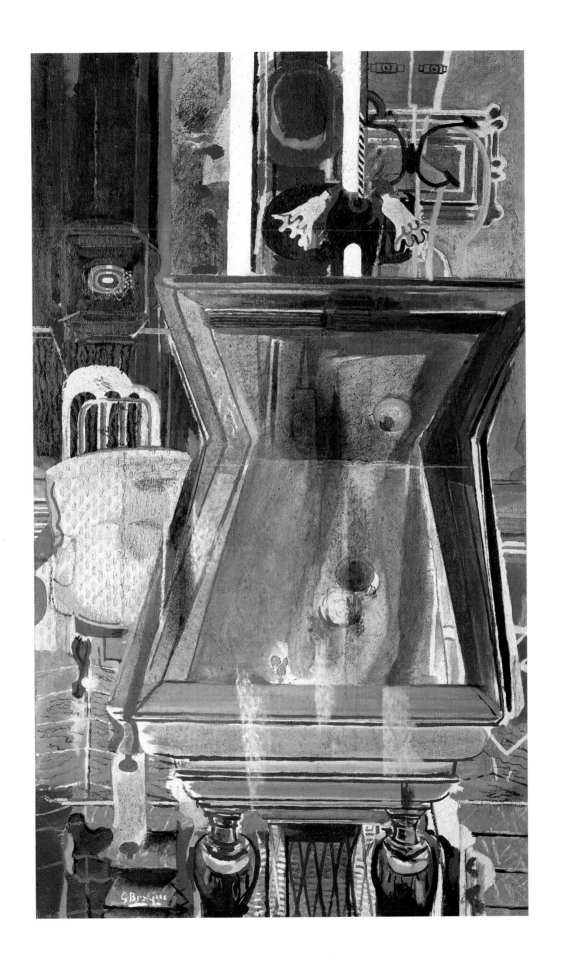

1945
oil on canvas
signed
130 × 97 cm
Maeght 94
Samir Traboulsi Collection, Paris

PROVENANCE

Aimé Maeght, Paris; Dr and Madame Soulas, Paris; sold Palais d'Orsay, Paris, 28 February 1978 (lot A); Perls Gallery, New York; Private Collection, New York; Andrew Crispo Gallery, New York; 1983, bought by Samir Traboulsi

Woman with a Book is one of a small number of figure compositions, mainly female, painted between 1942 and 1945, which also includes *La Patience* (1942, Maeght 1), *The Man with the Guitar* (cat. 37, largely painted in 1942) and *Femme à sa Toilette* (Maeght 95) of the same year as cat.14. They originate in the series of female painters and musicians in domestic interiors or studios of 1936–9, from which the first studio paintings developed in 1938. These modern muses were a homage to Corot's late studio paintings depicting female mandolin players seated at Corot's own easel, and also a recapitulation of the Cubist series of women with stringed instruments by Braque and Picasso, which were themselves indebted to Corot's figure paintings (see cat. 15a).[1] In cat. 14 the analogy is more precisely with Corot's young women reading (or holding books). Braque had previously painted the subject in 1911 (*Femme Lisant*, Beyeler Collection, Basel). In *Woman with a Book* the mandolin has been displaced to the table (or piano?) where it can be seen together with a pitcher and what may be the rounded top of an easel and the keyboard of a piano. Beyond are a patterned screen and a painting on the wall. The bold vertical line which divides the composition is not unprecedented in Braque's works and looks forward to the pleating of space found in the Studio paintings (cat. 19, 21).

Woman with a Book is characteristic of Braque's depersonalised, inanimate and hieratic figure paintings. Figures are relatively rare in Braque's work. He never painted portraits (except in his earliest works): the contrast with Picasso, for whom figures were always far more important, is very striking. Braque told Jean Paulhan that he lacked 'the assertiveness' to paint portraits: 'The portrait is dangerous.' (Paulhan, 1946, p.31) In 1952 he explained that his lack of any desire to do portraits was due to the horror he had always had of the presence of the model beside the work of art, and the danger such a confrontation implied for creative freedom. (Recorded by Marie-Alain Couturier, 1962, p.140)

This painting can be seen in a photograph of Braque's studio taken in 1947 and published in *L'Amour de l'Art* (cat. 14a), alongside *The Cauldron* (cat. 17).[2]

[1] Braque had a life-long admiration for Corot. In 1922–3 he had made a free study after Corot (*Femme à la mandoline*, Musée National d'Art Moderne, Paris). In 1930 he hung the Corot exhibition mounted in his dealer Paul Rosenberg's gallery. Two reproductions of Corot's female figures, including the *Portrait de Christine Nilsson*, 1874, can be seen in photographs of Braque's studio taken by Doisneau in 1957 (Limbour, 1957, p.28) and by Alexander Liberman (see cat. 15a).
[2] *L'Amour de l'Art*, 1947, p.216. Women reading appear in several sketchbook drawings of the period (Braque, *Carnets Intimes*, 1955, pp.97, 100: from the latter is derived the lacing down the front of the woman in the painting).

14a Braque's Paris studio with *Woman with a Book* and *The Cauldron* (cat. 17), from *L'Amour de L'Art*, 1947, p.216. Photograph courtesy Bibliothèque Forney, Paris.

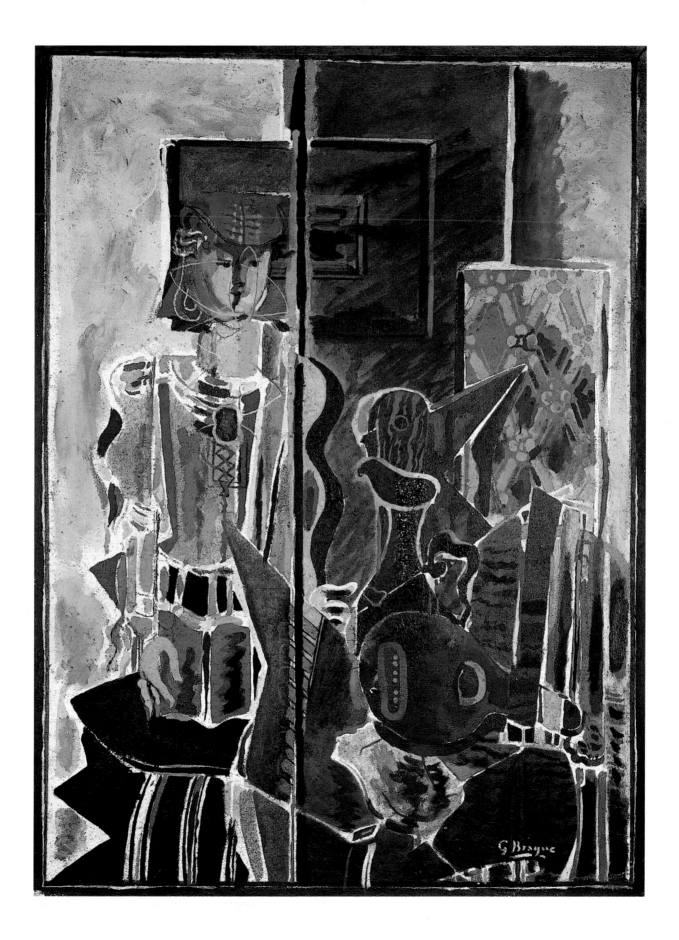

1946
oil and sand on canvas
signed and dated
105 × 105 cm
Maeght 106
Corporate Art Collection, The Reader's
Digest Association, Inc.

PROVENANCE
Aimé Maeght, Paris; Pierre Matisse Gallery,
New York; 15 May 1947, bought by The
Reader's Digest Association

On a visit to Braque's studio in 1946, the year
in which this work was painted, Anatole
Jakovski saw a 'large vase of old sunflowers,
the colour of dying embers' (Jakovski, 1946,
p.33). Other visitors such as Francis Ponge also
described the house and studio as full of wild
flowers, almost always including sunflowers,
and these are visible in photographs (Ponge,
1977, p.300). A vase of sunflowers can be
seen, for example, in photographs taken of
Braque's Paris studio in 1948 by Willy
Maywald (cat. 37a). Braque had begun to paint
sunflowers in 1943, and cat. 15 is the virtuoso
principal version of the series. He frequently
treated bouquets of flowers from the same
date, and two later examples are shown in the
exhibition (cat. 26, 28). Braque had previously
made a series of flower paintings in the mid-
1920s, chiefly of anemones.

The *trompe-l'oeil* frame of the *Sunflowers* is
complete with signature and date as if on a
label on the frame. The tablecloth spills over
onto the frame in its exuberance and throws
shadows over the frame, at once heightening
the reality of the still-life and drawing
attention to the conventions of painting.
Braque paid considerable attention to his
frames, sometimes painting them so that they
are an extension of the work (see cat. 25, 41,
42, 45).

When a journalist likened a vase of
sunflowers in Braque's house at Varengeville
to a van Gogh, Braque replied: 'We have to

honour our forebears!' (*France Illustration*,
1954, p.78) A reproduction of one of van
Gogh's sunflower paintings (*Vase with
Sunflowers*, 1889, Rijksmuseum Vincent van
Gogh, Amsterdam) is visible in photographs of
Braque's Paris studio taken by Doisneau and
Liberman (see cat. 15a). The pipe in cat. 15
can also be seen as a homage to van Gogh and
the pipe which stands in for him in *The Chair
and the Pipe* (1888–9, National Gallery,
London) painted at the same time as his
sunflower series. (Pipe and sunflowers are also
found together in Braque's first sunflower
painting, *Les Tournesols*, 1943, Maeght 64.)
Braque's own series of chair paintings, such as
La Chaise ([1947], Musée national d'art
moderne, Paris), is clearly indebted to van
Gogh's *Chair* (and its pair, *Gauguin's Chair*).
(See also *The Terrace*, 1948–61, cat. 38.)

Braque owned a late Cézanne flower
painting – a painter's Cézanne he called it –

the unfinished *Bouquet de pivoines dans un pot
vert* (c.1898, Venturi 748). He told John
Richardson that it was one of his treasures and
that he never tired of studying it. For him it
was 'perfectly resolved', not unfinished
(Braque, 1958, p.28). 'I have learnt more from
[Cézanne] than from anybody, and I continue
to do so.' (Braque, 1957, p.16)

The *Sunflowers* was shown at Braque's first
exhibition at the Galerie Maeght in 1947, as
were the 1944 *Billiard Table* (cat. 10) and the
Kitchen Table with Grill (cat. 8). Aimé Maeght
would be Braque's dealer for the rest of his
life. In his review of the exhibition, Raymond
Cogniat praised the combination of mastery
and liberty Braque had achieved. 'Such an
exhibition is worthy of a manifesto', he
argued, contradicting as it does the ideas of the
partisans of both realism and of abstraction.
(Cogniat, 1947, p.1)

15a Braque's Paris Studio. Photograph © Alexander
Liberman.

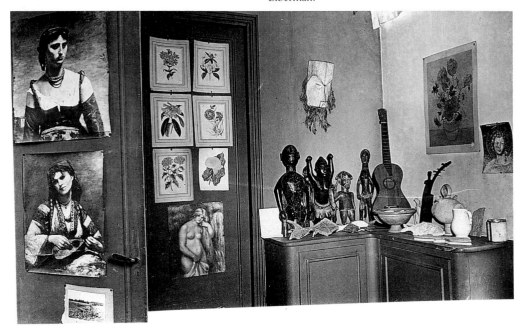

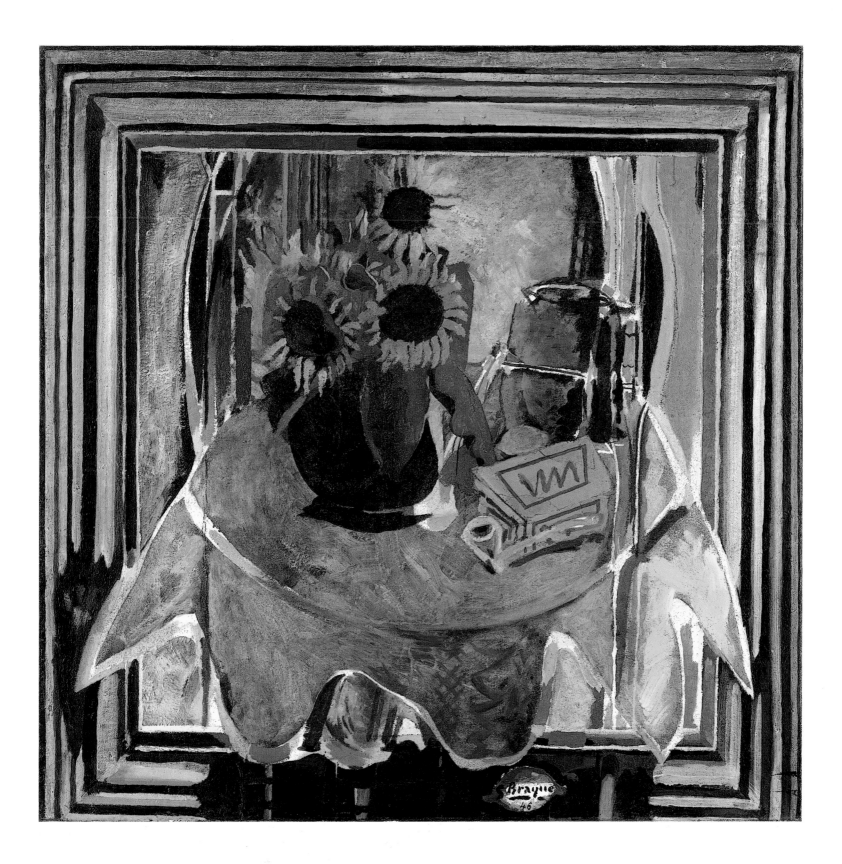

16 SAUSAGE
Le Saucisson

[1943–8]
oil on canvas
signed
23.5 × 34.5 cm
Maeght 52
Private Collection

PROVENANCE
Aimé Maeght/Galerie Maeght, Paris; Paul
Rosenberg & Co., New York; Georges Lurcy,
New York; sold Parke-Bernet Galleries, New
York, 7 November 1957 (lot 11), Lurcy Sale;
bought by Edward G. Robinson, Hollywood;
Knoedler Gallery, London

The spontaneity, directness and sensuous paint
quality of the *Sausage* recall Manet's late still-
lifes. It is an example of the small-scale cabinet
still-lifes of greater naturalism that Braque had
begun to paint alongside his larger works after
the First World War. In 1949 he explained
them to Patrick Heron as existing 'to express
direct emotion.' (Heron, 1958, p.5)

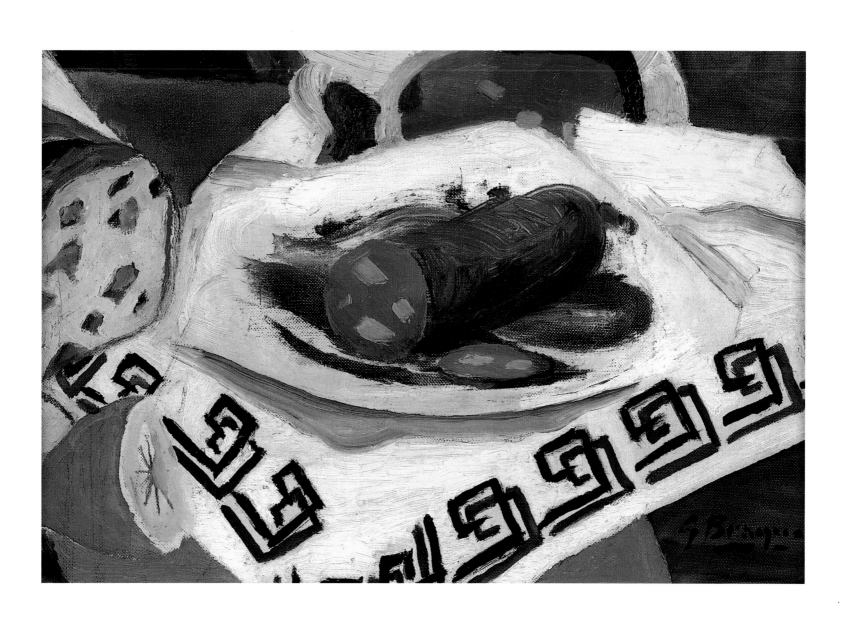

17 THE CAULDRON
 Le Chaudron

1947–9
oil on canvas
signed
116 × 69 cm
Maeght 13
Staatliche Museen zu Berlin, Nationalgalerie

PROVENANCE
Aimé Maeght/Galerie Maeght, Paris; 1968,
bought by Galerie Beyeler, Basel; 1971,
bought by Baukunst Galerie, Cologne; 1971,
bought from the Baukunst
Architekturgesellschaft mbH, Cologne by the
Nationalgalerie, Berlin

The Cauldron is one of the twelve paintings by
Braque that the poet René Char wrote about
in *Cahiers d'Art* in 1951, prefacing his remarks
with an apology to his friend for the act of
plagiarism, for turning paintings into words
('the poet's canvas!') (Char, 1951, p.146). Char
drew attention to the contrast of light and
shade in the painting: 'I love you, summer, for
providing the shadow for the greenery, closed
shutters for love, and beauty for your shaft of
sunlight that penetrates everywhere.'
 The Cauldron can be seen in progress in a
photograph of the studio taken by Rémy
Duval and published in *L'Amour de l'Art* in
1947 (p.216; cat. 14a). It was largely complete
by this date; Braque later added details such as
leaves, the white pot in the foreground
beyond the lemon and the table-leg in the
bottom right-hand corner. This evidence alters
the date usually given to the painting (1949).
The Cauldron is also partially visible in the Paris
studio in a photograph of June 1948 (see New
York, 1949, p.154). It can be seen alongside
Studio I, Studio II (cat. 19) and *Studio IV* in a
colour photograph taken by Felix Man in
1949 (see Man, 1954, n.p.). Photographs such
as Maywald's of 1948 (cat. 37a) give an idea of
the variety of vases, pots and vessels of all kinds
in the studio.
 The Cauldron is comparable with the
contemporary painting *Jeune Femme à la Palette*,

1948 (Leymarie, 1995, plate 32): compare the
vases of flowers, their curved contours, the
colouration and the play of light and shade.

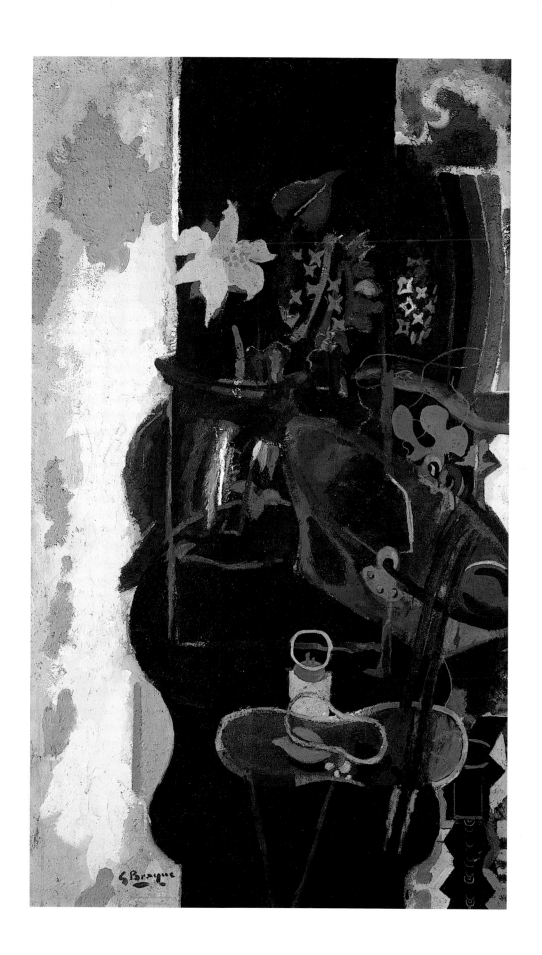

18 PROFILE AND PALETTE ON A DARK BACKGROUND
Profil et Palette sur fond noir

1949
oil on canvas
unsigned
100 × 65 cm
not in Maeght
Private Collection

PROVENANCE
Collection of the artist

This work has never previously been
exhibited, and was first reproduced only in
1995 (Leymarie, 1995, plate 92). A study for
Studio III (cat. 20), it shows the palette and
profile head also seen there. The profile head
of a woman inscribed in an oval resembles that
frequently found in Braque's engraved plasters,
for example *Tête* (1939, illustrated in Paris
(Leiris), 1982, plate 38), in painted plasters,
drawings and graphic works, for example an
etching for René Char's *Le Soleil des Eaux*
(1949, p.77). The most convincing reading of
the profile in *Studio III* and its study is perhaps
as one of the oval plasters. In a comparable
way, Braque included profile sculptures in
Studio II and *VI* (cat. 19, 22) which are derived
from his sculptures of female heads. These
profiles are all marked by archaic Greek art
and mythology, a profound source of
inspiration for Braque that was first manifest in
a series of etchings made in the early 1930s to
illustrate an edition of Hesiod's *Théogonie*.[1]

[1] The printing of the sixteen etchings was interrupted by
the death of Ambroise Vollard, who had commissioned
them; they were finally published by Aimé Maeght in
1955.

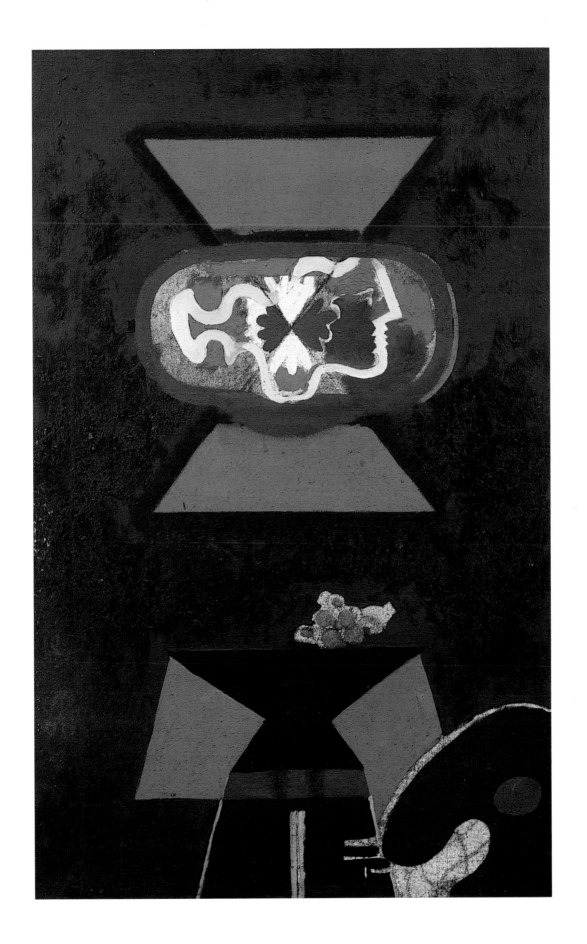

The Studio paintings are poetic transforma-
tions of Braque's own studios in Paris and
Varengeville. Both were built to his own
specifications. They were south-facing,
unusually, since Braque preferred the varied
light from the south. The light was filtered
through off-white cotton curtains and white-
washed windows (fig. 19). The Paris studio
occupied the top floor of Braque's house; at
Varengeville the studio was in the garden.
When his original studio there became too
small, Braque built a new one next to it in
1949–50. He also had separate sculpture
studios in each place. The painting studios
were very large rooms, and Braque employed
the same strategies to break up and modify the
space in each, using screens behind paintings
and large curtains strung across the corners.
The articulation of space in *Studios II*, *IV* and *V*
may owe something to the pleats of the
curtains and the hinges of the screens.

A sense of order governed the arrangement
of objects in the studios. Braque's huge
collection of paintbrushes was meticulously
organised, many placed like bouquets in vases
and pots (see fig. 21 and cat. 37a). From tree
trunks and branches found near the
Varengeville house he made palette stands,
lecterns for displaying his sketchbooks, and
chairs. Found objects from the beach and fields,
for example stones, pieces of wood and bones,
were present, as were wild flowers and plants
such as philodendrons. The poet Francis Ponge
likened the studio to a greenhouse; many
beautiful, luxuriant plants grew there as well as
paintings, and Ponge saw this as proof of
Braque's magic power. (Ponge, 'Braque-Japon',
1952) On the wall of the Paris studio Braque
had what may be an Asmat shield from the
south coast of Irian Jaya (see cat. 37a).[1]

19. Braque at work in his Paris studio, 1946.
Photograph © Brassaï, courtesy Archives Laurens

Above all the studio was dominated by Braque's paintings, on easels, leaning against the walls and propped up on the floor with the iron stands he made himself. He kept this work in progress constantly in his view, working on a number of canvases at once. This way of working encouraged interrelationships between works to multiply. Braque would rearrange the paintings in the studio frequently. Finished works which he wanted around him for reference would also be on view. He would often begin paintings in one place – Paris or Varengeville – and transport them rolled up on the roof of his car to the other studio to continue work on them. 'I take years to finish them', Braque told Dora Vallier, 'but I look at them every day. Arranged as they are, one next to the other, I have them constantly in front of me, I confront them.' (Vallier, 1954, p. 21) To the painter Jean Bazaine he said: 'I am, in the middle of my canvases, like a gardener among his trees: I trim, I prune, I guide ...' (Bazaine, 1943, p.1)

20. Braque's Paris studio with *The Echo* (cat. 32). Photograph by Gene Fenn, courtesy Archives Laurens.

21. Braque's Paris studio: brushes. Photograph © Alexander Liberman.

[1] The painted and incised design does not correspond to anything in the literature although it is Asmat in appearance. Braque also owned a ceremonial board from the Papuan Gulf (see Doisneau's photograph of Braque in the Varengeville dining room; *Le Point*, 1953, p.21). I am very grateful to Michael O'Hanlon of the Museum of Mankind for his assistance on these objects.

1949
oil on canvas
signed
131 × 162.5 cm
Maeght 8
Kunstsammlung Nordrhein-Westfalen,
Düsseldorf

PROVENANCE
Aimé Maeght/Galerie Maeght, Paris;
Collection Niarchos, Paris;
Collection Embiricos, New York; Knoedler
and Co., New York; 1964, bought by the
Kunstsammlung Nordrhein-Westfalen,
Düsseldorf

In this second painting in the series of Studios executed between 1949 and 1956 Braque introduced the bird which would appear in six of the eight works. It was not a real bird but a painted one which appeared in a large work, subsequently destroyed, which was in the studio when Braque was working on the series. This idea had been prefigured in a work of ten years earlier, *L'Atelier au Tabouret* (1939, 113 × 146 cm, Maeght 59), in which a painting of a bird in flight can be seen on the easel. The painted bird in the late Studio pictures rarely seems confined to its canvas, however, freeing itself to fly across the studio, always from right to left (see especially *Studio VIII*, cat. 23). Braque commented: 'All my life, my great preoccupation has been the painting of space and, by its very nature, a bird in flight conjures up and animates the spatial element and somehow makes it more real. However, don't imagine that there was anything systematic or self-conscious about the inclusion of a bird ... I did not introduce the bird for the sake of an effect; it just materialised by itself; it was, one might say, born on the canvas.' (Braque, 1958, p.26)

In *Studio II* there appears to be a second, smaller bird flying alongside the large one (compare *In Full Flight*, cat. 39). Photographs by Felix Man show the painting in Braque's Paris and Varengeville studios (Man, 1954).

The sculpted head of a woman seen beside the palette in *Studio II* and in *Studio VI* – comparable to the profiles in *Profile and Palette on a Dark Background* and *Studio III* (cat. 18, 20) – relates to sculptures by Braque such as *Hesperis* (1939) and *Aeglé* [1939], both carved in chalk and then cast in plaster and later in bronze (see Fumet, 1951, plates 4 and 7). Before making these sculptures, Braque had included female sculpted heads in several paintings, notably in one of the early studio paintings of *c.*1938–9, known only from a photograph (see Bowness, 1995, plate 214). These sculpted heads take the place of the female painters who occupied the early studio interiors. (There is often ambiguity over the nature of Braque's female presences, whether real, sculpted or painted: compare *Le Salon* and *The Man with the Guitar*, cat. 9, 37.)

Braque described the challenge presented by the subject of the studio to André Verdet: 'It took a lot of perseverance to hold such a heterogeneous collection together. Studios are always cluttered, full of things, teeming with objects. In my painting I was assailed on all sides by these different objects and the different planes they created ... The objects all at once developed lives of their own, each one different, none matching the next one. But my ultimate aim was a unified painting, not one of disparate parts.' (Verdet, February 1962)

In each of the Studio paintings the same objects recur: palettes, paintbrushes, easels, paintings, sculptures, vases, jugs, bowls and other vessels, plants, lights, tables, chairs. The studio is a place of metamorphosis: identities are malleable and many forms are equivocal or indeterminate. Braque said he sometimes liked to incorporate 'an accident or a "rhyme" into a painting', 'forms which have no literal meaning whatsoever.' (Braque, 1957 and Braque, 1958, p.30) Examples of such non-representational forms include, in *Studio II*, the arrowhead in the foreground or the diamond-shaped outline on the right, and the two white triangles in *Studio VIII* (cat. 23).

Looking back on the Studio series Braque commented: 'My series of *Studio* paintings continues to obsess me, these paintings of interiors represented a tremendous immersion in myself. As I painted them I was gripped by a kind of jubilation . . . I was in the happy state of someone to whom is revealed the harmony of objects between themselves and with man. The objects faded away, leaving me with the imprint, the echo of their poetic relationships. They no longer existed. My work was enlightened and it enlightened me. Everything became simple and full of meaning.' (Verdet, 1978, p.24)

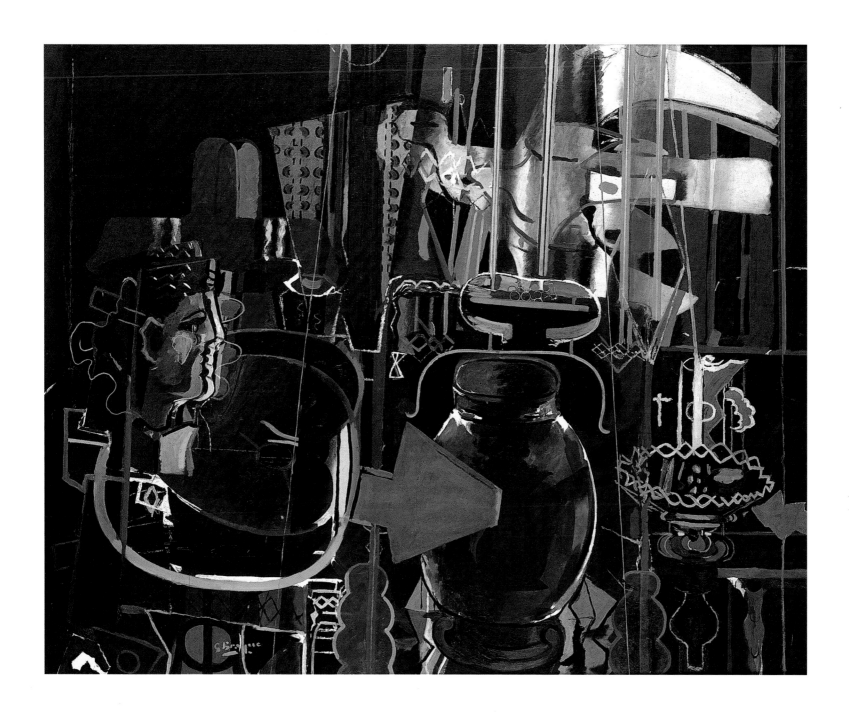

Studio III [also known as IV and V]
Atelier III

1949
oil on canvas
signed
130 × 74 cm
Maeght 11 (there named *Atelier V* and
illustrated in an unsigned state)
Lent by the Estate of Florene M. Schoenborn

PROVENANCE
Aimé Maeght, Paris; 1950, bought by Florene
M. and Samuel A. Marx, Chicago (Samuel
Marx died in 1963 and his widow Florene
later married Wolfgang Schoenborn)[1]

Braque considered that this painting and *Studio
I* (J.-P. Guerlain, Paris; 92 × 73 cm) stood
somewhat apart from the Studio series. With
their narrower focus and vertical formats, they
are also the only two not to feature birds.
Studio III represents a detail of the studio with,
in the foreground, sheet music for a 'SONATE'
(recalling Cubist lettering and other 'sonatas'
inscribed in Braque's paintings, such as that in
Femme à la Guitare, 1913, Musée National
d'Art Moderne, Paris); beside it are a glass, a
table or chair with a checked pattern, a palette
and brushes and a jug. On the left an electric
light projects from the wall which relates in
form to a light in Braque's Varengeville studio
(cat. 20a): a comparable light is found in *Jeune
Femme à la Palette* (1948). At the top are a
profile head as in the study (cat. 18) and above
it a small painting (or perhaps a mirror). A
preparatory sketchbook drawing for the
painting was reproduced for the first time in
1995 (Leymarie, 1995, plate 91).
 All the Studio paintings with the exception
of *Studio VIII* are predominantly sombre in
colour. Occasional bright accents punctuate
the dominant browns, greys and blacks. These
restricted colours – and the passages of brick-
like broken brushstrokes – recall Cubist
paintings; Braque explained that because he
was preoccupied with complex problems of
space in his Cubist researches, colour would
have been a distraction and a disturbance

(Vallier, 1954, p.16). This applied equally to
the Studio paintings. There was also what
Braque described as a muted note in the light
of the studio.
 Considerable confusion exists over the
numbering of the third, fourth and fifth Studio
paintings.[2] Braque worked on them
contemporaneously during 1949, so that in a
sense placing them in a sequence is not
relevant. Here we follow the numbering on
the backs of the paintings.[3]

[1] I am grateful to Ida Balboul of the Metropolitan
Museum of Art for her assistance concerning this painting.
On the reverse is what appears to be a landscape,
abandoned by Braque.
[2] For example the numbering used when the paintings
were first exhibited at the Galerie Maeght for ten weeks
from 10 February 1950 was not followed by the Maeght
catalogue of Braque's 1948–57 works, published 1959.
(The exhibition has often been dated erroneously January–
February 1950.)
[3] The number is visible on the reverse of Paul Sacher's
painting, *Studio IV* (130 × 195 cm, also known as number
III) in two of Doisneau's photographs of the studio in 1953
(*Le Point*, 1953, pp.7 and 18). *Studio III* and *V* (cat. 20, 21)
are likewise numbered in capital letters on the middle
crossbar of the stretcher in the same hand as *IV*. The
numbering used in the present catalogue is that used by
Douglas Cooper, 1972, and for the Braque retrospective at
the Orangerie des Tuileries, Paris, in 1973–4.

20a Braque's studio at Varengeville. Photograph ©
Alexander Liberman.

[1949–50]
oil on canvas
signed
145 × 175 cm
Maeght 9 (there named *Atelier III* and dated
1949)[1]
Private Collection

PROVENANCE
Aimé Maeght/Galerie Maeght, Paris; bought
c.1953 by Dr Paul Hänggi, Basel/Vaduz; by
descent; Christie's, London, 27 June 1994 (lot
34)

Studio V, the most complex of the series,
relates to *Studio II* (cat. 19) in its pleating of
space by means of a series of vertical lines, in
its treatment of the bird, and in the presence of
areas of the same pattern, perhaps on a screen
or hanging (there is also a fragment of it in
Studio IV; see fig. 1). In their use of pattern and
of black, both recall works painted by Braque
against black backgrounds after the First World
War, such as *Nature morte au compotier (Le
Radical)* (1918, Kunstmuseum Basel). In *Studio
V* the forms of the palette and of the bird
rhyme with one another, a poetic relationship
which Pierre Reverdy had observed in
conversation with Braque on the eve of the
opening of the 1950 Galerie Maeght
exhibition at which the first five Studios were
first shown. In a preparatory sketch for *Studio
V* (cat. 21a, 18.5 × 23.5 cm), the bird can very
clearly be seen to be a painted bird on a
rectangular canvas on an easel: in the painting,
this rectangular form is much less evident but
can still be picked out (the tip of the bird's
beak touches the left-hand edge, for example).
In addition to the easel which can be seen in
the foreground behind the palette, the form of
a second easel is suggested traversing the body
of the bird (both in front of and behind it),
comparable to those in *Studio II, Studio IX* and
Composition with Stars (cat. 19, 24, 34).
 On the lower right is a goldfish bowl with
fish (or one fish reflected), the subject of a

series of contemporary paintings (see cat. 25).
The blue of the water provides the brightest
points of the painting. Small areas of bare
canvas can be seen here. The table on which
the bowl is placed has been combed to suggest
wood-graining. A ruler lies on the table,
echoed by another beyond. On the left a vase
can be seen on a distinctive table with curved
legs such as that in *Le Guéridon rouge*
([1939–52], Musée National d'Art Moderne,
Paris).

1 *Studio V* was dated 1950 at the Galerie Maeght
exhibition which opened on 10 February 1950 (catalogue
published in *Derrière le Miroir*, nos 25–6, January–February
1950). However, the date 1949 has often been given to
the painting. It seems most likely that the painting was
begun in that year and completed at the beginning of 1950
in time for the exhibition. It was reproduced in *Cahiers
d'Art* in 1950 (p.391).

21a Study for *Studio V*, pencil on paper. Courtesy
Archives Laurens.

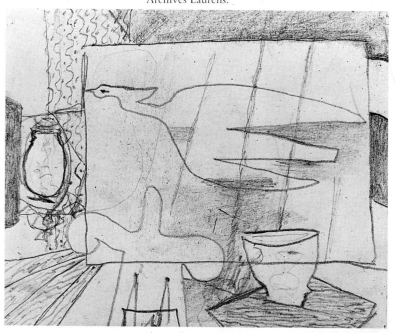

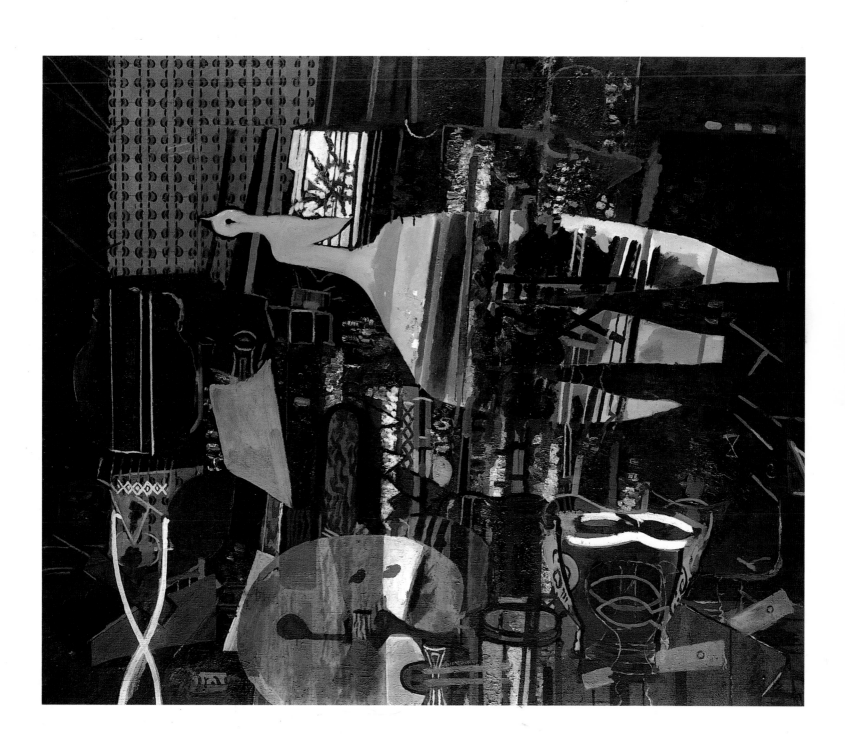

[1950-51]
oil (and sand?) on canvas
signed
130 × 162.5 cm
Maeght 29
Fondation Marguerite et Aimé Maeght,
Saint-Paul

PROVENANCE
Aimé and Marguerite Maeght; 1973, given by
them to the Fondation Maeght

The space in *Studio VI*, no longer articulated by
vertical lines, dissolves the objects in the
studio, for example the large amorphous
palette in the foreground.[1] Beside this Braque
has placed a copy of his *Cahier*, the recently
published book of his reflections and
aphorisms: the lettering in the painting
resembles that on Braque's cover lithograph
for the book (compare the word 'Sonate'
inscribed in *Studio III*, cat. 20). A sculpted head
of a woman, related to his own sculptures, can
be seen next to the palette as in *Studio II* (cat.
19). The rounded forms of vessels of different
characters occupy the space beyond, together
with canvases and two hanging lights. The
ravishing sombre palette of the painting is
illuminated by several touches of brilliant
colour, especially the two touches of pink on
the vase beside the sculpted head, and the blue
flower-pattern on the hanging lampshade at
the top of the composition. The surface of the
painting is textured with sand or grit and
(brush) hairs. The dimensions of *Studio VI* are
the same as those of *Studio II*.

The painted bird can be seen behind the
easel, now headless, its leg visible between the
easel's supports. It is loosely related to the
canvas form visible beyond it. A small white
naturalistic bird perches on the easel. Braque
described its purpose as bringing an element of
surprise to the painting, as with the bird he
would later add to the corner of *In Full Flight*
(cat. 39). This white bird arrived naturally,
Braque said. Asked whether, being so real, it

didn't claim all the viewer's attention, Braque
replied: 'It's the shock of the song…I wanted
everything to radiate from this bird, as
everything might radiate (in a similar painting)
from a star, the moon, the sun. At first you
only see the bird … Then your gaze spreads
outwards, beyond its light … and absorbs the
principal star. The song of its light floods the
painting. The painting finally becomes a song.'
(Verdet, February 1962)

This work is generally dated 1950–51;
however John Richardson dated the painting
1949–52 in 1955 and it was dated 1952 when
first exhibited (Galerie Maeght Braque
exhibition of 1952; catalogue published in
Derrière le Miroir, Braque issue, nos 48–9,
June–July 1952).

[1] John Richardson first described the space as liquid
(Richardson, 'The Ateliers of Braque', 1955, p.169).

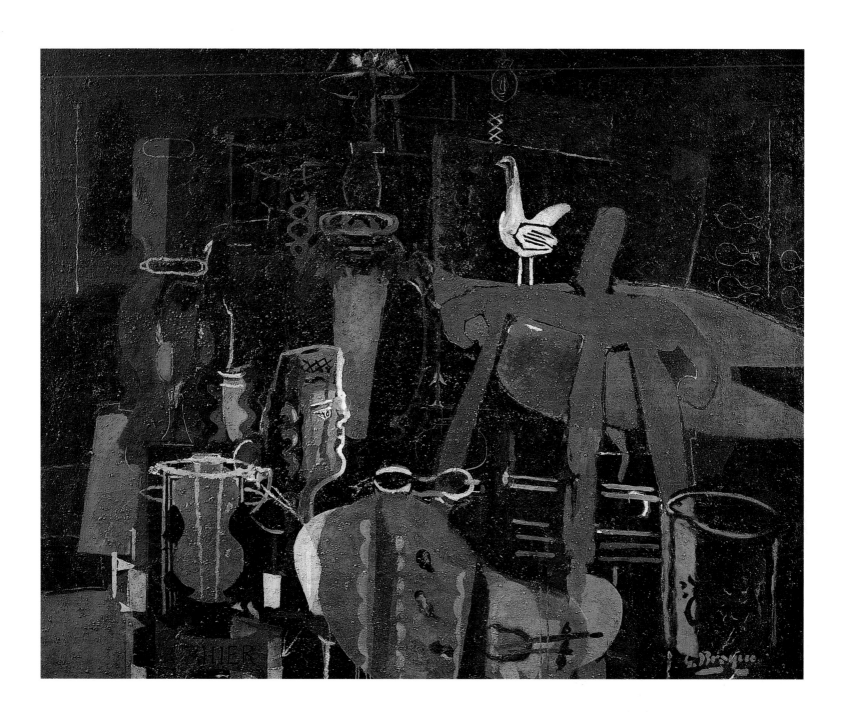

1954-5
oil on canvas
signed
132 × 197 cm
Maeght 93
Collection Masaveu, Oviedo

PROVENANCE
Aimé Maeght/Galerie Maeght, Paris; August 1955, bought by Douglas Cooper; William McCarty-Cooper; sold Christie's, New York, 11 May 1992 (lot 43); private collection, Madrid

Braque said that he had attempted 'to put all the discoveries of his lifetime into this picture' (Edinburgh, 1956, p.50). The progress of the painting, the largest of the Studios, was recorded by John Richardson in the unique account that he published in *L'Oeil* in June 1955 before *Studio VIII* was completed. The painting is brilliantly coloured, quite different from the other Studios in this respect, and Richardson related this to Braque's experience of designing stained-glass windows for the chapel of Saint-Dominique in Varengeville in 1953, which brought an interest in the luminous properties of colour and the simplification and accentuation of forms.

Shortly after completing the Varengeville windows, at the beginning of 1954, Braque began *Studio VIII*, preparing his canvas with a greyish priming. He worked from a coloured sketchbook drawing with colour notations of 1953 (cat. 23a). The basic composition is already established in the drawing, structured around the three rectangular forms of, on the left what will be the back of a vertical canvas in red (ambiguous in the drawing), in the centre a yellow table and on the right a horizontal red canvas. A photograph taken by Mariette Lachaud shows the painting at an early stage when it was still close to being a transcription of the drawing.

Richardson records that Braque continued to work on the painting during 1954 in both Paris and Varengeville. A colour photograph appeared in *Paris-Match*, 5–12 June, p.39. In the course of the year the flowers in the vases on the central table were suppressed. A complex still-life, barely indicated in the drawing, developed in the foreground, including dishes of cherries and apples, a bunch of grapes, a palette and brushes and a bottle. The cog-like object on the left perhaps derives from the wheels of Braque's sculpture *Cheval et Charrue: Les Travaux et les Jours* ([1939–40], cast in 1955), which photographs show in the studio. The two arbitrary white triangles in the centre act as a counter to the leftward flight of the bird. They appear to originate in the jagged edges of the large table in the preparatory drawing.

Photographs taken for the 1954 Christmas issue of *France Illustration* show *Studio VIII* in the Varengeville studio (cat. 23b): Braque would continue to elaborate the foreground, but the painting was far advanced. A colour reproduction of the work nearing completion, taken in March 1955, accompanied Richardson's *L'Oeil* article (pp.24–5). A comparison with the finished work shows that Braque made few changes: for example he painted over some of the white chalk lines in the central area around the vases and yellow table, and he signed the picture. He deliberately left the area of these vases sketchy and transparent in contrast to the rest of the painting (Braque, 1958, p.28).

The work was finished that summer and bought in August by Douglas Cooper, scholar of Braque and champion, with John Richardson, of *Studio VIII*, which was in their opinion the most audacious and culminating work of the Studio series.

The white bird which presides over the composition, detached from its red canvas, relates closely to several others alongside which it was painted: the bird in *Studio VII*, before it was reworked as *Studio IX* (cat. 24); one of the pair painted as a mural decoration for Aimé Maeght's house at Saint-Paul-de-Vence, the *Mas Bernard* (1954, Maeght 89); and *The Bird and its Nest* (cat. 31).

23a Study for *Studio VIII*, 1953, oil, watercolour and pencil on squared paper. Courtesy Archives Laurens.

23b Braque's studio at Varengeville with *Studio VII/IX* and *Studio VIII*. Photograph taken by Henri Parnotte for *France Illustration*, but not published, courtesy Archives Laurens.

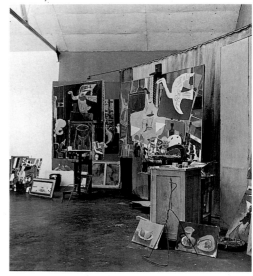

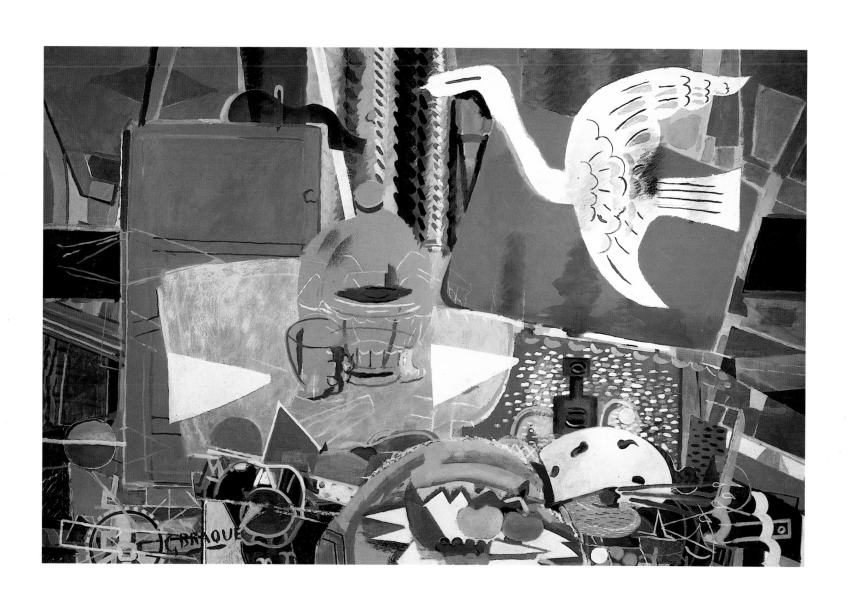

[1952–6]
oil on canvas
signed
146 × 146 cm
Maeght 104
Musée National d'Art Moderne, Centre
Georges Pompidou, Paris, dation (1982)

PROVENANCE
Aimé Maeght, Paris; Paule and Adrien
Maeght, Paris; 1982, given by them to the
Musée National d'Art Moderne in lieu of
death duties

Although it originated in a drawing of 1949,
Studio IX was the last of the Studio series to be
completed. It was, however, begun before
Studio VIII (cat. 23) in 1952 and 'completed'
and signed in 1953, becoming known as *Studio
VII*. Braque subsequently took it up again,
reworked it and exhibited the finished painting
in 1956 as *Studio IX*. *Studio VII*, the first state of
Studio IX, is therefore known only from
photographs, some of which are in colour.
Braque transported it between his Paris and
Varengeville studios, and it can be seen in
different stages of composition in Robert
Doisneau's photographs of both studios taken
in 1953 (see *Le Point*, October 1953, pp.7, 17,
18–19). Doisneau's Paris photographs were
taken on two visits, as is evident from the
different arrangements of the paintings in the
studio. The Varengeville photographs were
taken last – the clearest development is that the
bird's plumage is now differentiated. Liberman
also photographed the painting in this year in
the Varengeville studio shortly before
Doisneau (cat. 24a and frontispiece).

There are two preparatory sketchbook
drawings for *Studio VII* (cat. 24b and Leymarie,
1995, plate 98). Cat. 24b dates from 1949, the
year in which Braque painted the first Studios;
it is particularly close to the painting. The
large vase in the foreground and the bird in
flight beyond are painted images on two
canvases within the painting. On the left are

an easel (only part of which was depicted in
the painting), the sculpted head of a woman
(cut off at the edge of the painting, so that
only the jagged shape of her profile was
visible),a palette (flesh-coloured and sensual in
form) and brushes and a pot of flowers.

Cat. 23b shows the painting in the
Varengeville studio at the end of 1954
alongside *Studio VIII*: since the previous year
Braque had worked on the large vase in the
foreground and slightly modified the lower
right-hand corner. This is the beginning of the
transformation from *Studio VII* to *Studio IX*. In
an article published in June 1955 in *The
Burlington Magazine*, John Richardson noted
that the central area beneath the bird was the
first to be reworked. At the time of writing,
the major change which the painting
underwent – the fracturing of the bird, for
which Braque made a drawing (1953;
Leymarie, 1995, plate 99) – had not yet
occurred. In the completed painting the
pointed and cruciform structure of an easel
seems to impale the bird (compare especially
the easel in *Composition with Stars*, cat. 34, a
painting which was elaborated in part in the
same years). The bright yellow and orange
faceted forms (like shafts of light) and the
fracturing have been related to Braque's work
on stained glass in 1953. Having painted over
his original signature below the bottom right
edge of the large vase, Braque added a new
one in red over the plant. It is much less
evident in *Studio IX* that the large vase is a
painting within a painting: its status, 'real' or
painted, is equivocal. This vase and the smaller
dish within it are analogous to the similar large
vase with shadowy vessel within its contours
found in the foreground of *Studio II* (cat. 19).
Studio IX is the only one of the Studio series
with a square format.

24a Braque's studio at Varengeville with *Atelier VII/IX*
and *Ajax*. Photograph © Alexander Liberman.

24b Study for *Studio VII*, watercolour, oil, brown
wash and pencil on squared paper. Courtesy
Archives Laurens.

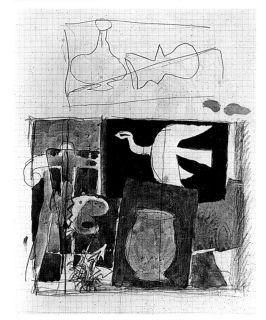

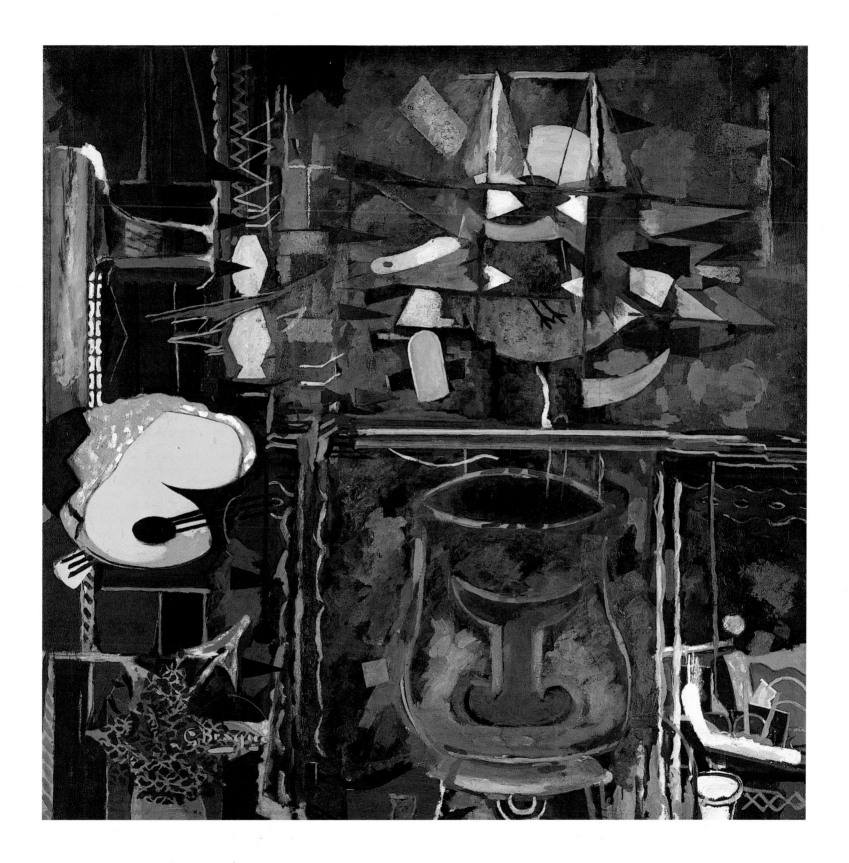

THE GOLDFISH BOWL
L'Aquarium (Les Grands Poissons)

[1948-51]
oil on canvas
unsigned
62 × 81 cm
not in Maeght
Private Collection

PROVENANCE
Collection of the artist

The motif of the goldfish bowl is found in Braque's work from 1944, either as the subject of the painting as here, or as an element in the composition, as in *Studio V* (cat. 21). It developed out of the still-lifes with fish, such as cat. 6 and 8, and reflected Braque's interest in painting vessels of different sorts (compare the bowl in *The Double Bouquet*, cat. 26). The striated fish of cat. 25 and a related work, *L'Aquarium* [1948–51], are the painted counterparts of Braque's incised sculpture *Poisson* ([1942], 35.5 cm in length), analogous to the sculpted heads Braque included in several of the Studio paintings. Brassaï's photograph of the studio in 1946 (cat. 3a) shows two bronze casts of this schematic fish – placed one in front of the other as in cat. 25; above is one of the first goldfish bowl paintings (Maeght 82) and the 1944–52 *Billiard Table* (cat. 13A) painting in progress, here with the goldfish bowl on a tripod which was later overpainted. Jean Paulhan described this scene exactly: 'As soon as they are placed on the ground, these two bronze fish … wriggle and swim, looking for all the world as if they were in their element. "Look, I've sculpted water"', Braque told him triumphantly (Paulhan, 1946, p.40). The paradox of this transformation is doubled in *The Goldfish Bowl*, in which the stripes of the painted fish translate the patterns of incisions made in the very two-dimensional sculpture of the fish. The fish is first found in several incised plasters made by Braque in 1939.[1]

Braque playfully sets the flatness and angularity of the pair of fish (which seem to swim in front of the bowl on the picture plane itself) against the volume of the water and roundness of the bowl. These large striped fish are contrasted with the small, more naturalistic spotted fish in the bowl. The painting has a five-band painted frame made by Braque that complements the colours of the painting and is an extension of it. *The Goldfish Bowl* seems originally to have been a larger painting that Braque subsequently cut down. It is just visible in a photograph of the first Varengeville studio taken *c.*1948 (reproduced in Bellony-Rewald and Peppiatt, 1983, pp.156–7) as part of what appears to be a larger, vertical canvas that Braque later cut the top off.

[1] See the engraved plaster of the fish visible in the photograph of the Varengeville studio reproduced in Zervos, 1940, p.4 (top photograph); and the fish on the *Fragment de vase gravé et peint* seen in the photograph beneath, which simulates the appearance of archaic Greek ceramics (it is reproduced in colour in Zervos, 1960, plate XVII).

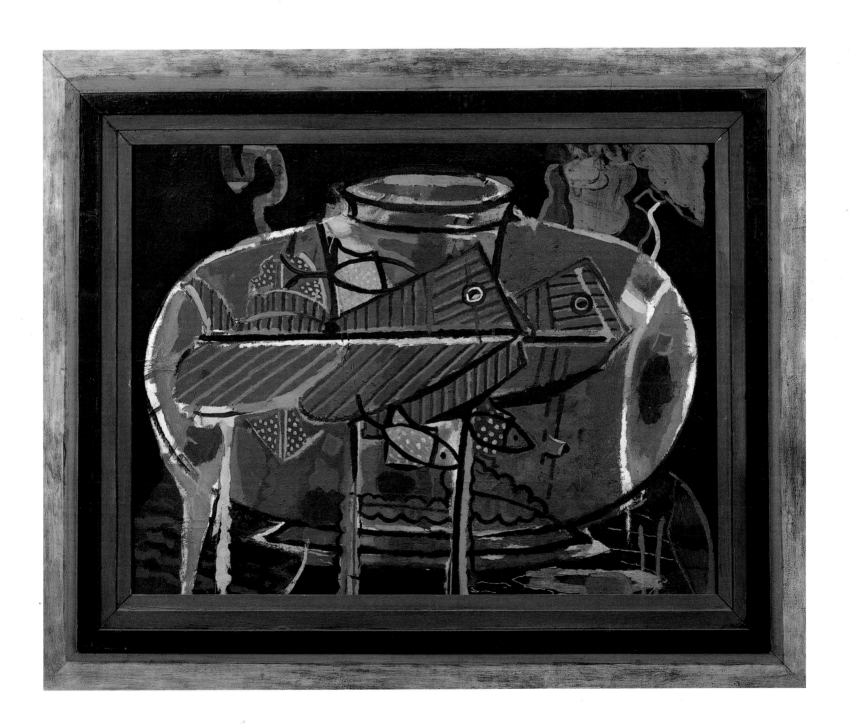

THE DOUBLE BOUQUET
Le Double Bouquet

[1948–52]
oil and sand on canvas
signed
100 × 100 cm
Maeght 42
Galerie Jan Krugier, Geneva

PROVENANCE
Aimé Maeght, Paris; Charles and Genia
Zadok, New York; Marlborough Fine Art;
sold Sotheby's, New York, 10 May 1988 (lot 43)

The Double Bouquet was largely completed in
1948 when it can be seen in several
photographs of Braque's studio, one taken in
June of that year in which it is visible on an
easel next to a vase of flowers (see New York,
1949, p.154) and another taken by Willy
Maywald (cat. 26a; in both photographs *The
Billiard Table* of 1947–9 also appears, cat. 13).

The poet René Char chose *The Double
Bouquet* as one of the twelve works he wrote
about in *Cahiers d'Art* in 1951: 'Side by side,
faithful opposites, yet within the same realm.'
(p.144) In the article the painting was
reproduced with the date 1950 (p.149):
Braque had made some modifications to the
left half, for example adding the diagonal
strokes to the upper part, and the work is now
very close to its final form. It is already signed.
The final touches were probably added in
1952, in preparation for the exhibition that
summer in which the painting was first shown.

The two contrasted representations of still-
lifes of flowers in this diptych draw attention
to the nature of painting, as do, in a different
way, *Sunflowers on the Table* (cat. 15).[1] An
important colour lithograph was derived from
the right-hand vase with its broad-leafed plant,
Feuilles, couleur, lumière of 1953–4.

Giacometti was particularly moved by
Braque's flowers. 'Why oh why do we find
these flowers so marvellous?' he asked at the
end of the piece he contributed to the Braque
special issue of *Derrière le Miroir* in June–July
1952. Here he described how he was drawn to

'this unknown factor, for me a feature of all
Braque's latest paintings, that is their great
attraction. They attract me because they are
profound likenesses, with the marvellous
resemblance that is shared by all the painters I
most admire …'.

His essay accompanied the 1952 Braque
exhibition at the Galerie Maeght (his third
there) which included this painting, *Studio VI*
and *The Two Windows* (cat. 22, 27).

[1] Compare the diptych-type pencil drawing in Braque's
Carnets Intimes, 1955, p.133, which juxtaposes a similar
vase and bowl. The fish in the bowl here resemble those
in *The Goldfish Bowl* (cat. 25).

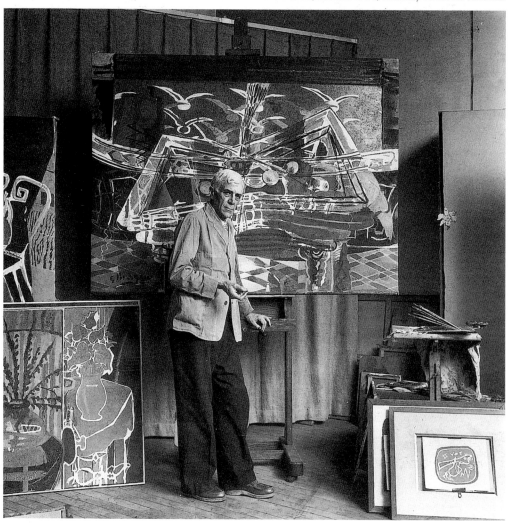

26a Braque in his Paris studio, 1948, with *The
Billiard Table* (cat. 13) and *The Double Bouquet*.
Photograph © Assoc. Willy Maywald/ADAGP, Paris
and DACS, London 1997, courtesy Archives Laurens.

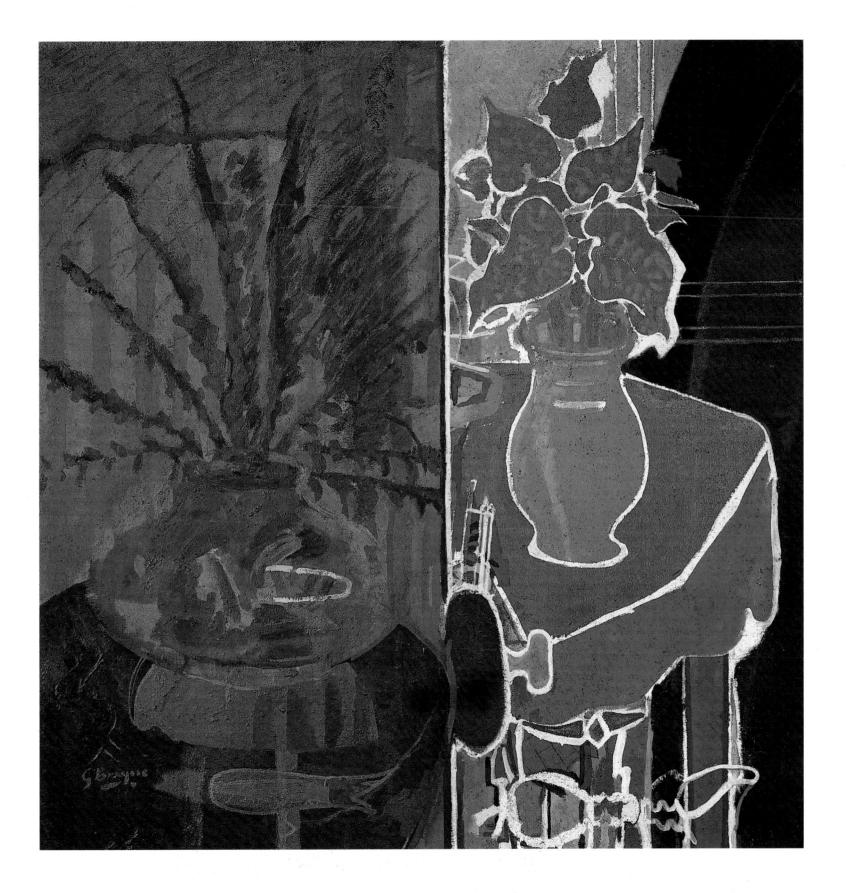

THE TWO WINDOWS (THE OPEN WINDOW)
Les Deux Fenêtres

[1951-2]
oil and sand on canvas
signed
97 × 130 cm
Maeght 41
Philadelphia Museum of Art:
Promised gift of Mr and Mrs Klaus Perls

PROVENANCE
Aimé Maeght, Paris; Fujikawa Gallery, Tokyo;
Perls Galleries, New York; Sotheby's, New
York, 8 November 1995 (lot 75)

Windows first appeared in Braque's work only
in the late 1930s (compare the half-open
window in *Le Salon*, cat. 9). In this
harmonious, dignified composition, a carafe,
stringed instrument, grapes, cup and other
objects are placed on a table covered with a
patterned tablecloth before the window. A
related painting of the same year entitled *La
Bandouria* (Maeght 45) suggests that the
instrument may be a bandurria (a small popular
instrument, a hybrid of the guitar and cittern
families): one featured in Braque's own
collection of instruments as can be seen in a
photograph of Braque's studio in about 1911
(reproduced in e g. Pouillon and Monod-
Fontaine, 1982, p.39). The painting can be
seen in progress on an easel in his new
Varengeville studio in a photograph taken by
Felix Man in 1951, beside *La Bicyclette*
(Maeght 40 [1951–2]; Man, 1954). The
evidence of this photograph modifies the date
of 1952 previously given to the painting.

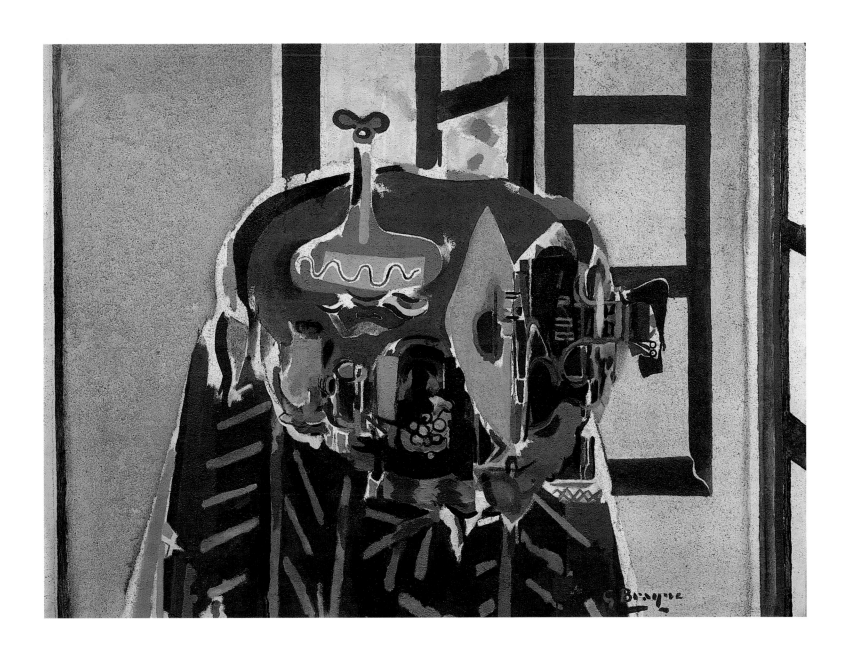

28 VASE OF FLOWERS
Vase de Fleurs

[1953]
oil on canvas
signed
116 × 60 cm
not in Maeght
Paule and Adrien Maeght Collection

PROVENANCE
Aimé Maeght

Vase of Flowers is a smaller variant of *Le Grand Vase*, without the decorative motif at the top ([1951-2], 179.5 × 72.5 cm, Maeght 50). Both are vertical compositions of vases set on small round tables with bouquets of flowers that are represented in a pointillist manner. Giacometti must have had a painting such as *Le Grand Vase* in mind when, in the essay that accompanied Braque's exhibition at the Galerie Maeght in 1952 (at which *Le Grand Vase* was shown), he wrote: 'How can I describe the sensation aroused by the very slightly off-centre vertical line of the vase and the flowers against the grey background?... Why, of all Braque's latest paintings, is it the yellow ochre vase that has stayed most vividly in my memory? Perhaps because by clinging to, by giving such weight to just one part of the surface of the simplest, and in some respects, the most insignificant of objects, he enhances everything that he does not paint, gives value to objects that are in themselves utterly drab and of no account, and exalts everything that surpasses them including the person looking at them.' (*Derrière le Miroir*, nos 48–9, June–July 1952)

 Vase of Flowers can just be seen already signed in the immediate foreground of a photograph of Braque's Paris studio taken by Robert Doisneau in 1953 and published in *Le Point* (p.18) in October of that year.

29 VANITAS (STILL-LIFE WITH SKULL)
 Vanitas (Nature Morte au Crâne)

[1941–54]
oil on canvas
signed
50 × 61 cm
not in Maeght
Mr and Mrs Claude Laurens Collection

PROVENANCE
Collection of the artist

Begun in 1941, this painting belongs to the
Vanitas series of which *Pitcher and Skull*, 1943
(cat. 4) is another example. In contrast to the
latter work, Braque here uses strong colours in
his palette, dominated by shrill purples. The
painting is visible in a colour photograph of
the Varengeville studio in mid-1954: the
background of the painting had still to be
completed (*Paris-Match*, 1954, pp.42–3).
Vanitas was previously believed to have been
finished in 1945.

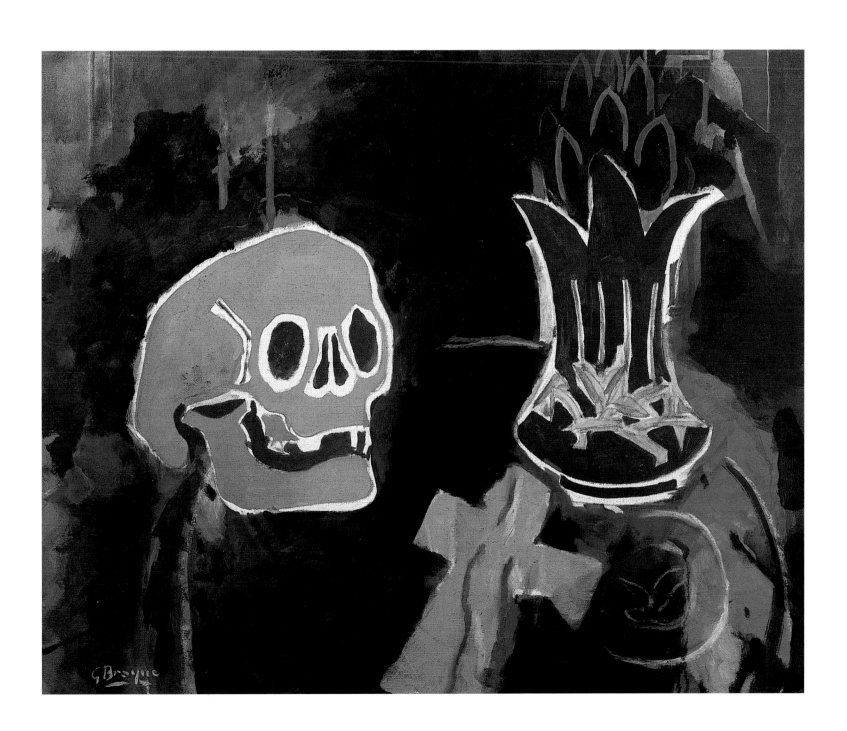

THE FIRE-BIRD
L'Oiseau au feu

[1954]
oil and charcoal on paper pasted onto panel
signed
27.7 × 48.9 cm
not in Maeght
John Richardson, New York

PROVENANCE
Given by the artist to John Richardson and
Douglas Cooper, *c.*1955

The iridescent fire-bird in flight is related to a
gouache of the same period, *Oiseau de feu*, of a
similar magical colouring (1955, illustrated in
colour in Fumet, 1965, p.197). A colour
etching based on the work shown here
entitled *Oiseau multicolore* was produced by
Maeght. A colour etching of 1958 also bears
the title *L'Oiseau de feu* (*Oiseau XIII*).

 Braque gave this work to John Richardson,
whose analyses of the Studio paintings and
interviews with Braque are particularly
valuable contributions to the literature on the
artist.

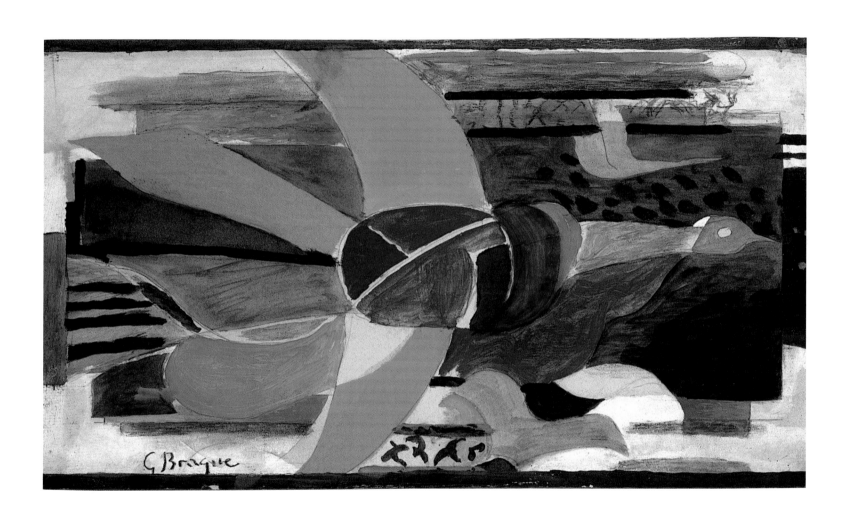

THE BIRD AND ITS NEST (THE BIRD RETURNING TO ITS NEST)
L'Oiseau et son Nid (L'Oiseau retournant à son Nid)

[1955]
oil and sand on canvas
signed
130.5 × 173.5 cm
Maeght 106
Musée National d'Art Moderne, Centre
Georges Pompidou, Paris

Not exhibited

PROVENANCE
Collection of the artist; bequeathed by Braque
to the Musée National d'Art Moderne,
entering in 1965

Braque kept this painting until his death and
his predilection for it is evident in a letter he
wrote to Jean Leymarie in 1958 in which he
described it as 'a painting that I am very fond
of and one which, I think, is a landmark in my
work. Birds and space have been a
preoccupation of mine for a long time. The
motif first came to me in 1929 for an
illustration to Hesiod.' (Leymarie, 1958, p.72)
Braque's etchings for Hesiod's *Théogonie*, made
in the early 1930s but not published until
1955, had a profound influence on his work.
The birds that appear in them and in related
incised plasters were inspired by the decorative
motifs of birds on archaic Greek and Etruscan
ceramics. Braque had loved the Louvre's
collections of these works since he was a
young man (see for example Bowness, 1995,
plates 203, 204). When in 1952 he was invited
to paint a ceiling for the Etruscan room in the
Louvre, he was able to offer his homage in
counterpoint to the collection he knew so
well, and it was entirely appropriate that he
chose birds as his subject-matter.

The truncated tree in *The Bird and its Nest*
may well itself be derived from the tree in the
first *Théogonie* etching, in which it is the source
of the branch which the Muse gives Hesiod on
Mount Helicon as a token of his poetic calling
(see also related etchings such as *Personnage et
tronc d'arbre* of 1932). Braque would have looked

again at these etchings as he prepared the
Théogonie for publication in 1955.

The sky in *The Bird and its Nest* is
represented in paradoxically thick, earthy
brown paint. Preparatory drawings for the
painting include cat. 31a, cat. 35a and a double
page (sketchbook Q 59) containing three
versions of the motif, on which the word
'CIGOGNE' (stork) is written twice.[1]

A project for *The Bird and its Nest* shows
the bird returning to the nest with something
in its beak (1955, oil, ink, pencil and pasted
papers on cardboard, 17 × 25 cm, Collection
John Richardson).

The squaring-up technique used by Braque
in transposing the composition of this painting
from drawing to canvas is visible in
photographs of him at work on the painting
taken by Mariette Lachaud (cat. 31b). These
also show that Braque re-stretched the canvas
on a smaller stretcher, reducing it on both
sides – the line along the top of the
composition is in fact a remnant of the
squaring-up process.

In May 1955, while the painting was in
progress, Braque visited the Camargue nature
reserve where his friend Lukas Hoffmann had
an ornithological station, the Tour du Valat.
He saw birds such as herons, egrets, flamingos,
recalling shortly afterwards: 'I saw great birds
passing over the lagoons, and from that vision
I took aerial forms. Birds have inspired me,
and I try to extract from them the maximum
profit for my drawing and painting. Yet I must
bury their natural function as birds deep in my
memory ... so that I can draw closer to my
essential preoccupation: the construction of
pictorial fact.' (Verdet, 1956, p.10)

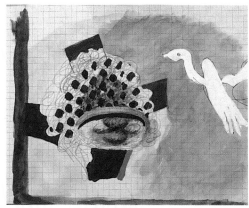

31a Study for *The Bird and its Nest*, pencil and
gouache on squared paper. Courtesy Archives
Laurens.

31b Braque in his studio at Varengeville with *The
Bird and its Nest*. Photograph © Mariette Lachaud,
courtesy Archives Laurens.

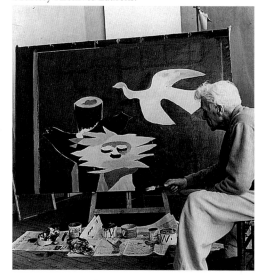

[1] See Braque, *Carnets Intimes*, 1955, pp.80–81; the
reproduction in Zurcher, 1988, p.255 shows that it is a
double-page spread.

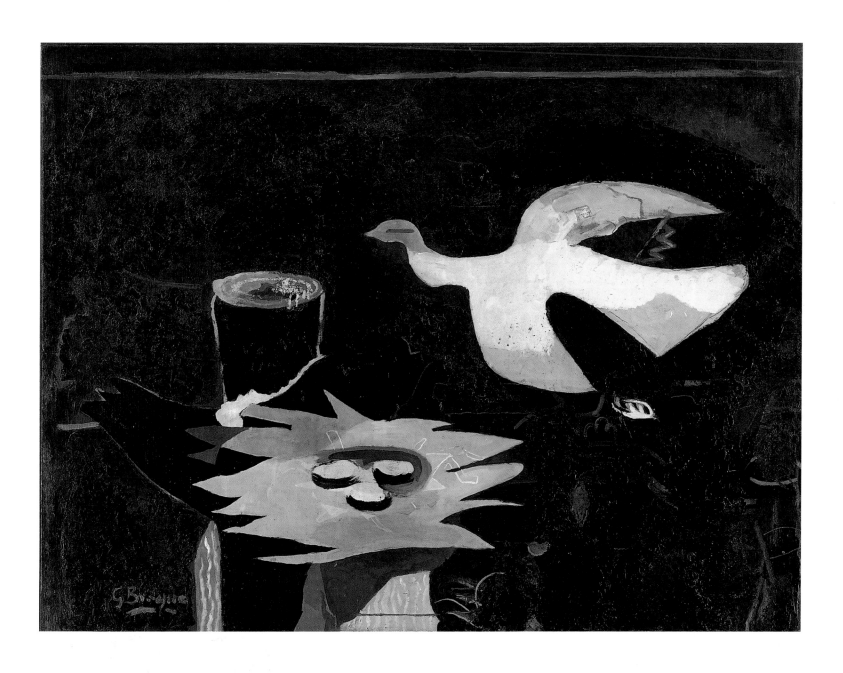

32 THE ECHO
L'Echo

1953–6
oil on canvas
signed
130 × 162 cm
Maeght 103
Private Collection, courtesy Helly Nahmad,
Geneva

PROVENANCE
Aimé Maeght, Paris; 1968, bought by Galerie
Beyeler, Basel; 1970, bought by a private
collection, Lausanne; sold Sotheby's, New
York, 2 May 1996 (lot 56)

The Echo can be seen in progress in Alexander
Liberman's photograph (frontispiece). At that
stage the bird had not yet appeared, while, in
Robert Doisneau's photographs of the
Varengeville studio in 1953, the painting can
be seen alongside *Studio VII* (later *Studio IX*, cat.
24). The bird is just emerging on the canvas
(there is an indication of what will become its
body only) and the newspaper is as yet
untitled, but the rest of the composition was
well advanced. The painting was not signed
until 1956 when it was first exhibited as *Le
Tapis Rouge* in the Braque exhibition that
opened at the Galerie Maeght on 4 May.

Braque paints part of the title of a
newspaper, 'L'ECHO ... R...' (probably *L'Echo
de Paris*), lying on the table-top, a revival of
the references to newspapers commonly found
in Cubist paintings and *papiers collés*: for
example, a fragment from the masthead of
'L'ECHO D'A ...' is pasted onto Braque's *papier
collé La Clarinette* (1913, The Museum of
Modern Art, New York), and inscribed into
the painting *Le Guéridon* (1913, Berggruen
Collection). The fragmentation of letters is also
a Cubist characteristic. The bird seems to draw
attention to the newspaper or to bear it in its
beak. The configuration of the bird perhaps
recalls the dove with outstretched wings
symbolic of the Holy Ghost. The stylised
branch form at the top of the painting is
echoed below as if in negative.

Braque had previously incorporated dead
birds into his still-lifes on several occasions, for
example *Nature Morte à la Perdrix* (1941,
Maeght 94), *Nature Morte à l'Echelle* (1943, not
in Maeght) or *Le Pigeon Noir* (1951, Maeght
30).

Braque painted a smaller version after this
unusually large still-life, *Nature Morte Rouge*
(Maeght 94, 73 × 87 cm, Staatsgalerie,
Stuttgart), which can be seen complete or
nearly so in photographs of the Varengeville
studio at the end of 1954 (cat. 23b). The
composition is closely related to *The Echo* but
for the dish of fruit that replaces the bird and
newspaper.

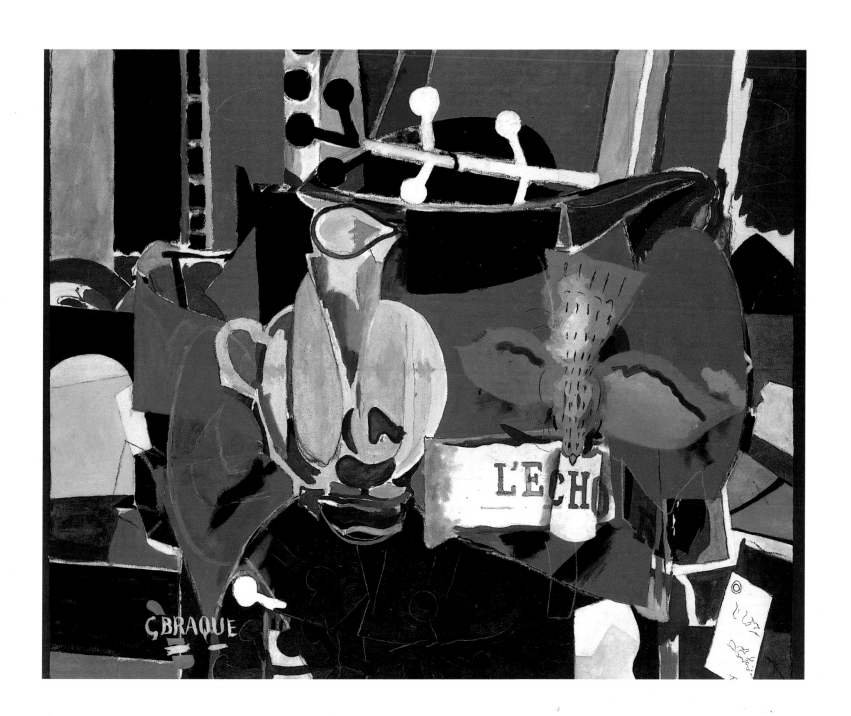

1956–7
oil on canvas (with painted hardboard frame)
signed
129 × 181 cm (185 × 238 cm with frame)
Maeght 117
Paule and Adrien Maeght Collection

PROVENANCE
Aimé Maeght

In the past, stated Braque in 1956, 'I used guitars, tables, carafes, sand and wallpaper to express what I had to say. Now it is the bird which helps me to explain myself. I started on the ground, and now I am slowly moving up toward the sky.' (*Time*, 1956, p.82) The boldly simplified *Black Birds*, with its highly schematic forms of birds silhouetted against a tactile pale-blue sky, is a companion piece to *In Full Flight* (cat. 39), begun in the same year. The monumental *Black Birds* looks back to the birds of the Louvre ceiling painted in 1952–3.

In a closely related gouache of 1956 (cat. 33a, 40 × 45 cm, Private Collection), a sun, moon or star form is also depicted (compare the pair of *Astre et oiseau* lithographs of 1958–9). The gouache has a comparable wide frame.

The Black Birds is visible in photographs taken by Robert Doisneau in 1957 and by Mariette Lachaud in 1958 (cat. 33b).

Braque's birds inspired Frank Elgar's *Résurrection de l'Oiseau*, published with lithographs by Braque in 1958, shortly after the completion of *The Black Birds*. Unrelated to any known species, writes Elgar, Braque's mysterious, archetypal bird 'draws its power to fascinate from its own indeterminate nature ... Never ... did Braque use such simplicity of means with such imaginative boldness.' (pp.34–5)

The predilection for birds shared by Braque and the poet Saint-John Perse resulted in *L'Ordre des Oiseaux* (1962), which comprised a text 'Oiseaux' by the poet published together with twelve colour etchings of birds by Braque. For Perse, Braque's birds have a magic charge; they are premonitory; they are our mediators between earth and sky; they are the essence of all species of birds: 'They are neither cranes from the Camargue nor seagulls from the coast of Normandy ... Though synthetic, they are pure creations that definitely do not owe their origins to any abstract idea. They have never inhabited the world of myth or legend; they utterly reject the inadequacy of the symbol, and belong to neither Bible, nor Ritual. Their real presence, however, owing nothing to fable or fairytale, fills the poetic part of man's nature; a real stroke brings them to the brink of the surreal. Braque's birds belong to no-one else ... They allude to nothing else, are memory-free and pursue their own destiny ...' ('Oiseaux', *XII*)

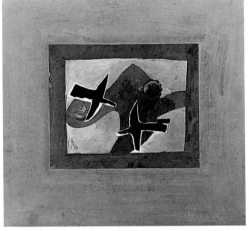

33a Study for *The Black Birds*, 1956, gouache on paper and card. Courtesy Archives Laurens.

33b Braque's Paris studio with *The Black Birds* and *Composition with Stars* (unfinished; cat. 34). Photograph © Mariette Lachaud, courtesy Archives Laurens.

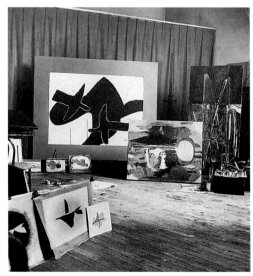

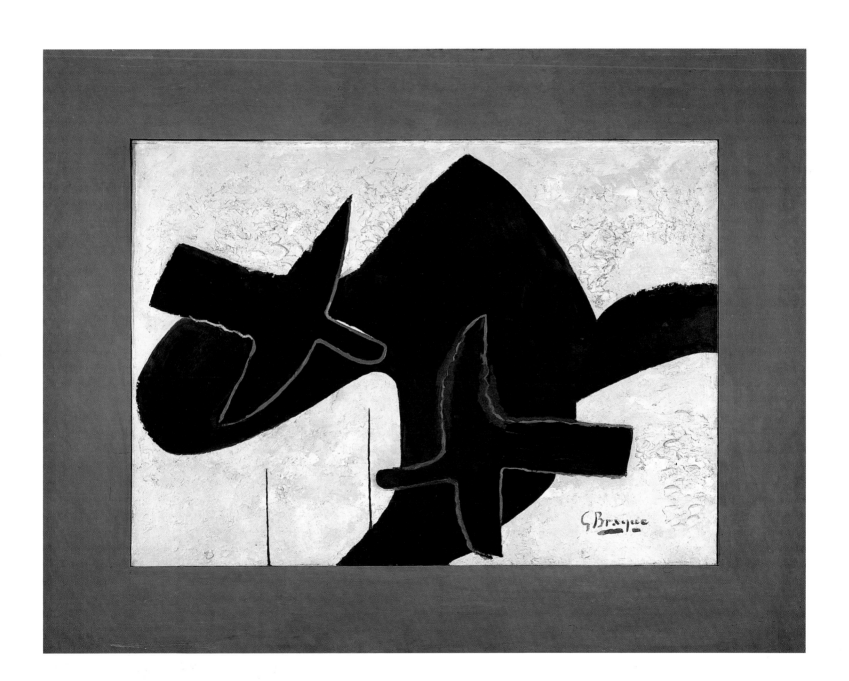

Composition aux Etoiles

[1954–8]
oil on canvas
unsigned
195 × 97 cm
not in Maeght
Private Collection

PROVENANCE
Collection of the artist

Composition with Stars is an exceptional work, a coda to the Studio paintings of great metamorphic freedom. It represents Braque's easel in the studio in front of which is a bird form which seems still in the process of metamorphosis. Its identity is uncertain, whether a painted bird on the easel, a dead or a real bird (compare *The Echo*, cat. 32). The presence of the stars, which made a late entry into the work, transfigures the whole. The painting remains infinitely mysterious.

The successive transformations of *Composition with Stars*, which Braque may have begun in 1954, can be followed to some extent in a sequence of photographs of the studio dating from 1957–8. Its first known state is shown in a photograph by Mariette Lachaud (see Liverpool and Bristol, 1990, p.25). Here the soaring peaked forms of the easel can be clearly seen, comparable with those of the easel in *Studio IX* (cat. 24) in particular. These forms would be partly obscured when Braque later reworked the top part of the painting and introduced the stars. The black and white eye visible at the right edge can be identified as that of Ajax in the recently completed eponymous painting ([1949–54], 180 × 72 cm, Maeght 79), influenced by Braque's engraved plasters (these were coated in black paint and incised to expose the white of the plaster beneath, a technique he had invented in the early 1930s). *Ajax* can be seen in photographs of the studio such as cat. 24a of 1953, where it is leaning against an easel to the left of *Studio VII* (IX).

When Mariette Lachaud again photographed the painting in the studio, on 1 April 1958, Braque had introduced some passages of the vigorous, broken brushwork which would characterise the final version of the painting, as well as adding two curvilinear forms to the central area: these would later suggest the contours of the bird (cat. 33b, with *The Black Birds*, cat. 33). The painting seems to be at the same stage of its evolution in Alexander Liberman's photographs (Liberman, 1960, plate 71 and cat. 40a). By 18 November when Lachaud again photographed the painting – the bottom half is obscured by other paintings – Braque had added an overlay of dashes to the top area (*Kunsten Idag*, 1964, p.52). The stars were still to come (related to those in Braque's Louvre ceiling and other works), and the bird too it seems.

Composition with Stars was first exhibited in 1990 (Liverpool and Bristol, 1990). It had previously been illustrated only once, with the title *Oiseaux et étoiles*, 1954 (*L'Oeil*, Paris, no.219, October 1973, p.39, fig. 12).

35 THE NEST IN THE FOLIAGE
Le Nid dans le feuillage

1958
oil and sand on canvas
signed
114 × 132 cm
Paule and Adrien Maeght Collection·

PROVENANCE
Aimé Maeght

This painting is a variation on the theme
introduced in *The Bird and its Nest* (cat. 31). It
relates back to drawings such as cat. 31a and
especially to the double page containing three
versions of the motif which Braque inscribed
'CIGOGNE' (stork), referred to in the discussion
of *The Bird and its Nest*. The bird in *The Nest
in the Foliage* is of the same type as the birds in
these drawings. Its wings are more naturalistic
than those in the earlier painting. Also related
to both paintings is cat. 35a, *L'Oiseau et son
Nid dans le Feuillage* ([1954], pencil and
gouache on gridded paper, 22 × 34,5 cm), the
leafy background of which is shared by cat. 35
(see also cat. 40, *The Bird in the Paulownia*).

The bird, flying out of the Studio paintings
into open space, was a central theme to which
Braque returned repeatedly in his late work.
Birds were ideal companions in the spatial
researches which preoccupied him. In a letter
written to Jean Leymarie in 1958, the year in
which he painted *The Nest in the Foliage*,
Braque wrote of being 'very haunted by space
and movement' in his latest works (Leymarie,
1958, p.72). He told Alexander Liberman:
'The bird is the summing up of all my art – it
is more than painting.' (Liberman, 1960, p.41)
Jacques Dupin argued in 1956 that what
mattered to Braque was less the bird than its
flight, less its physical representation than its
poetic revelation. (*Derrière le Miroir*, nos 85–6,
April–May 1956) They are archetypal birds.
Braque strongly resisted the reading of
symbolic meaning into them (as into his work
in general). He told John Richardson that:
'they just materialised of their own accord,
they were born on the canvas; that is why it's

absurd to read any sort of symbolic significance
into them. They are simply birds, species
unknown, though maybe an ornithologist
would be able to identify them for you.'
(Braque, 1957, p.16)

35a *The Bird and its Nest in the Foliage*, pencil and
gouache on squared paper. Photograph courtesy
Archives Laurens.

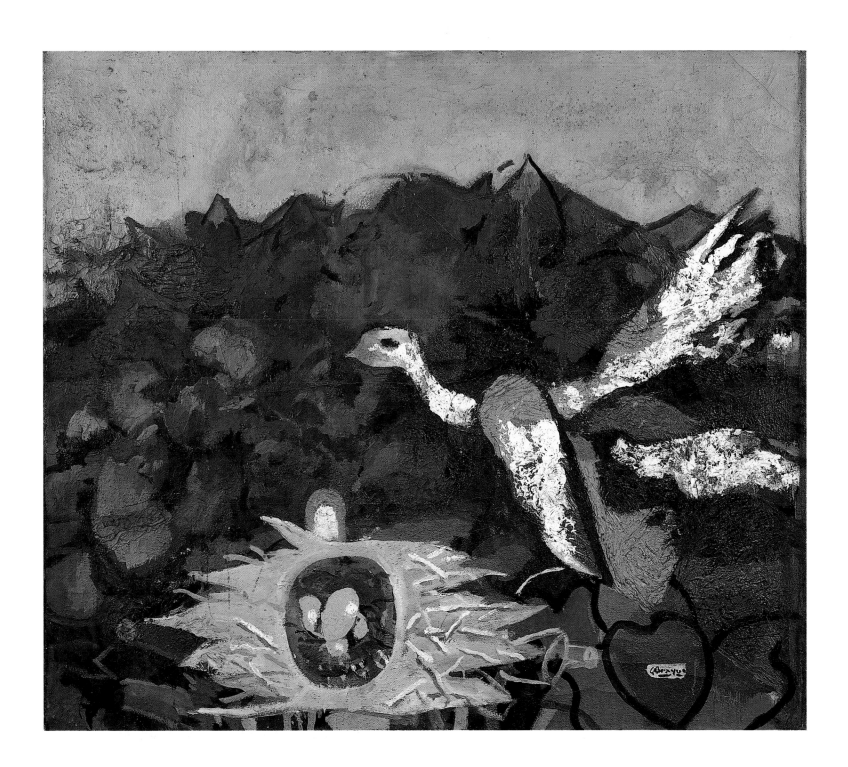

1960
oil on canvas
signed
84 × 195 cm
Paule and Adrien Maeght Collection

PROVENANCE
Aimé Maeght

The Plough is painted with a palette knife in
very thick impasto, suggestive of ploughed
earth. Braque knew the ploughs of the
Varengeville countryside well and he is
pictured in a joke photograph of 1931 seated
in a local farmer's plough (see e.g. Prévert,
1981, p.26). A group of photographs of
ploughs can be seen pinned to the door of his
studio (see Limbour, 1957, p.28 and cat. 15a).
A friend, the philosopher and writer Jean
Grenier, wrote in 1967: 'the world of
agricultural equipment and tools aroused very
deep feelings in him. How close he was to the
Earth!' (*Derrière le Miroir*, no.166, June 1967,
p.12)
 The first plough in Braque's work, in the
sculpture *Cheval et Charrue: Les Travaux et les
Jours* ([1939-40], cast in 1955), was inspired by
his reading of the archaic Greek poet Hesiod's
Works and Days with its description of
ploughing. Braque first painted the ploughs in
the fields of Varengeville in 1945 (*La Charrue*,
oil on plywood, 22 × 27 cm; see e.g.
Fauchereau, 1987, plate 112). They are the
subject of a series of late paintings, some on a
small scale such as *La Charrue*, 1959 (22 × 33
cm) or *La Charrue*, 1960, close to cat. 36 (oil
on paper, 11 × 35.5 cm), others monumental
such as cat. 36 and *La Sarcleuse (The Weeding
Machine)*, [1961–3], his last major work.
Ploughs also feature in some of Braque's
Varengeville landscapes, such as *Landscape with
Dark Sky* (cat. 41) and *Paysage à la Charrue*
(Maeght 102, 34 × 64 cm), both of 1955. The
form of the plough in cat. 36 and related
works looks back to the plough in the latter
painting, but the details have been lost in the

monolithic form of the implement in cat. 36.
 Braque wrote of the plough in his *Cahier*:
'The idle plough rusts and loses its usual
meaning' (Braque, 1947, p.50). In his poem
'Varengeville', Jacques Prévert likened
Braque's abandoned ploughs to his paintings of
beached boats (such as cat. 43, 45, 46; quoted
p.119).

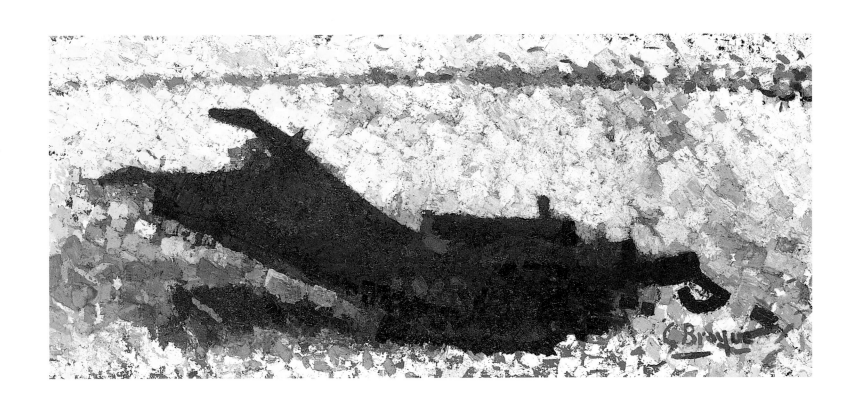

THE MAN WITH THE GUITAR
L'Homme à la Guitare

1942–61
oil on canvas
unsigned
130 × 97 cm
Mr and Mrs Claude Laurens Collection

PROVENANCE
Collection of the artist

The Man with the Guitar was largely painted in 1942 and relates to the figure paintings of that period, such as *Woman with a Book* (cat. 14). The guitarist is seen in mysterious silhouette with his back to the viewer like the male painter in *L'Homme au Chevalet* (collection Quentin Laurens) of 1942. *Le Peintre et son Modèle*, painted several years earlier in 1939, offered a precedent for cat. 37 with its similarly positioned male figure seated facing a female one (see fig. 4; Maeght 52, Norton Simon Museum, Pasadena). In *The Man with the Guitar* the woman is partially visible in profile and full-face on the left – like the female presence at the far right of *Le Salon* (cat. 9). Her hand is also seen below the chair. She perhaps wears the large peaked hat of the female figure in *Jeune Femme à la Palette*, 1942, (Private Collection, Paris). The distinctive gas lamp in the painting is also found in *La Patience* (1942, Maeght 1, private collection, France).

The Man with the Guitar can be seen, beside *The Washstand* (cat. 7), in a photograph of Braque's studio dated 1943 (cat. 7a; Bazin, 1945, p.2). It is also seen on an easel in the studio in 1948 in a photograph by Willy Maywald, and Braque probably retouched it at this time (cat. 37a): the modifications of 1961 were minimal.

37a Braque in his Paris studio in front of *The Man with the Guitar*. Photograph Assoc. Willy Maywald/ADAGP, Paris and DACS, London, 1997, courtesy Archives Laurens.

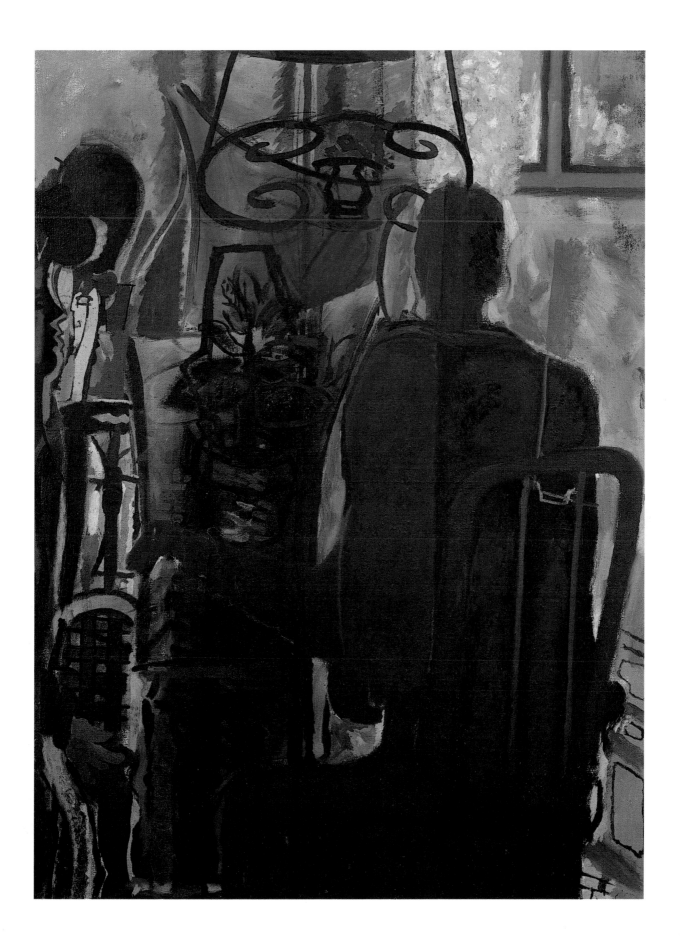

1948–61
oil on canvas
unsigned
97 × 130 cm
Private Collection

PROVENANCE
Collection of the artist

This painting evokes the terrace of Braque's Varengeville house (cat. 38a). Photographs show four stages of its evolution. They reveal that the space originally opened out at the back beyond a window or balcony, as with the window in the background of its pair, *La Terrasse* ([1948-9], Maeght 6, 114 × 146 cm, formerly collection of Dr. Paul Hänggi: the small window here resembles those of Braque's house, visible in the photograph (cat. 38a). The first photograph of cat. 38 in progress is dated 9 February 1949; the painting is next seen on an easel in a photograph by Felix Man (cat. 38b); a photograph of 11 June shows a further degree of complexity. In the final photograph, which is undated, the painting is nearing completion: the background has been closed in and wood-graining – also found in the related *Terrace* – has been introduced.[1] The result is a shallow space full of ornamental incident, with competing wood-grained and striped patterning. There is a sense of dappled light, but beyond this the feeling is rather of an interior than of an exterior scene.

 The painting implies a human presence, and related drawings in the *Carnets Intimes* do show figures seated at café tables – for example p.111 (top) and pp.114–5; the bottom drawing on p.111 (without figures) is close to the *Terrace* painting in the Hänggi Collection. Related works include the series of chair paintings indebted to van Gogh, for example *La Chaise* ([1947], Musée National d'Art Moderne, Paris), featuring the same cast iron chairs with their volutes. Braque returned to the subject of his terrace in paintings such as (*La Treille* [1953-4], Maeght 80) and *Le Store* (1954–61, Lake Collection, Japan).

38a Braque sitting at the table on the terrace of his house at Varengeville. Photograph by Felix Man © Lieselott Man.

38b Braque's studio with *The Terrace* in progress and *Studio 1*. Photograph by Felix Man © Lieselott Man.

[1] The photographs of February and June 1949 and the undated one are illustrated in Fumet, 1965, p.156.

39 IN FULL FLIGHT
A tire d'aile

[1956–61]
oil and sand on canvas mounted on panel
signed
114.5 × 170.5 cm
Maeght 107 (the first state of the painting,
painted in 1956)
Musée National d'Art Moderne, Centre
Georges Pompidou, Paris, Donation of Mme
Georges Braque (1963)

PROVENANCE
Collection of the artist; bequeathed by Braque
to the Musée National d'Art Moderne,
entering in 1965

Braque painted the first state of *In Full Flight* in
1956, exhibiting it at the Galerie Maeght in
May of that year. He reworked it before
allowing it to be shown at the Tate Gallery in
London in the autumn of 1956.[1] This state was
included in the catalogue of his work of 1948-
57 published by Maeght in 1959. Arrow-like,
the bird pierces an abstract round form in its
flight through highly tactile pale blue space.
The round mass may be a cloud or a moon
form, such as that pierced by the bird in *Oiseau
et Lune* (1952, 86 × 120 cm) and in *Nocturne*
(also known as *L'Oiseau,* 1958, 82 × 163 cm).
Also comparable are the round foliage pierced
by the bird in the painting *Oiseau et feuillage,*
(1956, 74 × 115 cm); the round sun and moon
forms in the pair of *Soleil et lune* gouaches of
1959 and in the lithograph *Equinox* of 1962;
and the round star in the two *Astre et oiseau*
lithographs of 1958-9.

A second, small bird seems to fly within the
wings of the large one.

The poetic simplicity of this image was
deliberately disrupted by Braque in 1961 with
the introduction of a small framed
representation of a work related to his painting
Le Canard in the lower left-hand corner (1956,
Maeght 109, oil and gouache on cardboard, 60
× 84 cm; see cat. 39a). This picture within the
picture, with its white bird flying from black
into pale blue, is a reversal of the main image.

Braque explained that he had made the
addition to what had been a finished work in
order to bring an element of surprise: 'After
four months of looking at it daily and living
with it I noticed that I was becoming far too
used to it. It was too easy on the eye. So I
decided to create a rupture by painting another
bird in a sort of rectangular white frame in the
bottom left-hand corner of the picture; it was
added a bit like a rubber-stamp, or even a
postage stamp. By creating contradiction, and
not discord, I have given the painting a more
unusual existence. These surprise effects are
sometimes essential. They prevent the advent
of dull routine' He described the perching
white bird in *Studio VI* (cat. 22) as being a
similar surprise effect (Verdet, February 1962).

On his practice of taking up certain
paintings years later Braque said: 'They were
in a state of suspense in time. Time is often a
precious ally, a good collaborator. It is not a
taste for perfection that led me to put them
aside, and then one day decide to take them
up again. I simply brought them a new
element.' (Verdet, 1978, p.43)

John Richardson watched Braque at work
on the painting: 'for days and weeks he went
on adding liquid greyish paint, layer by layer,
until the canvas had become so caked with
pigment that it could barely be lifted on and
off the easel. The result is a sky that has an
astonishing cumulus quality and seems more
tangible than the bird – a typically Braquian
paradox.' (Richardson, 1961, p.22)

The extraordinarily thick, rough impasto of
the tangible sky in *In Full Flight* contrasts with
the thinly painted bird and round form. Braque
said of the sky in his paintings: 'I tend to paint it
thickly and opaquely in order to suggest its
infinite depth. In my ceiling decorations in the
Louvre, for instance, I found it necessary to use
layer after layer of pigment on the sky so that
the onlooker would feel that the birds had
enough sky to fly about in and would at the
same time be made conscious of the sky as a
tactile element. I want to bring the sky – and
everything else I paint – within people's grasp.'
(Braque, 1958, p.28)

[1] For this reason the painting was not included in the
earlier Edinburgh showing of the exhibition (August-
September). This state of *In Full Flight* was exhibited
several more times, including at the Venice Biennale in
1958.

39a Studio with *In Full Flight* and *The Duck.*
Photograph © Alexander Liberman.

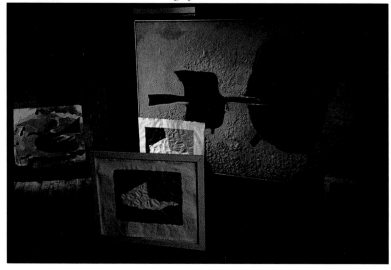

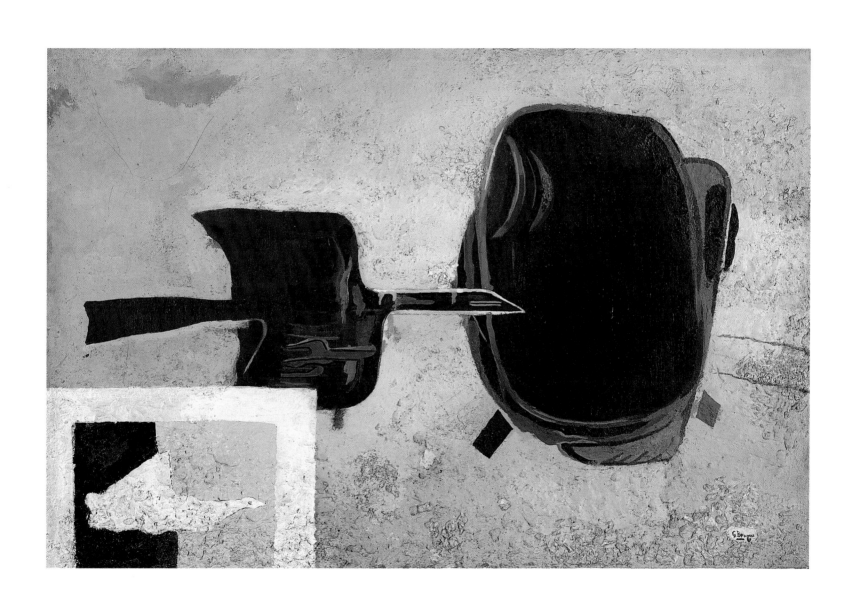

[1956–62]
oil on canvas
unsigned
129 × 173 cm
Private Collection

PROVENANCE
Collection of the artist

A paulownia tree, characterised by large, ornamental, lobed leaves, stood in the garden of Braque's house in Paris. The paulownia may also be represented in *The Nest in the Foliage* (cat. 35) and in the related drawing (cat. 35a). Related works include the painting *Oiseaux dans le Paulownia*, 1957 (88 × 107 cm) which shows the tree and two birds in flight.

The painting, which is an oval framed by a painted surround, can be seen in progress in photographs of 1958 taken by Alexander Liberman (cat. 40a) and Mariette Lachaud (see *Kunsten Idag*, 1964, p.52).

40a The studio in Paris with *The Bird in the Paulownia* and *Composition with Stars.*(cat. 34)
Photograph © Alexander Liberman.

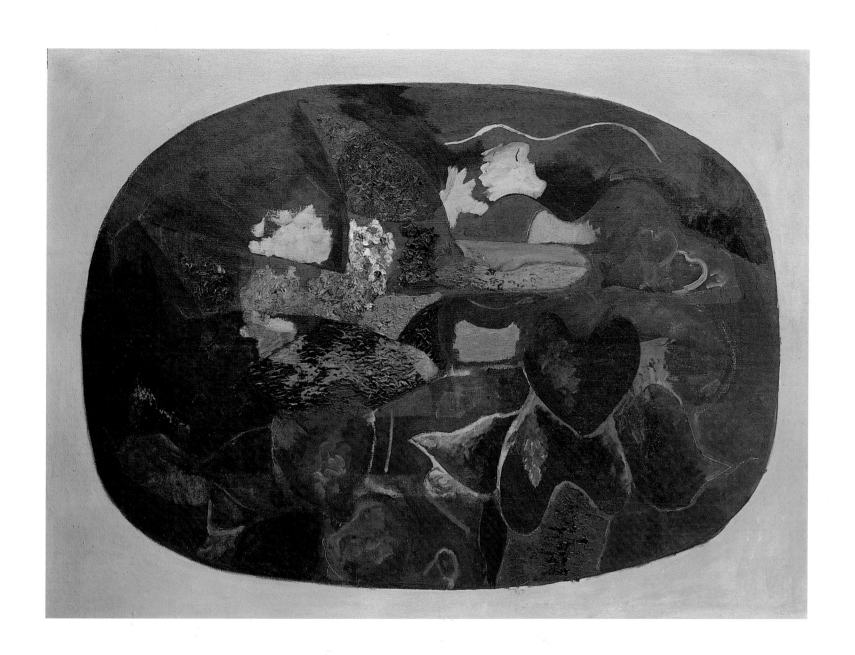

Braque's late landscapes and seascapes take as their subjects the shore and the plateau of the Pays de Caux at Varengeville to the west of Dieppe in Normandy, where he spent part of each year. Six are included in the exhibition. 'Braque says of them', Georges Limbour recorded in 1956, 'that he felt the need of release from the impressions of this landscape that he had accumulated over the years, the need to give expression to them.' (Limbour, 1956, n.p.) They come out of his profound attachment to this place.

Braque was brought to Varengeville in 1928 by his friend the architect Paul Nelson, who had a house there. He decided to build a house for himself on the edge of the chalk plateau a short distance inland. It was designed by Nelson in a rustic Norman style (according to Braque's specifications) and completed in 1931 (see Nelson in *Les Lettres Françaises*, 1962, p.11). From then until his death, Braque divided his time between Paris and Varengeville, arriving in the country for the summer and staying late into the autumn. It was a landscape he knew from his youth in Le Havre, when he would take bicycle trips in the region.

Between 1911 and 1928 Braque had abandoned landscape painting: his return to it coincided with his arrival in Varengeville. From 1928 until the outbreak of war in 1939 he painted a series of small seascapes, variations on the theme of boats beached on the shore, to which his late marines returned (see cat. 43, 45, 46). The first of these dates from 1949 and in the following year Braque painted his first Varengeville landscape.

Braque's Varengeville house faces south over the chalk plateau of the Pays de Caux: from it the poet Francis Ponge described 'a view across quite a large expanse of countryside, slightly undulating, with lots of sky. Normandy sky.' (Ponge, 1977, p.301) Accompanying Braque on a walk in the summer of 1952, Père Couturier recorded that Braque noticed everything and ceaselessly observed the changes of light (Couturier, 1962, p.147). The light at Varengeville is very changeable and the chalk cliffs give it a particular, luminous, soft quality. Couturier judged the clouds the most marvellous he had ever seen.

Despite their small formats and the simplicity of their subject-matter, Braque insisted that the late landscapes and seascapes were not minor works but, he told Jacques Dupin, 'glimpses of the outside world, forays into immediate reality, introductions to the elements – the flute and oboe solos so necessary in a full orchestral score.' (See Dupin in Prévert, 1981, p.22) Sky and earth are represented with great economy of means in these works, many of which are divided into horizontal bands of contrasting colours within unusually elongated formats. Most are characterised by rich, tactile paint surfaces often applied very freely with a palette knife. To many Braque gave hand-painted frames which are part of the works; in *Seashore* (1958, cat. 45), for example, the deep grey impasto of the sky extends to cover the highly textured frame.

In their subject-matter and technique Braque's landscapes – for example the birds flying over the wheatfield in *Landscape with Dark Sky* (1955, cat. 41) – recall van Gogh's last paintings of the plain of Auvers-sur-Oise, such as *Wheatfield with Crows* (1890, Rijksmuseum Vincent van Gogh, Amsterdam). Braque admired van Gogh's 'wonderfully rich sense of *matière*' and regarded him as a great painter of night (Braque, 1957,

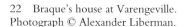

22 Braque's house at Varengeville.
Photograph © Alexander Liberman.

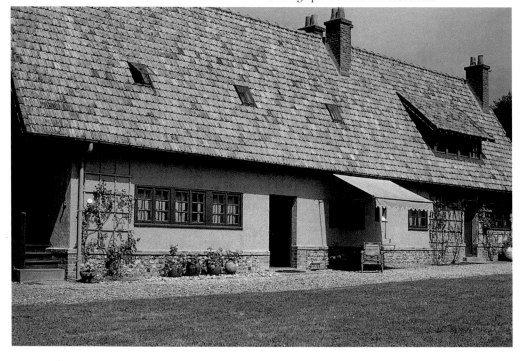

p.16). Braque's evocations of storm scenes with dark threatening skies suggest late van Gogh.

Braque painted the ploughs in the fields (as in the foreground of cat. 41), but never man himself. The seagulls and crows of Varengeville had, he said, influenced him very much, as well as the Camargue birds, and the birds of both places played a part in the late bird paintings (Liberman, 1960, p.41). Birds also appear in Braque's Varengeville landscapes, such as *Birds in the Wheatfields* (cat. 44) in which they are highly stylised.

Joan Miró lived in Varengeville in 1939–40 and his series of four paintings of 1939, *Le Vol d'un Oiseau sur la Plaine*, was also inspired by the heavy flight of crows over the Normandy plains. Like Braque he had been brought to Varengeville by Paul Nelson. Braque, who was then experimenting with sculpture, taught Miró much about techniques and materials at this time (see Bowness in Brighton, 1992, pp.49–50, 52, 66).

Jacques Prévert recorded his great sympathy for Braque's late Varengeville paintings in the poem 'Varengeville', published by Maeght Editeur in 1968 together with reproductions of Varengeville paintings by Braque:

Dark salt clouds
Sunlit shores
The skeletal plough
an earthly wreck
carcasses of boats
debris of the sea.

Giacometti also loved the late landscapes, writing on Braque's death: 'Of all his works I look with most interest, curiosity, emotion at the small landscapes, the still-lifes, the modest bunches of flowers of his very last years. I look at this almost timid, imponderable, naked painting and see a quite different kind of audacity, indeed a much greater audacity than that of the distant years: this is painting that for me occupies the highest peak in the art of today, with all its conflict.' (*Derrière le Miroir*, nos 144–6, May 1964, p.7)

When it was suggested to Braque in 1961 that there was a secret relationship between an austere, grey late seascape (compare cat. 46, 49, 50) and his early Cubist paintings, he agreed that such a connection did indeed exist: 'It is as if the thread which links these periods distant in time and in technique had never slackened... In the works I am doing today I find again an old acquaintance, the Braque of long ago.' (see Verdet, February 1962)

41 LANDSCAPE WITH DARK SKY
 Paysage au ciel sombre

1955
oil on canvas
unsigned
20 × 72.5 cm
not in Maeght
Private Collection

PROVENANCE
Collection of the artist

42 THE PLAIN I
 La Plaine I

1955–6
oil on canvas
signed
21 × 73 cm
Maeght 113 (top)
Paule and Adrien Maeght Collection

PROVENANCE
Aimé Maeght

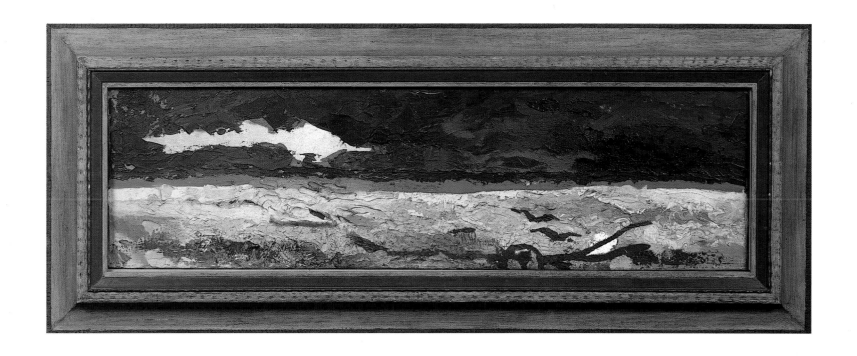

43 SEASCAPE
Marine

1956
oil on canvas
unsigned
25 × 65 cm
not in Maeght
Private Collection

PROVENANCE
Collection of the artist

44 BIRDS IN THE WHEATFIELDS
Les Oiseaux dans les blés

1957
oil on canvas
signed
24 × 41 cm
Maeght 118
Private Collection, courtesy of Thomas
Ammann Fine Art, Zurich

PROVENANCE
Aimé Maeght, Paris; private collection,
Argentina; 1989, bought by Thomas Ammann
Fine Art

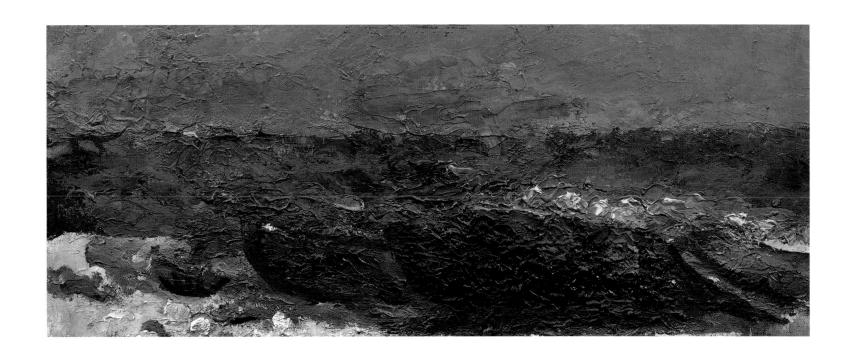

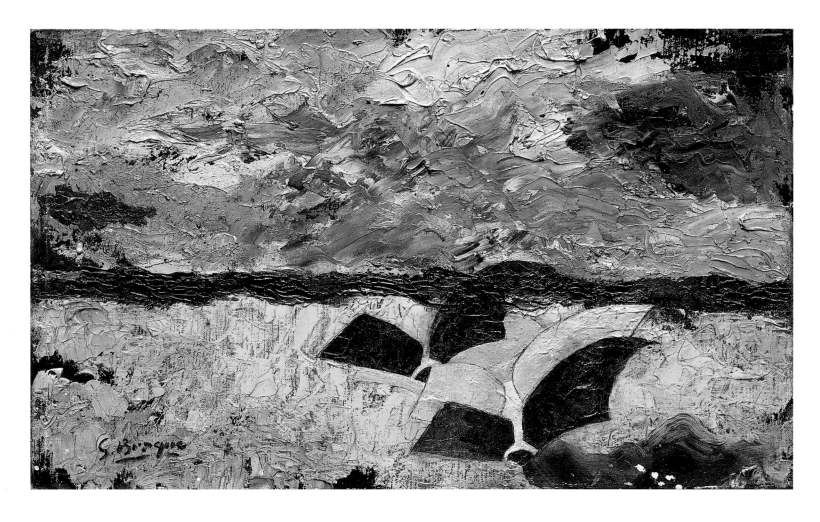

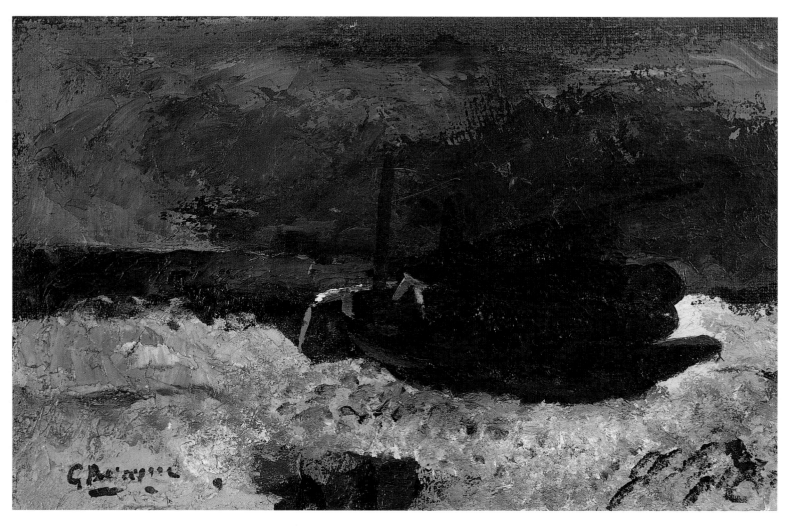

45 SEASHORE
 Bord de Mer

1958
oil on canvas
unsigned
31 × 65 cm
Mr and Mrs Claude Laurens Collection

PROVENANCE
Collection of the artist

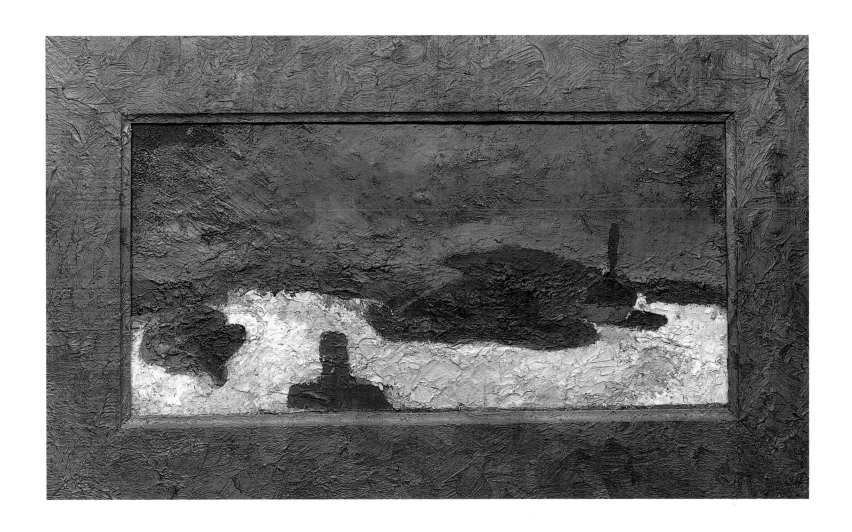

46 Seascape, The Storm
Marine, L'Orage, Barque sur la plage

1959
oil on canvas
signed
24 × 42 cm
Paule and Adrien Maeght Collection

Provenance
Aimé Maeght

AIX-EN-PROVENCE AND PARIS 1976-7, *Les Oiseaux et l'Oeuvre de Saint-John Perse*, catalogue of an exhibition organised by the Fondation Saint-John Perse at the Hôtel de Ville, Aix-en-Provence, and Musée Jacquemart-André, Paris 1976-7

L'AMOUR DE L'ART, Paris, 27th year, no.V, 1947, 'Intimités de Braque', five photographs by Rémy Duval, pp.214–18

BARCELONA 1986, *Georges Braque 1882–1963*, exhibition catalogue, (Ajuntament de Barcelona), Museo Picasso, Barcelona 1986

BARI 1983, *Georges Braque. Opere 1900–1963*, exhibition catalogue, Castello Svevo, Bari 1983

BAZAINE, Jean, 'Braque au Salon d'Automne', *Comoedia*, Paris, 5 June 1943, p.1

BAZIN, Germain, 'Georges Braque', *Labyrinthe*, Geneva, no.4, 15 January 1945, p.2

BELLONY-REWALD, Alice, and Michael PEPPIATT, *Imagination's Chamber. Artists and Their Studios*, London 1983

BIOT 1986, *Georges Braque*, exhibition catalogue, Musée National Fernand Léger 1986

BORDEAUX AND STRASBOURG 1982, *Georges Braque en Europe*, exhibition catalogue, Galerie des Beaux–Arts, Bordeaux, and Musée d'Art Moderne, Strasbourg 1982

BOUVIER, Marguette, 'De la Grèce au cubisme. Georges Braque sculpteur', (an interview with Braque), *Comoedia*, Paris, 29 August 1942, pp.1 and 8

BOWNESS, Sophie, 'The Presence of the Past: Art in France in the 1930s, with special reference to Le Corbusier, Léger and Braque', Ph.D., Courtauld Institute of Art, University of London 1995

BRAQUE, Georges, reply to the 'Enquête', *Cahiers d'Art*, Paris, 1939, nos1–4, pp.65–6

BRAQUE, Georges, *Cahier de Georges Braque 1917-1947*, Paris 1947; (the date 1916 instead of 1917 is used by Braque on the cover)

BRAQUE, Georges, 'Propos de Georges

Braque', *Verve*, Paris, vol.VII, nos27–8, 1952, pp.70–82

BRAQUE, Georges, interview in the *enquête* 'Sens de l'Art Moderne', *Zodiaque*, Cahiers de l'Atelier du Coeur-Meurtry, atelier monastique de l'Abbaye Sainte-Marie de la Pierre-qui-Vire, Saint-Léger-Vauban, Yonne, nos18–19, January 1954, pp.11–17

BRAQUE, Georges, *Carnets Intimes de G. Braque*, published as a special issue of *Verve*, Paris, vol.VIII, nos 31–2, 1955

BRAQUE, Georges, *Cahiers 1947-1955*, Paris 1956; (the two *Cahiers* together were translated by Stanley Appelbaum as Georges Braque, *Illustrated Notebooks 1917-1955*, New York 1971)

BRAQUE, Georges, 'Voice of the Artist – 2: The Power of Mystery', (based on statements made to John Richardson), *The Observer*, 1 December 1957, p.16.

BRAQUE, Georges, 'Braque discusses his Art: A dialogue with John Richardson', *Réalités*, London, New York and Paris (English edition), no.93, August 1958, pp.24–31, 72

Selected books illustrated by Braque

APOLLINAIRE, Guillaume, *Si je mourais là-bas*, Paris 1962

CHAR, René, *Le Soleil des Eaux*, Paris 1949

CHAR, René, *La bibliothèque est en feu*, Paris 1956

CHAR, René, *Cinq poésies en hommage à Georges Braque*, Geneva 1958

CHAR, René, *Lettera Amorosa*, Geneva 1963

ELGAR, Frank, *Résurrection de l'Oiseau*, Paris 1958

HERACLITE, *Héraclite d'Ephèse*, transl. by Yves Battistini, preface by René Char, Paris 1948

HESIODE, *Théogonie*, Paris 1955

MILAREPA, *Milarepa. Magicien-Poète-Ermite-tibétain. XIe siècle*, transl. by J. Bacot, Paris 1950

PAULHAN, Jean, *Braque le patron*, Paris 1945

and Geneva and Paris 1947 editions

PAULHAN, Jean, *Les paroles transparentes*, Paris 1955

PERSE, Saint-John, *L'Ordre des Oiseaux*, Paris 1962

PINDARE, *Le Ruisseau de Blé*, transl. by J. Beaufret, R. Char, P.A. Benoit, D. Fourcade; Alès 1960

PONGE, Francis, *Cinq Sapates*, Paris 1950

REVERDY, Pierre, *Braque - Une aventure méthodique*, Paris 1950

REVERDY, Pierre, *La Liberté des Mers*, Paris 1959

RIBEMONT-DESSAIGNES, Georges, *La nuit la faim*, Paris 1960

ROUX, Saint-Pol, *Août*, Paris 1958

BRAQUE, Georges, and Jean PAULHAN, *Correspondance, Sélections. Braque Paulhan, deux lettres de Jean Paulhan et quatre réponses de Georges Braque*, Paris 1984

BRASSAI, *The Artists of My Life*, London 1982 (translated from *Les artistes de ma vie*, Paris 1982)

BRIGHTON 1992, *The Dieppe Connection. The Town and its Artists from Turner to Braque*, published to accompany the exhibition *Rendez-vous à Dieppe*, Brighton Museum and Art Gallery 1992

CASSOU, Jean, 'Le Secret de Braque', *L'Amour de l'Art*, Paris, January 1946, pp.4–8

CHAPON, François, *Le Peintre et le livre. L'âge d'or du livre illustré en France 1870-1970*, Paris 1987

CHAR, Marie-Claude, *René Char. Faire du chemin avec …*, Paris 1992

CHAR, René, 'Peintures de Georges Braque', *Cahiers d'Art*, Paris, 1951, pp.141–9 (a shorter variant was reprinted as 'Lèvres incorribles' in Char, *Recherche de la base et du sommet*)

CHAR, René, *Recherche de la base et du sommet*, Paris 1971 (collective edition)

CHARBONNIER, Georges, *Le Monologue du Peintre* (interviews with artists including

Braque, originally broadcast on the radio), Paris 1959

CLEMENT, Russell T., *Georges Braque. A Bio-Bibliography*, Westport, Connecticut and London 1994

COGNIAT, Raymond, 'Braque', *Arts: Beaux-Arts, Littérature, Spectacles*, Paris, no.118, 6 June 1947, p.1

COOPER, Douglas, *Braque: The Great Years*, The Art Institute of Chicago 1972, published in conjunction with the exhibition held there October–December 1972; reprinted London 1973

COUTURIER, le Père Marie-Alain, *Se Garder Libre. Journal (1947–1954)*, Paris 1962

DAMASE, Jacques, *Georges Braque*, London 1963

DERRIERE LE MIROIR, Paris: Braque issues: no. 4, June 1947; nos. 25-6, January-February 1950; nos. 48-9, June-July 1952; nos. 71-2, October-November 1954; nos. 85-6, April-May 1956; no. 115, 1959; nos. 135-6, December 1962-January 1963 (Braque and Reverdy issue); nos. 144-5-6, May 1964 ('Hommage à Georges Braque'); no. 166, June 1967

DIEHL, Gaston, 'L'Univers Pictural et son Destin: Extrait d'une conversation avec Georges Braque', in *Les Problèmes de la Peinture*, sous la direction de Gaston Diehl, Paris 1945, pp. 307-9

EDINBURGH 1956, *G. Braque*, exhibition catalogue by Douglas Cooper, Royal Scottish Academy, Edinburgh, August–September 1956 (see LONDON 1956 for the Tate Gallery version of the exhibition which had a separate catalogue)

ELGAR, Frank, and Georges BRAQUE, *Résurrection de l'Oiseau*, Paris 1958

FAUCHEREAU, Serge, *Braque*, Barcelona 1987 (English translation of French original, published Paris, 1987)

FRANCE ILLUSTRATION, Paris, Christmas 1954, 'A Varengeville, chez Georges Braque', (unsigned), pp.73–80

FRANKFURTER, Alfred M., 'G. Braque', *Art News*, New York, vol.XLVII, no.10, February 1949, pp.24–35, 56

FUMET, Stanislas, *Braque*, Paris 1946

FUMET, Stanislas, *Sculptures de Braque*, Paris 1951

FUMET, Stanislas, *Georges Braque*, Paris 1965

GIEURE, Maurice, *Georges Braque*, Paris 1956

GUTH, Paul, 'Visite à Georges Braque', *Le Figaro Littéraire*, Paris, 5th year, no. 212, 13 May 1950, p. 4

HERON, Patrick, *The Changing Forms of Art*, London 1955

HERON, Patrick, *Braque*, London 1958

HOWE, Russell Warren, 'Braque, but only unawares', *Apollo*, London, 1949, p.104

JAKOVSKI, Anatole, 'Interviews et Opinions. Georges Braque', *Les Arts de France*, Paris, no.8, 1946, pp.30–6

KUNSTEN IDAG, Oslo, 1964, no. 1, special Braque issue with a text by Ole Henrik Moe

LASSAIGNE, Jacques, 'Un entretien avec Georges Braque', in the catalogue of the exhibition *Les Cubistes*, Galerie des Beaux-Arts, Bordeaux, and Musée d'Art Moderne de la Ville de Paris 1973, reprinted in *XXe Siècle*, Paris, December 1973, pp.3–9.

LES LETTRES FRANÇAISES, Paris, 6–12 September 1962, tributes to Braque on his eightieth birthday

LEYMARIE, Jean, 'G. Braque, *L'oiseau et son nid*', *Quadrum*, Brussels, no.v, 1958, pp.72–3

LEYMARIE, Jean, *Braque*, Geneva 1961

LEYMARIE, Jean, 'Evocation de Reverdy Auprès de Braque et de Picasso', Reverdy special issue, *Mercure de France*, Paris, vol. 344, January-April 1962, pp. 298-302

LEYMARIE, Jean, *Braque: les Ateliers*, Aix-en-Provence 1995

LIBERMAN, Alexander, 'Braque', *Vogue*, New York, 1 October 1954, pp.112–19, 173.

LIBERMAN, Alexander, *The Artist in his Studio*, London 1960, London 1988 with a variant selection of photographs

LIMBOUR, Georges, 'L'atelier parisien de Braque', *Derrière le Miroir*, Paris, nos 85–6, April–May 1956, n.p.; reprinted in Limbour, *Dans le Secret des Ateliers*, Paris 1986

LIMBOUR, Georges, 'Georges Braque: découvertes et tradition', *L'Oeil*, Paris, no.33, September 1957, pp.26–35, with photographs by Robert Doisneau

LIVERPOOL AND BRISTOL 1990, *Braque: Still Lifes and Interiors*, with essays by John Golding and Sophie Bowness, a South Bank Centre Touring Exhibition held at the Walker Art Gallery, Liverpool and the Bristol Museum and Art Gallery 1990

LONDON 1946, *Braque-Rouault*, exhibition catalogue, Tate Gallery, London 1946 (with a cover by Braque)

LONDON 1956, *G. Braque*, exhibition catalogue by Douglas Cooper, Tate Gallery, London, September–November 1956 (the same exhibition, supplemented by three paintings, as shown at the Royal Scottish Academy, Edinburgh in August–September 1956; there were separate catalogues for the two exhibitions)

MADRID 1979, *Georges Braque: Oleos, gouaches, relieves, dibujos y grabados*, exhibition catalogue, Fundación Juan March, Madrid 1979

MAN, Felix H., *Eight European Artists*, London, Melbourne, Toronto 1954 (photographs of Braque in his studios and at Varengeville)

MARTIGNY 1992, *Braque*, exhibition catalogue by Jean-Louis Prat, Fondation Pierre Gianadda, Martigny 1992

NEW YORK 1949, *Georges Braque*, exhibition catalogue by Henry R. Hope, The Museum of Modern Art, New York, and the Cleveland Museum of Art 1949

NEW YORK 1988, *Georges Braque*, exhibition catalogue by Jean Leymarie, Solomon R. Guggenheim Museum, New York 1988

NEW YORK 1989, *Picasso and Braque. Pioneering Cubism*, exhibition catalogue by William Rubin with a documentary chronology by Judith Cousins, The Museum of Modern Art, New York 1989

PARIS 1963, *Georges Braque, René Char. Manuscrits, Livres, Documents, Estampes*, exhibition catalogue, Bibliothèque Littéraire Jacques Doucet, Paris 1963

PARIS 1973–4, *Georges Braque*, exhibition catalogue, Orangerie des Tuileries, October 1973–January 1974

PARIS 1974, *Jean Paulhan à travers ses peintres*, exhibition catalogue, Grand Palais, Paris 1974

PARIS 1980, *René Char. Manuscrits enluminés par des peintres du XXe siècle*, exhibition catalogue, Bibliothèque Nationale, Paris 1980

PARIS (LEIRIS) 1982, *G. Braque et la Mythologie*, exhibition catalogue, Galerie Louise Leiris, Paris 1982

PARIS (POMPIDOU) 1982, *Georges Braque, les papiers collés*, exhibition catalogue, Centre Georges Pompidou, Musée national d'art moderne, Paris 1982

PAULHAN, Jean, *Braque le patron*, editions of 1945 (Paris), 1946 (Geneva and Paris), 1947 (Geneva and Paris) and Paris (1952, definitive edition); the latter edition is reprinted in Paulhan, *Oeuvres Complètes*, volume 5, Paris 1970

Perse, Saint-John, and Georges Braque, *L'Ordre des Oiseaux*, Paris 1962 (translations include that by Robert Fitzgerald, *Birds*, New York 1966)

Le Point, Souillac and Mulhouse, vol.xlvi, October 1953, Braque special issue, with essays including Stanislas Fumet, 'Georges Braque peintre contemplatif'; and Georges Limbour, 'Georges Braque à Varengeville' (reprinted in Limbour, *Dans le Secret des Ateliers*, Paris 1986); and photographs by Robert Doisneau

Ponge, Francis, *Braque Dessins*, Geneva 1946 (and Paris 1950)

Ponge, Francis, *Le peintre à l'étude*, Paris 1948

Ponge, Francis, preface to *Braque Lithographe*, catalogue established by Fernand Mourlot, Monte Carlo 1963

Ponge, Francis, *L'Atelier Contemporain*, Paris 1977

Ponge, Francis, Pierre Descargues and André Malraux, *G. Braque de Draeger*, Paris 1971

Pouillon, Nadine, with Isabelle Monod-Fontaine, *Oeuvres de Georges Braque (1882–1963)*, Collections du Musée National d'Art Moderne (Centre Georges Pompidou), Paris 1982

Prevert, Jacques, *Varengeville*, Paris 1968

Prevert, Jacques, *Couleurs de Braque, Calder, Miró*, Paris 1981

Reverdy, Pierre, *Braque - Une aventure méthodique*, Paris 1950

Richardson, John, 'Le nouvel "Atelier" de Braque', *L'Oeil*, Paris, vol.1, no.6, 15 June 1955, pp.20–5, 39

Richardson, John, 'The Ateliers of Braque', *The Burlington Magazine*, London, no.627, vol.xcvii, June 1955, pp.164–70

Richardson, John, *Georges Braque*, Harmondsworth 1959

Richardson, John, *Braque*, London 1961

Saint-Paul 1980, *Georges Braque*, exhibition catalogue, Fondation Maeght, Saint-Paul 1980

Saint-Paul And Paris 1971, *Exposition René Char*, exhibition catalogue, Fondation Maeght, Saint-Paul; Musée d'Art Moderne de la Ville de Paris 1971

Teriade, E., 'Confidences d'Artistes - Georges Braque', interview with Braque, *L'Intransigeant*, Paris, 3 April 1928, p. 6

Time, New York, 29 October 1956, 'Braque: the cool fire–spitter', (unsigned), p.82

Vallier, Dora, 'Braque, la peinture et nous. Propos de l'artiste recueillis par Dora Vallier', *Cahiers d'Art*, Paris, 29th year, no.1, October 1954, pp.13–24 (translated as *Georges Braque. Ten Works*, with a discussion by the artist: Braque speaks to Dora Vallier, London 1963; collected in Vallier, *L'Intérieur de l'Art: Entretiens avec Braque, Léger, Villon, Miró, Brancusi (1954–1960)*, Paris 1982)

Vallier, Dora, *Braque, The Complete Graphics, Catalogue Raisonné*, New York and London 1988 (a translation of *Braque. L'oeuvre gravé. Catalogue raisonné*, Paris 1982)

Venice, 1948, *Verbale della Seduta per l'Assegnazione dei Premi alla xxiv Biennale 1948*, Fondo Storico delle Arti Contemporanee, Venice, 1948, Premi

Verdet, André, *Georges Braque*, Geneva 1956

Verdet, André, 'Avec Georges Braque', *XXe Siècle*, Paris, 1962; reprinted in Verdet, 1978

Verdet, André, *Georges Braque le solitaire*, Paris 1959

Verdet, André, 'Le sentiment du sacré dans l'oeuvre de Braque', *XXe Siècle*, Christmas 1962, pp.17–23 (reprinted in part in Verdet, 1978)

Verdet, André, 1978, *Entretiens, notes et écrits sur la peinture: Braque, Léger, Matisse, Picasso*, Paris 1978

Washington 1982, *Georges Braque: The Late Paintings 1940–1963*, exhibition catalogue by Herschel B. Chipp, introduction by Robert C. Cafritz, The Phillips Collection, Washington D.C.; the exhibition was also shown at the Fine Art Museum of San Francisco, the Walker Art Center, Minneapolis and the Museum of Fine Arts, Houston 1982–3

Zervos, Christian, 'Braque et la Grèce Primitive', *Cahiers d'Art*, Paris, 1940, pp.3–13

Zervos, Christian, *Georges Braque. Nouvelles Sculptures et Plaques Gravées*, Paris 1960

Zurcher, Bernard, *Georges Braque: life and work*, New York 1988 (a translation of *Georges Braque, vie et oeuvre*, Fribourg 1988)

Numbers in bold refer to pages of catalogue entries of works exhibited. Figures are indicated by (fig.) after page number. Comparative illustrations to the catalogue entries are indicated by e.g. (cat. 17a) after page number.

PHOTOGRAPHIC CREDITS

All works of art are reproduced by kind
permission of the owners. Specific
acknowledgements are as follows:

All works by Braque reproduced in this
catalogue are © ADAGP, Paris and DACS,
London 1997

Anders, Jörg P., Berlin, cat. 17
Basel, Oeffentliche Kunstsammlung Basel,
Martin Bühler, fig. 8
Brassaï, © Gilberte Brassaï, cat. 3a, fig. 19,

Fenn, Gene, fig. 20
Germain, Claude, Paris, cat. 22
Hickey-Robertson, Texas, cats. 2,6
Izis, fig. 13
Klein, Walter, Düsseldorf, cat. 19
Lachaud, © Mariette Lachaud, cat. 31b, 33b,
fig. 14
Liberman, © Alexander Liberman,
frontispiece, cats. 15a, 20a, 24a, 39a, 40a, figs.
21, 22
© Lipnitzki-Viollet, fig. 12
London, Prudence Cuming Ass. Ltd., cat. 16

Man, Felix, © Lieselott Man, cats 38a, 38b
Maywald, © Assoc. Willy Maywald/ADAGP,
Paris and DACS, London 1997, cats. 26a, 37a
Paris, Galerie Adrien Maeght, cats. 28, 33, 35,
36, 42, 46
Parnotte, Henry, cat. 23b
Rosenthal, Lynn, fig.7
Routhier, J.M., Paris, cats. 11, 25, 29, 37, 40,
41, 43
San Gabriel, Calif., A.E. Dolinski
Photographic, fig. 4
Sima, © Michel Sima/SELON, fig. 1